A COLLECTOR'S
ODYSSEY

A COLLECTOR'S
ODYSSEY

ROBERT H. BLUMENFIELD

BLENHEIM HOUSE BOOKS
Boston, MA

Blenheim House Books
Boston, MA

ISBN: 978-1-947368-15-6

Library of Congress Control Number: 2017957728

Printed in China
21 20 19 18 17 • 5 4 3 2 1

Book design by Dotti Albertine

It is virtually impossible to acquire the knowledge and experience to educate oneself merely by just attending a university or school. Only by touching, looking at, and examining objects can one achieve the acumen of an expert.

The following individuals have been my teachers, advisors, and confidants, who over the years, through countless conversations and meetings, lunches, dinners, and phone calls, have shared their advice and experience. In some cases, we have visited museums, auction houses, and dealers' galleries together all over the world. Their encouragement, support, and advice have helped me become the collector I am today. With gratitude and thanks, I dedicate this book to all of them.

—ROBERT H. BLUMENFIELD

Brian Beet

Anthony Carter

Richard Coles

Nicholas Grindley

Brian Harkins

Gerald Hawthorne

James Hennessy

Hei Hung Lu

Cola Ma

Hugh Moss

Paul Moss

Will Strafford

CONTENTS

I don't believe great art collectors are made—I believe they are born. And endowed with special attributes: passion, drive, aggressiveness, commitment, and resourcefulness. It's in their DNA. The very good ones search for the very best, most beautiful, rarest, and finest. It's not about finding the most expensive objects; it's about the objects you can't do without. The ones that keep you up at night and in some cases obsess you. The Chinese say the longest journey starts with a single step, and for as long as I can remember, I have been collecting. While other boys occupied their time with sports and other endeavors, I was drawn to more artistic pursuits. Growing up in New York City exposed me to architecture, museums, restaurants, music, and theater.

In grade school I started thinking it would be great to live in a museum. I loved the idea of living among beauty. Everywhere I looked in museums, I saw something new and pleasing. I felt sure that if I could just figure out how to have that feeling all the time, I would be happy.

Collecting came to me early. Every Saturday morning, I went alone to the Brooklyn Museum's children's art program, which I loved—my gathering of memories of those visits may be the most valuable collection I have.

Until I was fifteen, I shared a small bedroom with my sister. Despite the ever-present material constraints, even then I was collecting. I stored my acquisitions on the closet's single shelf, which served as the cradle of my passion. At night, wielding a flashlight, I pored over my collections.

I started with cards: baseball cards, picture cards of movie stars, and the like. Eventually I graduated to collecting stamps, becoming a fairly serious philatelist. Even now I recall fondly my solo Saturday excursions to Nassau Street and its generous cache of stamps. Of course, philately wasn't any "cooler" then than it is now; while my grade-school colleagues were busy playing stoopball, punchball, and hit the penny, I was busy with my stamps. Needless to say, I was often alone, enjoying only the company of my collection.

When I speak with other collectors who really "get it," we are consumed by fellowship and mutual regard for the objects we love. Collecting, I've learned, is most importantly about personal relationships.

This pursuit has led me across the world and into all sorts of unexpected situations. I've met and befriended people from every walk of life. I have seen countless singular and beautiful things, objects that never fail to make me marvel at human creativity and skill. I've enriched my life in countless ways through my pursuit of great art.

I've never been a "money" collector, the sort of person who calculates the fiscal value of an item, buying and selling art the same way one would stocks or bonds. This is not to say that I don't bring a business sensibility to my pursuit. There is a surprising amount of overlap between buying art and my other primary pursuit, Southern California real estate development. Every work of art I have purchased has spoken to me, and I buy only

the pieces that I feel belong in my personal collection. Similar pressures and competing interests are at play in both real estate and art. And just as there is a bit of cold, hard business mixed in with art ownership, there is no small amount of intuition and creativity required for success in real estate. Both endeavors have required me to refine my judgment and my instincts.

Today I am fortunate to own more than one thousand works of art—including delicate lacquer dishes and vessels, boxes from fifteenth- to eighteenth-century China, classic eighteenth-century English and French furniture, paintings and sculpture from ancient times and the modern world. Because of the intense interest from auction houses, collectors, and dealers, I have decided to share the journey behind my pursuit, consideration, and acquisition of these pieces—my collector's odyssey, which has brought me to tiny villages in rural China and to the greatest auctions in Europe.

My adventure began in 1978, when I entered the shop of a mid-Manhattan Asian art dealer and was immediately struck by the beauty of a seventeenth-century blanc de Chine porcelain statuette depicting Guanyin, the bodhisattva or goddess of mercy. I stood and marveled at that exquisite porcelain. I had never seen anything like it and I had no idea what it was. I was so impressed by this statue that I tried to buy it, but it was not for sale. I began to wonder what other treasures might be hidden away in the back of the store. I'd always heard that the best pieces in any shop were seldom on public view, so I headed for the rear of the shop and noticed an invitingly closed cabinet. I've always been curious: I opened the cabinet, peered into the darkness, and that single experience set me on the path toward Asian art that I would walk for the rest of my life.

I discovered a magnificent seventeenth-century brush pot depicting the Seven Sages of the Bamboo Grove. The elegance of the craftsmanship and the unparalleled beauty of workmanship moved me. I had to own it. That bamboo brush pot became the cornerstone of one of my greatest collections.

❆ ❆ ❆ ❆

The art world as we know it today is dramatically different from that of thirty or even fifteen years ago. Taste—especially good taste—is timeless. However, while the artifacts that the tasteful admire may be hundreds of years old, collecting has evolved into an ever more modern, ever more complex, and ever more global enterprise. The very structure of the art trade is changing. High rents in London and New York are forcing dealers to leave the scene, giving auction houses an ever greater role.

Why consign a piece to a dealer with a relatively small circle of buyers, when you can put it up for auction and let potential bidders from around the world send the price sky-high? As a result, the art world is consolidating in ways that would have been unimaginable just a decade ago. Very few people actually get to see what happens inside the world of high-end art collecting; fewer still got to watch the industry transform itself over the course of several decades. I am in the fortunate position of having experienced the evolution of the industry firsthand.

Let me tell you a story.

A friend recently alerted me to a small jade cup that was coming up for auction in Paris. I have a large collection of Chinese jade, and I am always looking for new and exciting pieces. My friend sent me a photo. He had already seen it in person, and more importantly, he had already fallen in love with it.

"It might be Sung," he told me, meaning the piece could date to the Sung Dynasty (960–1279). Great pieces from that era often fetch high prices at auction. The auction house had estimated that the piece was newer, seventeenth or eighteenth century, and had priced it accordingly. If my friend was right and the auction house was wrong, I could stand to get the jade for far less than its true value.

If I were only interested in art as a financial transaction, my decision would have been made for me. I would get the jade simply because the cost was much less than the potential benefit. However, after looking at the piece and speaking with my friend, I eventually decided against bidding on the cup. Why? Because I didn't *love* it. Rarity is not enough; uniqueness is not

enough. Even value is not enough. A piece has to reach out and grab me. For me, a treasure has three components: beauty, rarity, and condition. I have to have that urgent feeling in the pit of my stomach that means, *you have to have this.*

There are people who have hard-and-fast rules about what they buy (e.g., certain eras, certain ages, certain levels of quality, etc.), and they don't deviate from them. I could never work that way. Instead, my rule is this: I can't bring something into my collection if I don't want to live with it. I am a treasure hunter, and "treasure" is defined in deeply personal ways. A treasure is something that gives you joy. When I looked at that jade cup, I just saw a cup. So, while in the grand scheme of the historical record and the balance sheet, that jade cup may indeed be a treasure, it wasn't *my* treasure, so right or wrong, I let it go.

I'm not the first admirer of art to think of himself, in some way, as the curator of his own private museum. In fact, many collections now housed in museums were assembled by private individuals. Looking at these collections, it is possible to get a sense of how these individuals approached buying and selling, and what they personally prized.

Consider two heavyweight collectors who eventually supplied famous museums with their acquisitions: J. Paul Getty and Belle Linsky. Getty may be familiar to you (the museum he donated his collection to bears his name, after all) but Linsky is more obscure.

Belle Linsky and her husband, Jack, founded Parrot Speed Fastener, the company that invented the Swingline stapler, which made them very wealthy. She donated much of her collection (more than five hundred pieces) to the Metropolitan Museum of Art in New York, where you can view them today. Getty and Linsky both had keen eyes, and at roughly the same time, they frequently bid against each other for items. Linsky, however, would often outbid Getty. Yes, outbid John Paul Getty!

Getty was a money buyer. There was a hard ceiling on all his bids, and he let someone else have the piece before he overspent. Though he was an oil magnate, Getty was famously (or infamously) frugal: so miserly was he, they say, that he installed a pay phone at his vast English estate in order to prevent workmen and visitors from driving up his telephone bill.

I seriously doubt that Getty was ever physically present at the same auctions as Linsky, but nevertheless they competed for pieces—Getty dispatched his agents; Linsky relied on her eyes. Linsky bought the pieces that moved her; Getty only bought the pieces that made financial sense. She often beat Getty simply because she wanted a given piece more, whatever it might have been. That's why Getty's core collection (the collection bequeathed to his trust), while impressive, often seems lacking in some way. By contrast, when you look at the Linsky collection at the Met, you get an indelible feel for the strong sensibility and keen eye this woman brought to her collecting. In the late 1990s, when the Getty museum moved to Brentwood, many people asked me, "Was Getty actually a great collector?" He certainly had many fine things. It's difficult, however, to be a truly great collector if you are always looking for a bargain.

It seems hard to believe, especially when we are talking about a world where tiny objects sometimes sell for millions of dollars, that collecting isn't about the money. It's *never* about the money. It's about possessing the greatest pieces, the most wonderful art that has come out of thousands of years of human history.

There's no escaping the fact that greatness has a hefty price tag. Even when these objects were new, they weren't inexpensive. No one was getting a "deal" on Chippendale furniture in 1775. This applies to more than English furniture and Chinese jade, of course. A skilled lawyer with an Ivy League education and years of successful litigation experience can charge more than the personal injury guy with the late-night infomercials. Quality comes at a premium.

I learned this lesson early and from a perhaps unlikely source: my mother. She was not a collector. She was a working-class woman in Brooklyn. She didn't have money, but she did have an excellent eye. My earliest experience with the world of antiques and art came on trips to Brooklyn antique shops with my mother. She had modest household funds, and we bought what she could afford. She often arranged to pay for the pieces

over time—sometimes a dollar or two a week. She appreciated beautiful things, and she taught me to appreciate them too. She wasn't a connoisseur; she just bought what she liked, which itself was a valuable lesson.

She taught me to value the things that resonated with me. "If you see it and love it," she always told me, "buy it, because you may never see it again." In another life, she might have been a great businesswoman, and a great collector.

I carry my mother's words with me everywhere I go. There is no substitute for that feeling of seeing something and just knowing that it is right for you—in a sense, that it already belongs to you. I have always sought to buy the objects that strike me in that way, and for the most part, this has made me very successful as a collector.

I didn't start buying Chinese art objects because they were worth a lot of money. That wasn't even true when I started collecting decades ago. I bought those pieces because I thought they were great and I wanted them to be a part of my life. They were treasures to me, even if they were not yet treasures to the rest of the collecting world. History has borne me out, and these days the trade in Chinese art is booming. Even if the tide had never turned, however, and my pieces had not appreciated in value, I would still be pleased with them because I bought them out of love.

This book will tell you how I acquired many of my most beautiful objects. I chose these pieces not only because they are unique but also because they bring joy to my life. Buying art is never easy; it's difficult to find real treasures and costly to procure them. One of the themes of this book is that great pieces of art seldom "slip through" today. In my early collecting days, you could find things that no one else had recognized as valuable. Today, thanks to the Internet, the world has become too sophisticated and treasures seldom carry the bargain price tags they often did early in my collecting career. To find something great today, you have to know where to look, what to look for, how much to spend, and perhaps most important, when to walk away if the price is too high or the provenance is questionable.

I am an unabashed perfectionist, and I agonize over everything I buy. Every piece I own must be rare, beautiful, and as close to perfect as possible. This book brings you along on my hunt and chase, and I hope you feel the passion and the thrill of the acquisition.

It's one thing for someone to claim he has a great collection of unique and extraordinary pieces; it's another thing entirely for the market to concur.

In 2010, I decided to sell all my seventeenth- and eighteenth-century Chinese rhino horn and ivory carvings. Anticipating the coming restrictions on trade, I added several other pieces from my collection—paintings, bronzes, and wooden figurines—to enhance the catalogue. The auction, *For the Enjoyment of Scholars: Selections from the Robert H. Blumenfield Collection,* included approximately 20 percent of my total collection, and was held at Christie's in New York. The event ignited worldwide interest on the part of the media, dealers, and collectors, both in my collection and in my methods of collecting. The response to the auction was overwhelming.

Most single-owner auctions need minimum expected sales of $3 million to $5 million to compel an auction house to offer beneficial terms—insurance and shipping on purchases, photography, in some cases a hardcover catalogue—to consigners whose collections are likely to reach these figures. My auction featured 158 pieces I had painstakingly accumulated over a period of thirty years. The entire catalogue was predicted to sell briskly, with a high estimate of $5.4 million. To my surprise and pleasure, the sale realized more than twice the initial high estimate, $13.9 million, which I took to be fairly strong proof that the market valued my collection as much as I did!

Christie's attributed the auction's success to a buoyant market, my refined taste and exceptional eye for desirable pieces, and to the demand for fresh, beautiful, and rare works. An example: One of the items I offered was a Chinese hand scroll. The face on it was painted by the inestimable Yu Zhiding, the official painter in the court of Emperor Kangxi. This painting, entitled *Happiness through Chan Practice: A Portrait of Wang Shizhen,* is

Imperial handscroll

among the most superb examples of early Qing portraiture. The composition is a psychologically complex and revealing study of its subject, Wang Shizhen, offset by a lush landscape.

As is often the case with Renaissance European art, the master did the key artwork and his studio completed the rest. A superlative example of Qing Imperial art, the portrait is followed by fifteen colophons, each lauding Wang Shizhen's accomplishments and character. I purchased this hand scroll from Christie's for $40,000, and less than twenty years later it was estimated to sell for between $80,000 and $120,000. Instead, it realized a record-breaking $3.5 million at auction! The buyer was a Shanghai collector building a museum into a large real estate development. Like me, he was a real estate developer, and his current project was a shopping center in downtown Shanghai. The city asked him what public amenities he was willing to provide and gave him a list of suggestions—including a museum. I identified with his situation because the same thing happens in the city where I work, Santa Monica, California, and perhaps in most cities around the world. If you want to build

something, you have to be ready to provide something "extra" for the residents. The hand scroll would be a great coup for the new museum.

How do you find great pieces of art like that hand scroll? How do you navigate the ever-changing art world, with the relationships among dealers, auction houses, collectors, museums, and investors in constant flux? I will answer these questions as we travel the globe in search of the best of the best. I hope our journey will shed light on the current state of the art market across the world, from the perspective of a single collector.

AT HOME IN ASIA

In Old Hong Kong

As I became more and more interested in collecting Chinese art and artifacts, my desire to educate myself became insatiable. I sought out bits of information wherever I could, but this information wasn't always easy to find. The best advice was to go to the source—the dealers and antiquarians of London, Paris, New York, and pre-takeover Hong Kong.

Of all the places I've been and all the fantastic cities of the world I've seen, none captures my imagination quite like Hong Kong. In addition to the city's stunning beauty, it was a treasure trove of the objects I desired, and I truly enjoyed the hunt for them. To this day, I have more than just the items I purchased; I have my memories of the pursuit, the food, the smells, the people, and of course the joy of doing what I love.

Hong Kong, for me, was simultaneously intimately familiar and startlingly novel. Raised in New York, I was instantly at home with the city's energy and infrastructure. It's truly the city that never sleeps—even more than New York—and I immediately loved it. Like a shared second language, natives of vertical cities like New York, Hong Kong, and Tokyo, have very little difficulty translating their lifestyle to other vertical cities. My wife, Sharon, is from Seoul, so she shares this ability. I am always amazed at the ease with which she navigates the labyrinthine subways of New York, London, and Paris, even when she descends into them sight unseen.

But Hong Kong is also reluctant to reveal its secrets at first glance. I first discovered the city as a young man traveling the world in 1964, and it has had a hold on me ever since. In those days, arriving flights still descended into the old Kai Tak Airport, a single, alarming airstrip jutting out into Victoria Harbour. These pilots needed to thread a narrow needle; the airport was abutted by mountains and skyscrapers, not water or empty plains.

With 17,000 people per square mile, Hong Kong is one of the most densely populated cities in the world. Space is at a premium and demand is sky-high, meaning engineers and architects had no choice but to build up, eventually making Hong Kong the world's most vertical city. The imposing skyline makes for stunning vistas, to be sure, but it meant landing on the island was absolutely hair-raising.

I must not have been the only one alarmed—though oddly thrilled—by this abrupt landing. In 1998, Kai Tak Airport was decommissioned in favor of the much larger Chek Lap Kok Airport, which occupies an island all its own. This new airport is certainly more spacious and comfortable. Nevertheless, it lacks that unique thrill that the old airport provided; soaring between apartment buildings on approach, passengers could catch the briefest glimpses of families sitting down to dinner through their open windows.

In my early Hong Kong days, Pan Am was still offering around-the-world flights. Pan Am 1 went west, and Pan Am 2 went east. As long as you didn't double back, you could circumnavigate the globe, stopping in any number of wonderful cities along the way. I took this journey with a friend, and while we visited many places, I knew right away that Hong Kong was extraordinary.

Opposite: Old Kai Tak airport / Photo by Getty Images / Russ Schleipman

As my happy madness for collecting grew into a full-blown mania, I made regular trips to Hong Kong to acquire both objects and knowledge. On early trips, I was the proverbial innocent abroad: I didn't know the language, the geography, the people, or the social mores. I did, however, come to the city with a passion for learning and collecting, and I knew that Hong Kong was a world hub for Chinese art. I also knew that I needed to be in the thick of that action. This was the supply source for the London and New York Asian art trade, so it made sense for me to be there.

I began taking regular trips to Hong Kong, threading the Kai Tak needle after the fifteen-or-so-hour flight, arriving in time for dinner, or even better, a party. My hotel's courtesy vehicle, usually either a Daimler or a Rolls-Royce with a fully liveried chauffeur, whisked me to my hotel and my awaiting suite.

During those years, I stayed on the Kowloon side of the city. Kowloon is directly across Victoria Harbour from Hong Kong, and was among the exurbs that first saw intensive development in the early twentieth century. Originally a tiger-hunting ground for the colonial British in the nineteenth century, Kowloon is currently the largest and most densely populated part of Hong Kong.

I especially liked the Regent Hotel, which was right on the water. When it opened in 1981, the Regent was thoroughly modern and exceedingly beautiful. The whole interior was stone, and staff members in crisp white Mao suits were constantly polishing it until it shone like a mirror.

I proceeded directly to the concierge, in the center of the gleaming lobby. "Hello, Mr. Blumenfield! I trust your travels have gone well. Your room is ready." Such service! Many cultured visitors to the city preferred the traditional comforts of the Peninsula, a world-famous hotel across the street, but I preferred the Regent, not only for its splendid service, but also for the magnificent vistas from my "harbor view" room.

I always seemed to reach my room around dusk. I immediately pulled a chair up to the enormous, floor-to-ceiling windows and opened the blinds. The porter brought me fresh fruit and a pot of exquisite jasmine tea. There I sat at the window, staring out at the glittering, colorful tiara that was Hong Kong at night. The shimmering white halo of the city proper and the hypnotic pendulum of ferryboats crossing back and forth through the harbor helped me decompress after the long flight. The aromatic jasmine tea filled the room, and the cooling breeze blew in off the water. The name Hong Kong—literally, "fragrant harbor"— seemed remarkably appropriate.

But these are memories of a Hong Kong gone by. Now Kowloon, on China's mainland, is stitched to Hong Kong Island by the subway and the shoreline bristles with new high-rises. It's beautiful in its way, but it's not the Hong Kong I remember.

Of course, I hadn't come all that way to gaze out a window. After a meal and a good night's sleep, I hit the streets in earnest, attending auctions and reconnecting with friends, acquaintances, and associates in the city. Time and exposure led me to fall in with a crowd of like-minded and similarly passionate folks in the antiquities scene. This coterie of characters—some expats, some locals—gave me my earliest lessons in Chinese art and culture, and also in the practice of collecting. Eventually, I became very well connected in the expat community, especially the spots where young English-speaking transplants congregated. We got together to socialize and compare notes about our experiences in the city.

Finding great things may have been easier in those days, but it was by no means easy. As a neophyte collector, I had yet to learn the shortcuts, secrets, and unwritten rules of collecting. Fortunately, many of the people I met in Hong Kong during this formative period were incredibly generous with their information and their contacts. I owe a debt to the collecting community for sharing information that I couldn't have gotten otherwise.

My collections really blossomed, thanks to these friends and this city. These memories are among my most cherished. I was young, successful, and hungry for knowledge, and Hong Kong and its denizens delivered the education I so desperately wanted, and which has stood me in good stead to this day.

The World of P.K. Wong

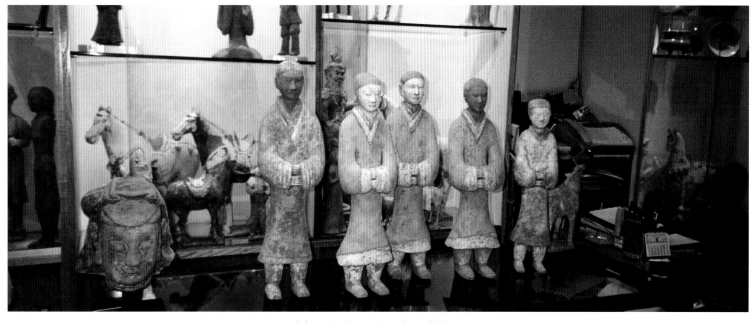

Galaxy Art, Hong Kong Central District

After a few trips to Hong Kong, I had developed a network of extremely knowledgeable people who nurtured my interest into expertise. One of these people was Hugh Moss.

Admittedly, I was a bit intimidated when I met Hugh. Hugh comes from a long line of dealers, and his family has a storied history in the world of collecting. Hugh's father had been dealing in Chinese art for decades. Meeting him was naturally a daunting prospect for a newcomer.

But Hugh was unfailingly friendly and helpful. He was a dealer but he also collected, and we quickly discovered that we often liked the same things. Hugh was born and raised in England and immigrated to Hong Kong as an adult. During Asia Week, when Asian art dealers from around the world descended on the city to share their collections, he had a place outside the city proper in Sha Tin.

I don't remember exactly how we were introduced, but he frequently invited me to his club in Sha Tin, or to his home, where we talked about art and collecting. Hugh is not only a collector but an artist and calligrapher in his own right. He'd had a number of adventures and always had a good story to tell. He had a big walk-in safe in the wall, hidden behind a tromp l'oeil backdrop, and he'd go into it and offer me things. I always appreciated his rock-solid advice about collecting Chinese art.

I used to tell him which objects interested me and where I was staying, and he suggested people to contact. Sometimes he joined me for these meetings.

For one such meeting he brought me to the Prince's Building in Hong Kong's Central District. The second floor housed a shop called Galaxy Art, which was owned by a man named P.K. Wong.

Galaxy Art's average visitors could be forgiven for mistaking it for another junky little antique store peddling trinkets and bric-a-brac to uninformed tourists. But P.K. had a lot more than that to offer. He constantly sourced from all over Mainland China and connected with a number of collectors, making his shop a fast-paced clearinghouse for just about everything. Because he spread his net so wide (and because he moved such an enormous amount of stuff) he always had the most incredible things. Many collectors in Hong Kong made his shop the first stop on any expedition, because just about everything from the mainland came through there at some point.

Hugh visited the shop with me because he knew the importance of getting a good introduction. Without someone to vouch for me, P.K. would have considered me to be just another tourist, not a serious collector. Eventually, of course, people would have seen that I was buying things—expensive things—and paying quickly. But a verified introduction puts the buying process in focus, saving everyone a lot of time.

Hugh was part of a group of collectors who frequented many of the same shops and dealers, and he gave me a crash course on the little tips and shortcuts to finding the most desirable things. He recommended going to Galaxy Arts every morning; P.K. usually got new things in from Mainland China late at night. These were often objects that had just been dug up—in some cases, quite literally. P.K. wrapped them in newspaper and put them behind the desk for the next morning.

Many of his regulars—Hugh, a legendary dealer named Robert Ellsworth, a British barrister named Brian McEleny, and eventually me—came in every morning, and he would show off the new pieces. Not just a great place to buy new things, P.K.'s shop was also a kind of salon, where incredibly knowledgeable people gathered to talk about their shared passion for Chinese *objets d'art*. The shop itself wasn't large; probably only about five hundred square feet, all told. Even so, it was a very popular spot for collectors and dealers, and was always packed.

The first time I went to Galaxy Arts with Hugh, he had something specific he wanted me to see. It was a *ruyi* (scepter), and I gathered it was a very good specimen because he was clearly surprised when I didn't buy it. Shortly thereafter, we were both vying for a bamboo scholar's staff with an inscription. Hugh dearly wanted it, but I ended up getting it. In response to these incidents, Hugh sent me a drawing he had done. He called it "The Rejected Scepter," and it depicted a scholar holding a staff while simultaneously refusing a *ruyi*. He wasn't at all upset; that was just the sort of thing that amused him. I'm sure my befuddled reaction entertained him all the more!

I wasn't interested in the *ruyi* scepter, but other items immediately caught my eye. Being a native New Yorker and a resident Californian, I know nothing about subtlety in either business or pleasure. Indeed, I can hardly help being bold and aggressive at times, and these character traits also arise when I collect. Thus, when I saw something in the Galaxy Arts showcase that I did like (a carved ivory stand, likely imperial), I reached right over and pointed it out to P.K. "What's that?" I asked.

"Oh, no, no, no," P.K. said, shaking his head sadly. "That's reserved for Mr. Jackson." Everyone knew Dave Jackson. Well, everyone except me. He was an English shipper, and I did eventually meet him, but I did not know him at the time. If I had, I might not have done what I did next.

"Has he paid you for it yet?" I asked.

"Oh, no. He hasn't paid yet."

"If he didn't pay, then it's for sale," I argued. When P.K. seemed not to be able to argue with that logic, I knew I had him. "How long has it been here?"

"Several weeks," P.K. admitted.

"And how much are you asking for it?"

He told me the price, and it was very reasonable. "Sounds fine," I said. "I'll take it." And P.K. sold it to me.

Galaxy Arts was a cornerstone of the Hong Kong art trade,

Carved, stained ivory stand

and that little carved ivory stand was the first thing I ever bought, on my first trip to P.K.'s lair.

My introduction to P.K. and Galaxy Arts also resulted in my introduction to the estimable Robert Ellsworth. In those days, he frequented Hong Kong and could often be found in Galaxy Arts, looking at new items and passing the time. With Hugh, P.K., and Ellsworth in attendance, the "campus" of Hong Kong had its professoriate, with Galaxy Arts it had its lecture hall, and I provided its eager student body.

Ellsworth was both extremely fascinating and somewhat intimidating. He never graduated from high school, and he worked his way up from a shop boy at a New York antiques gallery, eventually becoming a world-renowned maven of Chinese decorative arts. Truth be told, he was one of the most successful

dealers I've ever encountered. His shop (Ellsworth & Goldie) operated out of New York for decades. Ellsworth literally wrote the book on Chinese furniture. His resplendently illustrated *Chinese Furniture: Examples of the Ming and Early Ch'ing Dynasties* has been like a bible since it was published in the 1970s. Like me, he also collected English furniture, and his famous Fifth Avenue apartment overlooked the Metropolitan Museum.

As expected, the home was furnished with a number of amazing Asian pieces. As the Chinese say, "he could spot the pearl in a market full of fish eyes." He seemed to have a sixth sense for collecting. He was especially knowledgeable about Chinese furniture and Ming-era Chinese painting.

He was also a philanthropist of stunning largesse. He donated more than five hundred nineteenth and twentieth century

paintings and calligraphic works to the Met, as well as a number of pieces to museums in China, thus returning a substantial portion of their cultural record. He was an invaluable resource for me when I was a novice, and I know he was equally generous with other eager pupils. I had the privilege of knowing Ellsworth for years, passing many an enjoyable afternoon visiting his home and trading stories. Even so, I never bought from him. Maybe because of his great success as a collector, he was tough to buy from—probably because he didn't care whether or not a piece sold. Owning the thing, he reckoned, would be just as good as selling it; the situation was always a win-win for him, so it was always tough to get a deal. I'm sad to say Ellsworth won't read this book; he passed away while I was writing it.

❆ ❆ ❆ ❆

On my first visit to Galaxy Arts, I also purchased a small jade chop. A chop is a printing stamp, usually but not always made of stone. They have been used to affix signatures or authenticating marks since at least the third century BC. This one had an image of a book and a ribbon carved into it. I liked it so much I decided that I wanted to have my own personal seal for documents and items in my collection.

Chinese art includes two main types of seals: leisure seals and studio seals. A leisure seal usually conveys some sort of motto intended to enhance good fortune. A studio seal is more professional, offering information about the artist and (as the name implies) the studio in which he worked.

I wanted a studio seal for a while, but first I needed a studio name. I ruminated on it for a long time, and eventually I asked my friend Kingsley Lu in Hong Kong for advice. "Oh, I can help you with that," he said immediately.

My friend suggested I transliterate my name (which is German for "flower field") and developed a Chinese version of my name: Tián Hu. He wrote out the characters and gave me a number of design options. After I'd picked one, another friend (who made regular trips to Mainland China) connected me with an amazing carver who made me two seals, one big and one small. Years later, when I held my first sale, I insisted my studio seal appear on the cover of the sale catalogue as a small reminder that even a great collection begins with small steps.

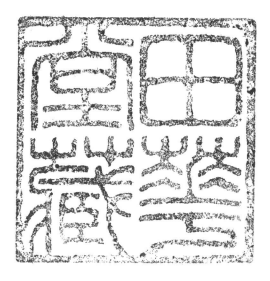

Personal studio seal

The Yellow-Flowered Pear

After those first few trips, I made my Hong Kong visits a regular priority. I relied on my connections with the collecting community there to provide lively, informative conversation, point me toward prospective purchases, and educate me on antiquities and the trade in antiques.

Thankfully, one connection usually led to another, and I soon knew a number of interesting people, each with unique expertise and connections. This Hong Kong education helped me slowly realize that finding a great object and then being able to buy it is really the luck of the draw. But chance favors the prepared, and fortune favors the bold. The more people I knew, the luckier I seemed to get!

I made it a point to socialize with others in the trade to discuss furniture, art, and relevant news. Hong Kong is small, albeit densely populated; there are only so many places to go. With enough time and exposure, you start seeing the same faces over and over.

I stopped hitting the shops though, because there was soon nothing left to buy. Dealers and proprietors were my most reliable and knowledgeable informants. I attended auctions by day and social events in the evening; I loved sharing my passion with like-minded souls and I cultivated my connections over great meals and fine wine.

One night I attended a party thrown by Grace Wu Bruce. At that time she was married to a nobleman, the Honorable James Henry Morys Bruce. They had a beautiful home, and she regularly hosted dinner parties so new people and established regulars could meet and mingle. She was a hospitable woman, and while she was not a dealer at that time, she was interested in Chinese furniture and very knowledgeable about it.

When I expressed an interest in Chinese furniture, she told me, "You've got to go see Hei Hung Lu."

Hei Hung Lu was a dealer of some repute. He specialized in Chinese furniture, and had a showroom in his enormous flat in Kowloon, right on Nathan Road. He was a Peking Muslim, and he lived across from one of the five principal mosques in Hong Kong.

"It's not your average shop," Grace explained. "It's more like an office, but he has a good deal of merchandise. He has a large back room full of things. I think he actually has eight or ten warehouses all over Hong Kong, all fully stocked."

"How do I meet him?" I asked. I was still a bit wet behind the ears, but I had been around long enough to know that the most significant figures in the collecting community were rarely accessible to the layman.

"You need an introduction. Ask Bobby Ellsworth," she suggested.

As it turned out, Ellsworth was very close with Hei. He was godfather to Hei's children, and hosted them whenever they were stateside. Naturally, Ellsworth was willing to make the introduction for me. I'm hopeful he told Hei I was a serious person, a sincere collector, and that I could afford to buy quality things—all categorical truths!

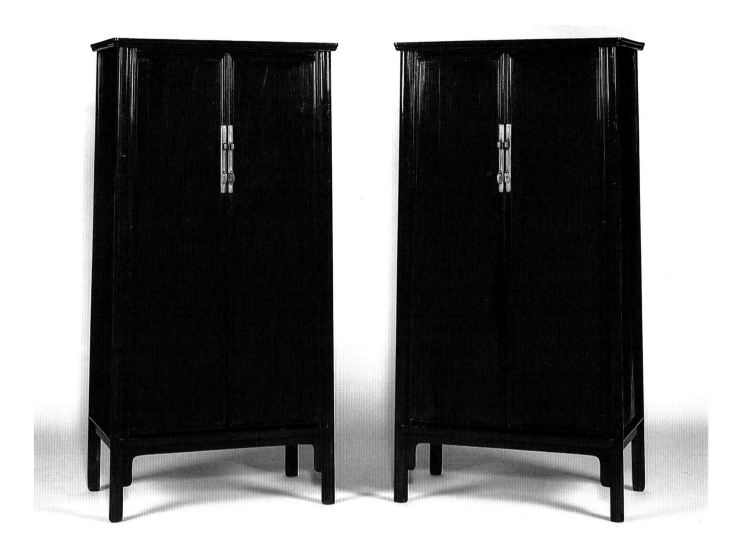

A pair of rounded corner *Huanghuali* cabinets from the 17th century

Hei specialized in *huanghuali* furniture. *Huanghuali* (literally, "yellow-flowered pear") is a wood in the rosewood family. Rosewood is prized for furniture because it is dense and durable and richly colored; it even smells good! Rosewoods were a favorite of Chinese furniture builders because Chinese craftsmen traditionally built most furniture without screws, nails, or glue, relying on joinery alone.

Craftsmen carve grooves and tongues into the various pieces of a chair or table and then fit them together exactly, without any binding. The chairs in particular are very refined. Virtually all their component parts—rails, arms, and legs—are the same width, making it nearly impossible to tell where the pieces had been fitted together. Interestingly, the pieces could actually be taken apart, put into burlap bags, and transported as bundles of sticks.

Huanghuali is tough enough to be manipulated in that way but still well grained enough to be beautiful. There are many types of rosewood, and several used for furniture, but craftsmen and customers have long preferred the *huanghuali* strain for its color, fragrance, and even its medicinal properties. I bought quite a number of *huanghuali* pieces from Hei—not just furniture, but also boxes and other lovely objects.

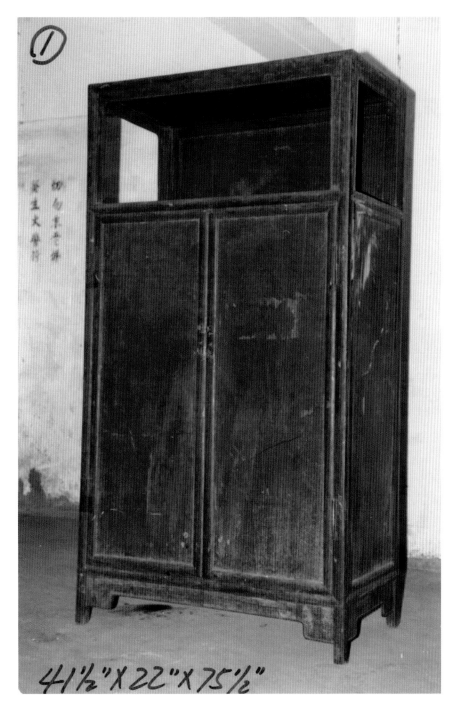

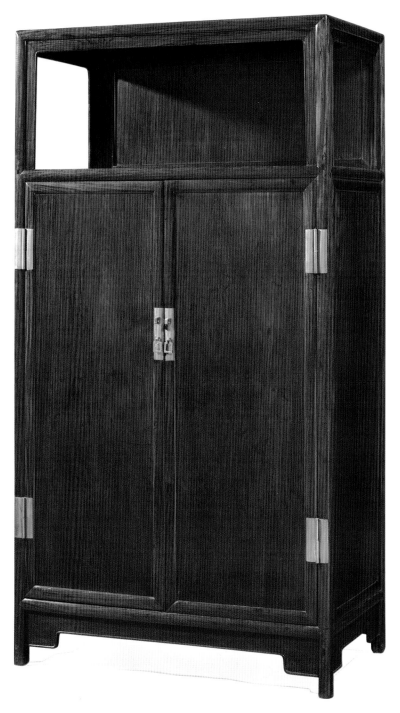

Chinese *Huanghuali* cabinet (before)

Chinese *Huanghuali* cabinet (after)

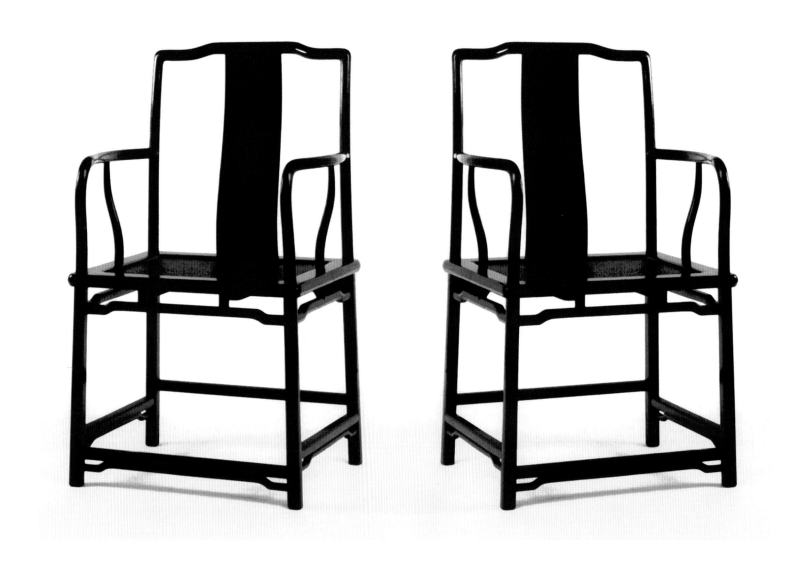

A pair of very rare Zitan imperial chairs from the 17th century

One of the first pieces I bought from him, though, was a wonderful carved scroll pot made from *jichimu*. *Jichimu* is a type of Chinese wood that, when cut properly, has a grain resembling a chicken's wing. The pot I purchased from Hei was beautifully carved and executed. It was one of those things that just spoke to me the moment I saw it.

"What is that?" I asked. I had never seen anything quite like it before.

"Oh," Hei said casually, "it's a scroll pot. *Jichimu.*" As I branched out into purchasing furniture and other wood products, I had to learn the types of wood commonly used in Chinese woodworking, and also the unique techniques that go into creating any one of these gorgeous carved objects. Hei proved a capable instructor in these matters.

"Can I buy it?"

Hei looked doubtful. "I must talk to Mr. Ellsworth about that," he said. Despite their close relationship, Hei never called Ellsworth by anything other than his surname.

"Okay," I said, nonplussed. "Is there a reason?"

"He said he liked it. He might want to buy it."

Hei picked up the phone and called Ellsworth. He told him how I'd come in and let him know that I had asked after the scroll pot.

"Then let him have it," Ellsworth told him. And with Ellsworth's blessing, that scroll pot was the first of many pieces I bought from Hei Hung Lu.

That pot may have been more expensive than it should have been, but Hei was always expensive. In retrospect, he may simply have been ahead of the curve. Since that time, *huanghuali* furniture has ballooned in price: I bought a cabinet from him years ago for $25,000. When I sold it at auction in 2012, it went for $250,000.

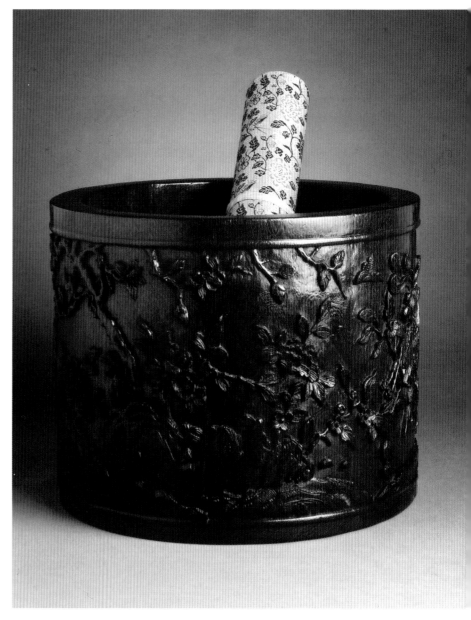

Carved Jichimu scroll pot

Hei was gifted with a preternatural instinct for markets and prices, and his pieces were always of incredibly high quality. He didn't fall into the trap of over-restoring or needlessly repairing pieces better left alone. Even good dealers sometimes find themselves inclined to overdo it, but Hei, to his credit, adopted a minimalist approach to restoration.

If there was something missing from an object, he had a team of people in his shop to make the repair. He always showed me the pieces in their original condition first so I could appreciate what his craftsmen had accomplished. Consequently, his restored pieces were beautiful and largely undisturbed. Because of Hei's restraint, the pieces he sold demand even higher prices now. People tend to want *huanghuali* pieces as close to their original condition as possible, and Hei's wares maintained that original character.

Hei was a peculiar man; he never went to auctions—extremely odd for an antiquities dealer. He never went to the other side of the bay, to Hong Kong proper, and he was also vegetarian. My meals with Hei, at Kowloon's finest vegetarian restaurants, featured some of the most incredible food I'd ever tasted.

We ate, talked at length about art and collecting, and afterward took a cab out to his warehouses. I walked up and down the aisles, transfixed. Treasures heaped upon treasures, stacked from floor to ceiling—everything from fairly ordinary furniture to astonishingly rare items. But even more incredibly, Hei had the entire inventory committed to memory and could speak encyclopedically about his wares. Needless to say, I learned a truly enormous amount from him.

Many of his pieces had just arrived from mainland China—mostly from old houses that had been vacated, destroyed, or otherwise emptied. His furniture was predominantly Ming and early Qing, roughly dating to the seventeenth or eighteenth century. As a collector, I found the seventeenth-century pieces the most desirable. Every now and again you'd find a great piece of furniture dating to an earlier period, but generally speaking, the seventeenth century produced the most exquisite furniture.

"What's that up there?" I might ask, pointing at some half-obscured piece near the top of the heap.

Hei had a small army of cleaners and restorers working around the clock. He would dispatch one of them to climb up and fetch the piece down … without a ladder. Everything back then was low-tech, done by hand with elbow grease. These restoration specialists would delicately wash and polish dirty furniture, getting down on their hands and knees if necessary. Watching these meticulous artists, it felt like I'd wandered into a time machine and come out in a village full of punctilious tradesmen who did everything the hard way. If I saw something interesting, I had merely to point it out to Hei, and as long as it wasn't spoken for he had it brought down and cleaned for my inspection.

I bought a number of pieces from him in this way. I've sold a few, but I've held onto far more. Today I have a great collection of Chinese furniture, most of it from those packed warehouses in Kowloon. I was extraordinarily privileged to have met people like Hei Hung Lu, who allowed me a critical outlet and offered significant conversation about East Asian art.

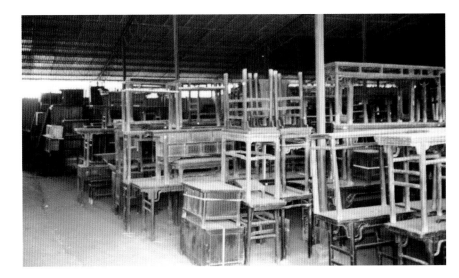

Eastern Pacific warehouse

Eastern Pacific warehouse

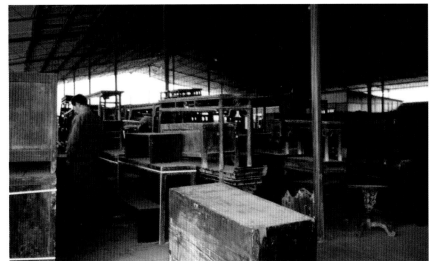

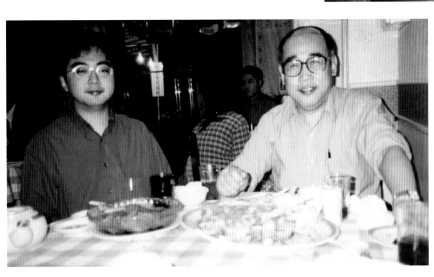

Hei Hung Lu (right) and his son Andy Hei (left)

New Tricks to Find Old Treasures

Trips to Galaxy Arts remained a regular part of my Hong Kong circuit. Right away, I realized the educational potential of both the objects P.K. Wong stocked and the clients to whom he sold them. These twice-a-year trips to Hong Kong quickly became the axis around which my world revolved.

My days in Hong Kong were very regular and predictable. I checked in with P.K. at Galaxy Arts first, asking if he had anything for me. He rarely said yes. P.K. specialized in older treasures, items outside my interest at that point. Eventually I would turn my attention to early wares, but at that point I was more focused on the education I was getting from P.K.'s clientele.

Robert Ellsworth could usually be found seated on a little stool in the middle of P.K.'s shop, sorting meticulously through dishes of jades. He pushed everything he deemed fakes, low quality, or simply not to his taste to one side. He didn't say anything, but he would slowly build up a little pile of pieces he liked.

Another collector, an expat lawyer originally from England, also frequented the shop. Many years later, he donated most of his collection to a museum in Bath. But in those days he was mingling with the rest of us, all hoping to find that needle in the haystack.

I suppose you could say these men were my competition; each of us harbored an unquenchable thirst for great objects. On a practical level, however, they were steady sources of advice and inexhaustible repositories of tips and leads. Everyone had such varied tastes and idiosyncratic needs that only occasionally did we actually come into conflict over a particular item. In general, everyone was very gracious about sharing their sources and suggesting places to hunt.

"Have you gone to Cat Street?" one would say, recommending a concentration of antiques dealers there.

"How about Hollywood Road?" another would ask. I always found that funny: I'd flown halfway around the world from California, only to find myself back in Hollywood!

Hong Kong's Hollywood Road was indeed a major center for ancient art. The street was lined with dealers' shops, and you could spend a profitable and enjoyable day strolling in and out of them. The dealers set eye-grabbing displays in their windows, enticing you to peer in and see what caught your fancy. I prowled up and down both Hollywood and Cat, going into shops, inquiring about items, and developing rapport.

Hospitality is very important to the Chinese, as it is in most of Asia, which meant I would inevitably be invited to lunch by whomever I happened to be with at midday. It was a great way to get to know dealers and shop owners. It was also a great way to sample some of the city's wonderful out-of-the-way restaurants.

Lunches at these restaurants were often sumptuous affairs lasting two or three hours. Hong Kong Chinese tend to meet and confer in restaurants, rather than entertaining in their homes. Over these lunches I made sure I asked lots of detailed questions about the objects I sought. I gathered all the information I could, and got a great meal in the process!

After lunch, it was time to check in again with P.K. New things were always coming into his shop, and unless I was constantly

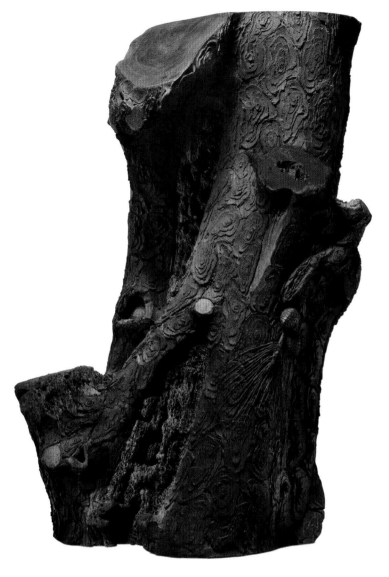

Yixing carving, resembling a tree trunk

checking, I might very well miss something. He always answered with a gruff "no," but told me to keep coming back. I was too scared of letting something slip by to ignore his advice!

It didn't take me long to realize I needed to work smarter, not harder. I told P.K. exactly what I wanted. I told him which jades and ivories I liked. I mentioned that I was interested in blanc de Chine and bamboo. These weren't the sorts of things in which he normally dealt; he was more immersed in the grave goods and statuary markets. But he knew that I was a good buyer, so he started to make the extra effort to source the things I was seeking.

As this understanding developed, I bought more and more pieces from his shop. Ultimately, I became a very good customer. One day he showed me a beautiful *yixing* carving.

Yixing is a reddish-brown clay that occurs naturally in the Jiangsu province of China. Traditionally it is wet-carved, a process that produces truly amazing results. This piece in particular had long colophons (inscriptions with seals) all over the body. The carving was meant to resemble a natural tree trunk, and at first blush that's exactly what it looked like. But a careful eye could see that it was some talented artisan, not Mother Nature, who had designed the curves and crenellations of the bark.

I wasn't completely green, but this was a long time ago, and I was petrified I'd choose unwisely. So I asked P.K., "What do you think?"

"Don't ask me," he said, "trust your own eyes. Always trust your own eyes." He learned this from years of buying and selling, and he was absolutely right. As a collector, I have learned to trust my eyes more and more every day. Today my eyes are quite trustworthy.

At the time, however, I was still uncertain. I peppered P.K. with questions. I asked him to translate the colophons; I asked him about the technique of manufacture and about the provenance. And then I turned and asked another dealer who happened to be standing close by, a man named Brian Morgan, a partner of Bluetts, what he thought of the carving.

Brian barely knew me, though we had seen each other around the Hong Kong antiques circuit. I could tell he was a little impatient with my waffling. "Robert, it's bloody marvelous. If you won't have it, I will."

Brian's response gave me the jolt I needed to make a decision. "Calm down, calm down," I said. "I'm buying it."

《 《 《 《

There was so much to learn. How to find and authenticate an object, how to develop a sense for a fair price, how individual sellers like to do business, how to make and maintain social connections—and how to do all this and still make time for eating and sleeping!

I was always on the lookout for new strategies of acquisition, but my Hong Kong education was also a race against my teachers. I was nervous I would let something pass me by, only to have it fall into the eager hands of my instructors. So I kept my ear to the ground and was always ready to make adjustments to my hunt.

One day I dropped into a Hollywood Road shop owned by one of my new acquaintances. He dealt in early wares, and he gave me a tip: the delivery lorries (that is, trucks) always came on Thursdays. Theoretically, he surmised, an enterprising collector (like me) could follow them along their route and check out the new wares just as they arrived. Nothing was stopping me. Why not?

So I started waking up early on Thursday mornings to catch the lorries before they started their runs, and tagged along behind them. I'd wait for them to unload and then rummage through whatever they had delivered. Most of the objects on these lorries were made of clay and wrapped in paper to protect them during the trip. I had to inspect each package closely just to know its contents. If I saw something I liked, I went in to talk to the dealer right away, thus getting the jump on my competition.

Above and left: Workers unloading a lorry's contents on Hollywood Road

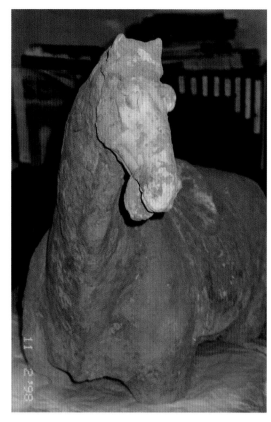

Imperial Tang horse from the tomb (before cleaning)

One morning I was watching as the workers unloaded a lorry's contents into a shop known for dealing in only the most exquisite examples of Han and Tang tomb wares. There were ritual wine jars, carved horses and camels, vases and other vessels—anything someone might have wanted in the afterlife. Pieces ranged in age and ran the gamut of condition, from pristine to very battered. Some were painted, others were glazed, and still others were bare. The only thing they really had in common was that they moved fast.

One package caught my eye, and I asked the dealer to unpack it so I could get a closer look.

He obliged and unwrapped the paper, revealing a beautiful Tang horse. Though the Tang Dynasty clay horses are commonly considered to be more ornate and sophisticated, there are a number of really remarkable examples of ceramic horse statues from the Tang period.

But it got even better: "There's a rider for it," the dealer said. "A horseman goes on top."

"Where is it?"

He retrieved another tightly wrapped package from the pile. "But it's very dirty. If you want to come back, I'll clean it for you."

That it was dirty made perfect sense; often these items were loaded straight from the grave into the trucks for shipping. No one bothered to clean or restore the pieces until they got to the dealers. The good thing about this, however, was that there was practically no human wear and tear on these objects. Unlike a Chippendale table or a Ming chair, grave goods are intended to be left alone. They are not to be lived with; they are not refinished to keep up with fashion or worn out from daily use. They belong to the dead and are meant for spectral, not physical use.

So it was that my lovely horse, hand-painted in the seventh century, still had its original, vivid color. The rich hues were partially obscured by earth, and I happily left the cleaning to what I thought were the able hands of the shop owner.

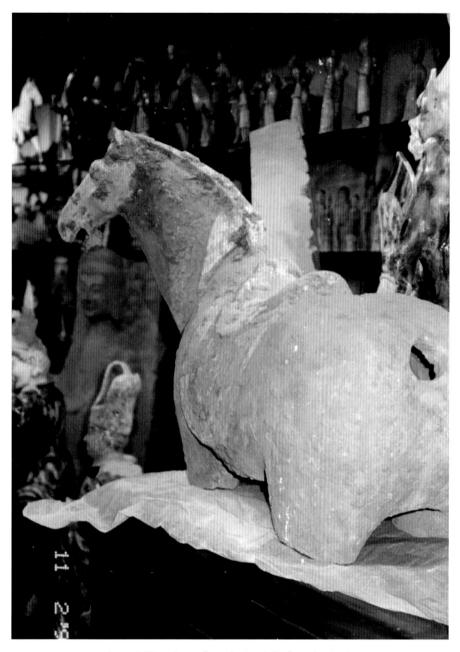

Imperial Tang horse from the tomb (before cleaning)

But when I came back for the piece a few days later, I was bewildered when I was presented with an entirely bare horse. No mud, true—but no paint either. This cleaning had been much more thorough than I had anticipated.

"What did you do to it?" I asked.

"We hosed it down," the shop owner said, as though it were obvious. I found out later they had actually used an ordinary garden hose. Naturally, the delicate paint washed away with the dirt. "It's not a problem," he tried to assure me.

"It is a problem," I said. "The paint is gone!"

"No problem," the shop owner said again, brightly. "I have another horse very similar to this one; take this horse!" He pointed me toward another similarly aged horse that he had recently received.

"Whatever you do, don't touch it," I said warily. "I don't care about the mud or dust or anything like that. I'll take it just as it is."

I bought the other horse, and subsequently a second horse to go with the first one I had purchased. I left both pieces in their original condition on the off chance that there might be a repeat of the disastrous garden hose incident.

I shared this story with a friend, who at that time was the head of conservation at the Los Angeles County Museum of Art. "I'll clean them for you," she said. "Don't let anyone else touch them."

She moonlighted doing restoration, and she was incredibly meticulous about her projects. Her attention to detail bordered on obsession, and she was passionate about her work. This restoration took her about six months. She worked over it tirelessly with an arsenal of tiny, delicate tools—scalpels, dental scrapers, and the like. The mud came away speck by speck, particle by particle, grain by grain, until the original, rich color was revealed. By the time she was done, my horse looked like it had stepped right out of ancient China.

I know that my horse was hardly the only priceless object to have been accidentally and unfortunately stripped of its decoration in this way. In fact, it's become so hard to find these statues intact that many people have resorted to repainting bare statues in the hopes of adding that extra value.

I once walked into the shop of a well-known dealer, and in the back room—perfectly visible from the showroom—were several technicians busily repainting a clay horse. One artist was applying watercolor paint to the clay and then drying it with a hair dryer! They didn't even attempt to hide what they were doing.

This kind of fakery has become so rampant that many collectors now send their things to Oxford University for thermoluminescence (TL) tests to determine the age of all the components of the piece. Fortunately, common practice for reputable dealers now includes certification that the item is authentic and intact.

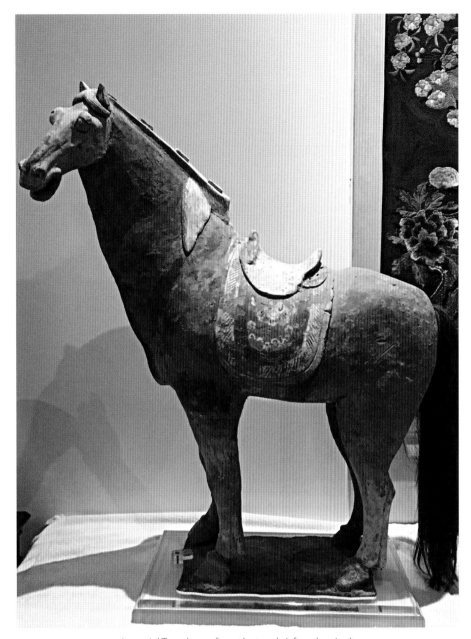

Imperial Tang horse from the tomb (after cleaning)

The Taihu Rock

Sometimes I had to go out of my way to receive an introduction to meet a major player in Hong Kong; other times, it happened almost accidentally. Such was the case when I first met C.L. "Cola" Ma. I simply wandered into his shop one day as I was making my rounds. His wife was working when I came in, and she greeted me politely as I poked around the shop.

"What is that?" I asked, pointing at a table I liked, "and how much does it cost?"

"I don't know. My husband is out, but he will be back shortly." I decided to wait because I was never comfortable walking away from something, knowing as I did that I might never see it again. You can never be too cautious, not with so many other savvy and dedicated collectors combing the streets. I learned this lesson time and again in Hong Kong!

I took a seat in one of the Ming chairs displayed in the shop, which isn't something one frequently gets the chance to do. The woman offered me some tea, and I drank it while we chatted politely.

Eventually the door opened, and a middle-aged man appeared.

"Are you Mr. Ma?" I asked, standing up.

"Yes. Cola Ma," he said.

I bought the table from him that day. It would be the first of many successful deals between the two of us. We quickly became very good friends as well. In fact, Cola and his driver always picked me up when I arrived in Hong Kong for my biannual trips. The moment I landed, we got right down to business. He had

lived in Hong Kong nearly forever, and was an excellent furniture dealer. He and Hei were probably the best I ever encountered, and they cultivated a friendly rivalry.

Cola frequently visited the Chinese countryside. After years of dinners and conversations and purchases, he eventually started tailoring these expeditions to my tastes. He had good instincts and sometimes anticipated things I hadn't yet requested!

One day we were en route to one of his warehouses, and I mentioned offhandedly that I was looking for a scholar's rock. I saw Cola smiling slightly, as if he had a secret.

"Why are you smiling?"

"I have … something really nice."

"Really? What's that?"

"A wood Taihu rock." A scholar's rock is usually limestone, valued for its uniquely beautiful and contemplative properties. They are found in a few places in China, but the Taihu Lake region near Dongting Mountain produces some of the finest and most interesting specimens. Its generous limestone deposits and moving water is perfect for crafting these asymmetrical, porous, and often downright ugly stones, which have been collected since the eighth century. "Kangxi, with original stand," Cola added.

Scholars believed that these stones inspired creativity, so they were often kept in libraries or studies. When Cola told me about the Taihu rock, I imagined something small enough to sit on a desk and inspire profound thoughts. "That sounds nice. Is it small? And it's made of wood? That's definitely not my image of a Taihu rock."

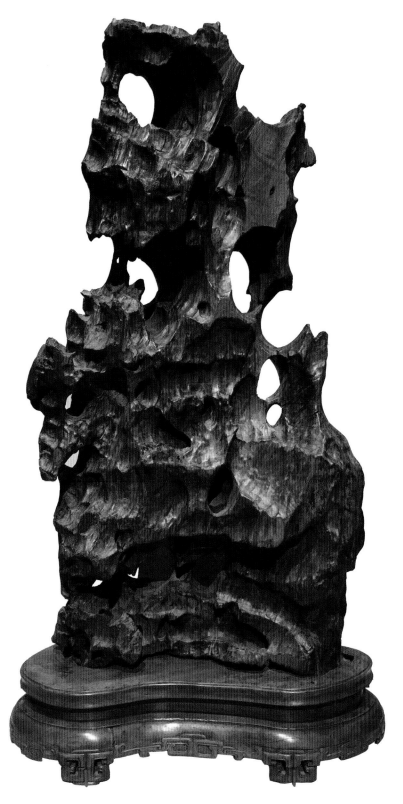

Carved wood Taihu rock

"No, no. Wood," Cola assured me. "And it is big."

"How big are we talking here?" I imagined that this was the type of miscommunication that commonly occurs when people try to talk across languages. A scholar's rock would typically be big at around six to eight inches tall.

"I don't know, three feet?"

I almost fell off my train seat. "Three feet? Are you serious?"

"With original stand," he added helpfully. I made it a habit to only buy rocks that came with their original stands because I considered the stands to be part of the totality of the artwork. A stand is like the frame of a painting; they are often overlooked in Chinese art, but they too were created by great artists, craftsmen, and finishers. Besides, what was I going to do with a lone rock?

Needless to say, I was very intrigued by Cola's tale, and I asked to see it right away. As soon as I set eyes on it, I knew it was special. In fact, it was so special that it's in my house today.

❮ ❮ ❮ ❮

Cola Ma lived in Hong Kong but hailed from mainland China. I regularly visited him on the mainland, and he took me along on his rounds, picking up the items he had sourced.

Usually we traveled near Beijing, but sometimes he took me out to his large factory in Tianjiang. He made reproductions of Ming furniture for shops all over Europe and America. By all accounts, he did very well. But he never forgot that his passion, first and foremost, was for the real deal. He was always on the lookout for genuine *huanghuali* or *zitan* pieces.

"What are we doing today?" I would ask. It was always a bit of a crapshoot … but certainly an adventure.

"I've been offered a pair of stools," he said on one of our outings. A pair of *huanghuali* stools, in fact. "They're very nice." They were unfinished, so they didn't have the color or the gleam that one usually sees on this type of furniture.

These items typically came to us from farms and small homes in rural China. As it turned out, the stools were in a

slaughterhouse. It's hard to describe how disconcerting it is to wind up in an active abattoir in a foreign country where you don't speak the language! There was certainly something cinematic about it, but not in a good way.

"Cola, why are we here?" The smell was getting the better of me.

"You'll see, you'll see." We were there to meet a man who sold furniture. He had acquired the stools, and of course they were wonderful.

"Do you like them? I could negotiate for you," Cola offered.

"Yeah," I agreed. "I like them."

They began speaking Mandarin. After a few minutes of back and forth, it seemed like a deal had been struck. Cola turned and picked up the stools, and we walked them back to the car, as simple as that.

No place was too remote or obscure for Cola. I remember I once bought a painting table (a table designed to do calligraphy on) from him. I was waiting for the delivery when a van pulled up, driven by a farmer. There, on the roof and upside down, was my painting table. I watched it bounce all the way down the road to meet me.

Seeing the jostling table, I had to remind myself repeatedly of how great Cola's artists and restorationists were. Even with some rough treatment along the way, these objects would regain their former beauty.

❮ ❮ ❮ ❮

Cola wrote to me about his travels and acquisitions. At this time, I was buying a lot of brush pots and other scholar's objects from him. "What else have you found?" I wrote back to him once. He described a *huanghuali* and *wu mu* cabinet that was out in the country, and I promised to have a look at it on my next visit.

It was a long trip to meet the seller of that cabinet. The car ride was nearly two hours, but thankfully the cabinet was still there, intact, unharmed, and secured in the back when we

Huanghuali stools inside the chest

Huanghuali pair of stools

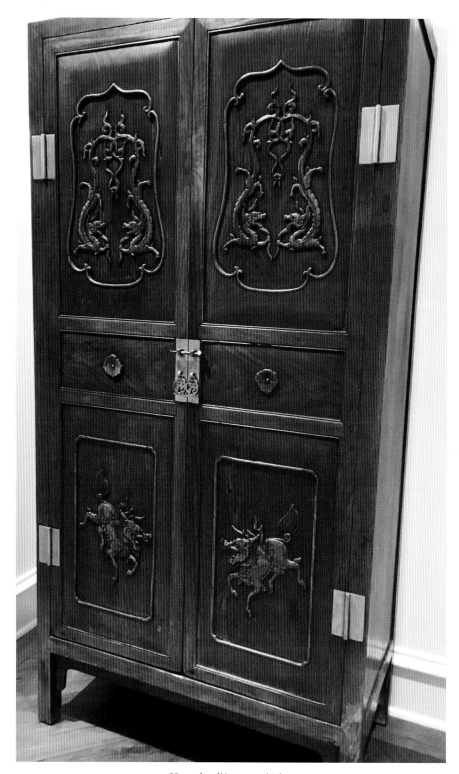

Huanghuali boxwood inlay

arrived. That cabinet was a delightful *huanghuali* piece, probably dating to the eighteenth century, but on the cusp of the seventeenth. The doors were inlaid with a really stunning design in boxwood, which is a very uncommon feature for *huanghuali* furniture.

"I like that a lot," I said. "How much?"

Cola relayed this to the owner. This was the quirk of Cola's business model: these people may have had the appearance of simple country folk, but they frequently knew very well the value of the things they had. They weren't shy about asking for a lot of money for anything that seemed unique, different, or simply good. The cabinet's owner was no exception, and he named a sum that I found a bit excessive.

"Why so much?" I asked Cola, who just shrugged.

"That's what he wants."

And of course, Cola had to make a profit on this piece as well. I decided I would stretch my negotiating muscles and see if I could talk him down a bit.

"I can't buy that," Cola translated for me as I spoke. "That's too expensive."

Instead of the haggling I expected, the man immediately shut the deal down. "Well then, no problem. We can't do business. You came for nothing."

Unfortunately, the seller was really holding all the cards in this situation. I wanted the cabinet, and I knew that if I didn't get it right then, I would almost certainly never see it again.

"Calm down, let's try to make a—"

As soon as Cola translated my words, the man cut me off: "No. That won't do."

My brief attempt at negotiating had fizzled out, and I bought the cabinet at the asking price because I knew that I would regret not buying it. Cola had it sent back to one of his workshops where they cleaned and repaired it. Approximately a year later, it joined its fellow *huanghuali* pieces in my home.

As the years went by, however, these kinds of deals became increasingly difficult to make, and I had fewer and fewer reasons to travel to China. It is sad in many ways; it definitely felt like the end of an era—for me at least, a wonderful one.

The world was changing; the market was changing. When I first started visiting Hong Kong, there were still large government-run warehouses in mainland China, containing the artifacts and collectibles that had survived the Chinese Civil War and subsequent Cultural Revolution. Foreign collectors would occasionally visit these warehouses and select pieces to buy.

Those warehouses have since been dissolved. With them went the most concentrated source of the smaller objects that I collect. With every passing year, I am more and more thankful that I was in that right place at that right time; that I experienced those days, and brought back such an amazing collection. Nothing ever stays the same, but I do feel I've managed to carve out some pieces of the past and bring them with me into the future.

A Visit to Hugh Moss

Given unlimited monetary resources, and an unlimited amount of time and passion to learn, anyone can be a decent collector. But knowing about the artifacts—what they're made of and how they're made, the history that shaped the circumstances of their creation—is only a part of the odyssey. To be a great collector, one must learn the culture and personalities of collecting itself.

Different cultures have different "styles" of collecting, and play host to different collecting markets. One must be familiar with these markets in order to know what to expect when using them to procure objects. But—and this is crucial to remember—markets, cultures, and indeed whole societies, are still made up of individual people. Being a great collector means being able to navigate the interpersonal landscapes that form the terrain of the market.

My purchases from Hugh Moss involved a predetermined choreography. We each had something the other wanted, so this dance worked to our mutual benefit. Hugh made his home in Sha Tian, a tony district in northeast Hong Kong. Once he invited me to lunch, after which we went to his house and looked through what he had to see if there was anything for me to buy.

The first few times I visited were a test to determine whether or not I'd be a suitable dance partner. He set a few knickknacks before me, without discussion. I turned them over critically in my hands and set them delicately but deliberately aside as if to say, "I'm not interested in these." I never wanted to impugn the objects themselves; I couldn't afford to offend Hugh. After I'd rejected the first offerings, he'd nod, remove the rejected items,

then bring out something a little better. I would feign slight hesitation, say something noncommittal and indecisive, and ultimately set those aside as well.

Eventually, Hugh saw me as a suitable partner, once my tastes had passed his examinations. I wasn't just a fly-by-night accumulator, and I could prove it. Eventually Hugh produced something really fine. "Oh, that's nice," I said. "Are you offering it to me?"

"Yes. You can have that, if you want it."

And that was how you got something really great from Hugh Moss.

Hugh was hardly the only person who used this style. In fact, these types of negotiations are common throughout East Asia. Here in the West, we tend to think of "business deals" as immediate, detached, transactional interactions that get directly to the point. Conducting business in this way would be anathema to East Asian art dealers. "Getting to the point" without greasing the social wheels would be considered a faux pas. In these cultures, conducting business requires no small investment of time; two negotiators must build their rapport to a point at which doing business would be socially appropriate.

As often as not, sellers will, as Hugh did, test your ability to discern quality and examine your taste more generally. In Japan, a collector might spend days—literally, a few twenty-four-hour periods—eating, drinking, and socializing with a dealer before that dealer at last produces a single item!

As you might imagine, this holistic approach to business has a great deal of charm, although it is not without its drawbacks.

Wan Li fitted lacquer box

Imperial carved bamboo writing set

The hospitality feels leisurely and gracious. It cements relationships between buyers and sellers, and it allows for serene contemplation and shared admiration of incredible artifacts and artwork. As I've said before, the building of community is one of the most attractive features of collecting. Why would we buy these things in the first place, if not to enjoy them?

However, dealers are both business associates and friends, and the line between these is often frustratingly blurry. Every so often, someone I know will show me an item simply because I am, like them, a fan of lacquer or jade or bronze—but the item is not in fact for sale. Hugh once showed me a magnificent soapstone carving. I misread the situation and made him an offer. He politely told me that the carving had already been promised to another client; he only showed me the carving because he thought I might like to see it. Imagine my embarrassment! No one wants to be known for being awkwardly overzealous or mishandling delicate situations.

He finally offered me a skin bamboo imperial calligraphy set which included an ink stone and box, ink rest, scroll weight and a round paste box, all in an original Wan Li box. We concluded the deal, had a nice roast pigeon lunch and parted ways.

A Treasure House ... in Sarasota

As with anything that requires both a range and a depth of knowledge, collecting is an ongoing education. Of course, passing and failing mean something quite different, and the stakes are often quite a bit higher in the world of collection than in the academy. In collecting, real money is at stake, not just grades!

Every collector has a story about a lost opportunity or an incorrect assessment, but good collectors learn from these experiences and mistakes and press them into the service of future acquisitions. Good collectors leverage past failure into future success.

I have been fortunate to have never lost money on a piece. But that doesn't mean I haven't come close! Inexperience and ignorance are pernicious conspirators. Indeed, some of my biggest failures turned into successes over the long term.

About thirty years ago, when I was just getting serious about collecting Chinese art, my sister (a decorator in Florida) gave me a call.

"Can you be in Sarasota tomorrow morning?" she asked, almost as soon as I picked up the phone.

"I suppose I could take a red-eye," I said, "but why?"

"I'm decorating a house for this family, and their father has a house up in Sarasota. It's full of antiques. Mostly from China."

Immediately, my ears pricked up. At the time I was focused mainly on collecting export porcelain, specifically armorial porcelain. I was teaching myself what to buy and what to avoid, more or less. I've always trusted my instincts, and they have served me quite well in both business and collecting. And I've always been attentive to my mother's sage advice to buy things you love because you may not get a second chance.

I knew an opportunity when I heard one, so I hopped on a plane right away. My sister met me at the airport and took me directly to the client's rather nondescript house. Once I got inside, however, it was clear that this place was anything but ordinary.

Apparently this man, who was in the insurance business, took frequent trips around the world, and it was his practice to go into shops and purchase their entire inventory. Not just one or two pieces, but the whole shop. Naturally, this made for a collection of overwhelming depth and breadth. I felt like Ali Baba, in a cave with innumerable treasures.

The room was scattered with wooden crates, each bearing a meticulous list typewritten on onionskin paper. The pages offered some description of the contents of each box, but these were imperfect summaries. There was simply too much to catalogue completely. The owners of the house, the couple who had hired my sister, were in a tax bind after the death of their father. They needed money, and they needed it fast, meaning I didn't have the luxury of looking carefully through every crate. It was now or never.

I bought liberally, perhaps because the feeling of the place was so overwhelming. I got an armorial vase that I still have, though it turned out to be Paris porcelain (porcelain goods produced in Napoleonic France in an attempt to reproduce the popular Chinese blue-and-white at a much more affordable price).

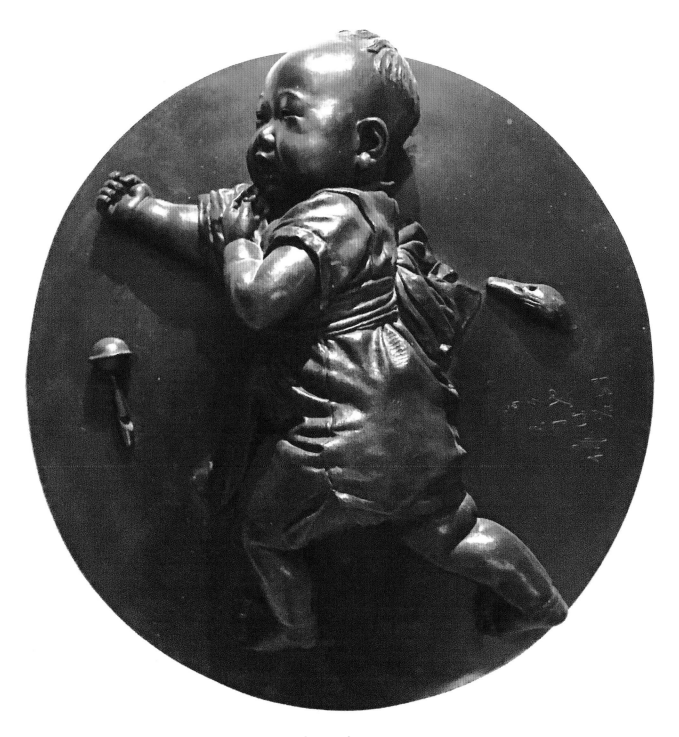

Japanese bronze

I also bought a large signed Japanese bronze of a small boy that still hangs in my home.

I saw shoeboxes full of little lacquer pieces. They were *netsuke* and Japanese *inros*, small decorative accessories to hang on kimonos, which were probably eighteenth and nineteenth century, Maki and Takamaki. They were exquisite. And the seller told me her daughter had been wearing them around her neck, much to my chagrin. They were consequently too damaged to buy.

At that time, there was a perfume called "Opium" made by Yves Saint Laurent. It was packaged in a red plastic container that replicated the Japanese *inros*. Women started to wear these perfume containers around their necks for decoration, so when the two granddaughters saw these, they wore the real ones not realizing how valuable they were.

Everything I bought that day I bought because I loved it. Even if I'd had a more focused sense of what I was looking for, there were just too many crates and too little time. There were a number of dishes, saucers, and other ceramic pieces that were

Opium perfume container

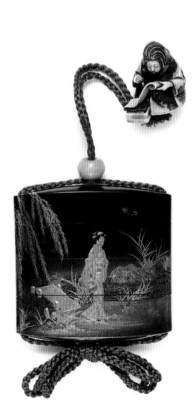
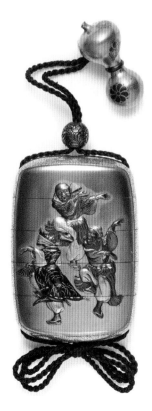
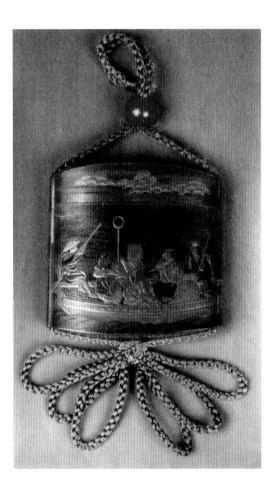

Left, Center, and Far Right: Lacquer *inros* worn on kimonos

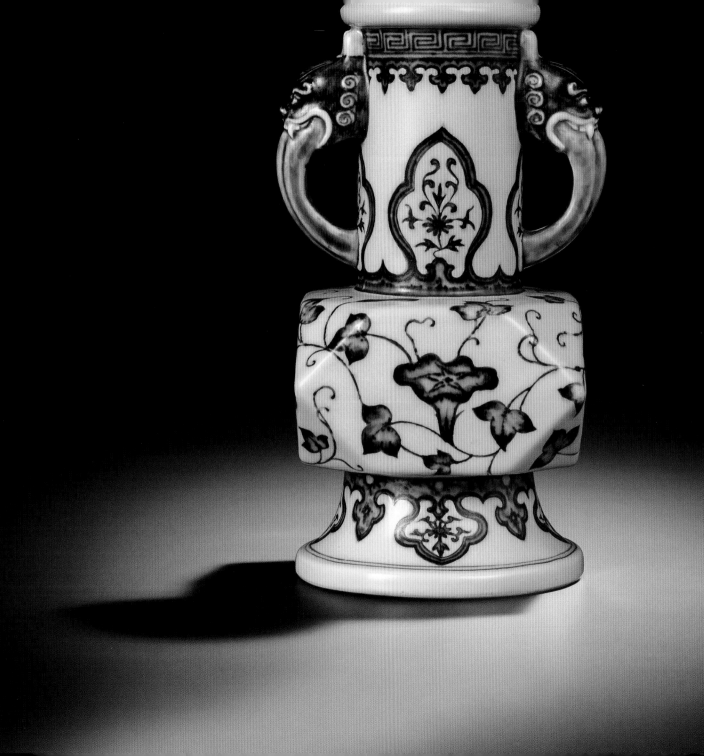

Imperial yellow underglazed blue vase (left and above)

Chinese with marks that would probably be very valuable today. I passed them all up.

Several years later, I was invited to take a private tour with the curator of the Baur Foundation, a museum of East Asian art in Geneva. The Baur collections did not disappoint. I wandered the rooms, marveling at the beautiful pieces. And then I found myself face to face with the twin to a Chinese vase that I had plucked from that Sarasota house years before.

"I have the same vase," I told the curator.

I knew more about Chinese art and techniques at that point, so I could tell that it was a faceted vase, underglazed in blue with a yellow overlay. The neck was a rich purple color in a fretwork design.

The vase at Baur, like my vase at home, also featured a small double circle, an imperial six-character mark, the symbol of the short-lived Yongzheng Emperor. The vases were both imperial, dating from the thirteen-year reign of Yongzheng, between the Kangxi and the Qianlong emperors, roughly 1722 to 1735. I purchased it in Florida for $275. I sold it for $150,000, and it's been sold again for even more.

It was the first time in years that I'd really thought about those crates, packed full of unknown treasures. If an imperial vase was languishing there, what else was in those crates? What else had I left in that house? What mistakes had I made by my inaction?

Sometimes I dream about that house. In the dream I am my present self, opening yet another of that idiosyncratic collector's crates, only this time I discover pieces that I've wanted for years. Things I thought would never appear on the market. Things I thought were lost or destroyed. Things that maybe never even existed at all. I find all the things that ignorance and inexperience leave behind.

If the high of discovery is one of the great positives of collecting, then this feeling of loss surely sits on the other side of the spectrum. In the final accounting, however, the hopeful expectation of searching out new objects will always outweigh any regrets about the lost ones or those left behind.

On the Hunt in Paris

I was recently in Paris, on vacation with my wife and son. I rarely travel without making time to check out the local auction scene. In Paris, that scene is robust and interesting.

I made a point of stopping in to chat with a friend of mine, a dealer who owns a small shop on the Left Bank.

The life of a dealer today can be solitary. They sometimes spend days sitting in a gallery or antique store in front of a computer, never seeing any customers in the flesh—or at least not customers who care to chat, let alone buy. The digital age has changed collecting as much as it has everything else, and modern dealers do much of their work online, viewing pictures and contacting other agents via e-mail to inquire about items. Most dealers I've met welcome the chance to actually talk with someone who understands their passions.

Dealers and collectors experience art differently than most people. Reading about a piece in a book, or even seeing it in a museum, is fundamentally different from being able to physically handle it. Not many people know this, but as a potential buyer, you can hold a $5 million vase in your hands. You can feel the texture of the pottery and the glaze. You can turn it over and look at every single surface for yourself.

This is how collectors and dealers hone their senses. Listening to—and learning from—someone who has years or decades of on-the-ground experience with these objects is a great way to improve your own judgment. In addition, many of the dealers

I've known have been smart, interesting, funny people with a wealth of great stories to tell. I could sit and talk to them all day. On this particular day, my friend's shop was one of the first places I'd visited in Paris, and I was hoping that he could point me in the direction of something interesting.

"Well," he said thoughtfully, "did you see the cloisonné basin that's coming up at the Drouot?"

The Hôtel Drouot, in Paris's ninth arrondissement, is more clearinghouse than auction house. It has occupied its position on the street of the same name since the mid 1800s, undergoing a number of restorations, each of which maintained its unique if somewhat haphazard charm.

Unlike traditional auction houses like Christie's or Sotheby's, the Drouot is more loosely organized and more varied. It has sixteen rooms (*salles*) and a rotating roster of art, furniture, jewelry, and virtually every other type of collectible, even household items like pots and pans. There's a lot of chaff and not much wheat, and looking through the collections sometimes feels a bit like rummaging through a pack rat grandmother's attic.

That feeling, however, is part of what makes the Drouot exciting. No, you probably won't come home with a treasure, but there's always that possibility. *Antiques Roadshow* has tapped into this fantasy for years.

Although it isn't my first priority, I sometimes poke around at the Drouot, especially in the *salle* that houses *l'art d'Asie*. On

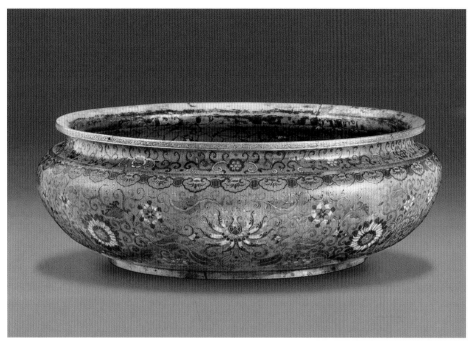

Kangxi cloisonné basin (side)

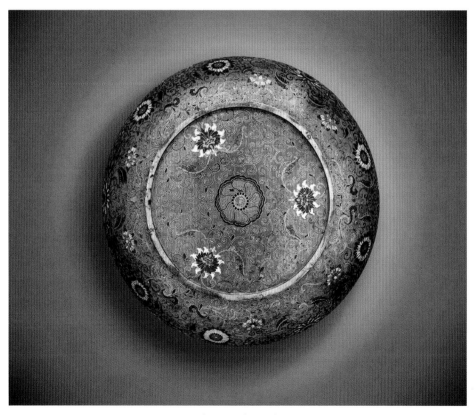

Kangxi cloisonné basin (bottom)

this particular trip, I hadn't even looked at their catalogue. My dealer friend found the relevant page online and pointed out the basin to me.

"Wow," I said. I could tell right away that it was good. "How are you dating it?"

"They're calling it Kangxi," he said, "and I agree."

The Chinese Emperor Kangxi's reign (1662–1722) was well-known for producing some of the finest examples of the blue-and-white porcelain for which China is so renowned.

"Have you seen it?" I asked him, peering at the little photo on the screen. "Have you touched it?"

"Oh yes, I quite like it," he told me. "I don't have the money to bid right now, unfortunately."

I perked up. "So you don't mind if I bid then?"

"*Bien sur que non.*"

Unfortunately, I only had about an hour to get to the auction, which was on the other side of the Seine. My friend was kind enough to call the auction house to see if I could place a bid by phone or online, but it was too late.

"The only thing to do is go over there," he told me.

It was going to be tight, and my wife and twelve-year-old son, Derek, were with me. It would have been easy to just let this piece go and continue my vacation. That, however, is not the kind of collector I am. I'm always looking for the next wonderful object, and I'm willing to go to great lengths to get it. I'm relentless because I know that the truly great

finds come along only rarely, and one must leap at every chance.

I gathered up my wife and son and gave my friend a hasty good-bye before running out the door calling, "Taxi! Taxi!"

My wife is used to this sort of thing, though she herself has limited interest in the proceedings. My son, on the other hand, sees himself tagging along with Indiana Jones—running out the door and chasing down a taxi to find a priceless treasure.

Our driver was attentive to my cries of "*vite!*" and "*nous sommes pressés!*" and he wove expertly in and out of the narrow Paris streets. In the back of the car, my wife was marveling at this new demonstration of my lunacy, while Derek was practically jumping out of his skin.

The taxi dropped us at the Drouot and we raced inside, running through the *salles,* trying to find the right room. Finally, we found the expert in charge, Thierry Portier. The room was packed with people, and he was at a small desk in front of the auctioneer. We had met before, and thankfully, he remembered me.

"I want to bid on the basin," I told him, still slightly breathless.

"*Pas de problème*," he said easily. Because he knew me both personally and by reputation, he allowed me to bypass the registration process.

I was not the only person interested in the cloisonné basin; the room was full to bursting. This auction was of particular interest to the Chinese contingent, which has been a steadily growing presence in auction houses of the Western world. As China's

Kangxi cloisonné basin (top)

economic fortunes have risen, the trade in Chinese art and other collectibles has become increasingly brisk. Most of the buyers are very young men, generally from mainland China (though some hail from Taiwan or Hong Kong). Some of them are dealers; others are acting as "agents" for wealthy private collectors in China.

These agents have little money of their own, so they frequently board three or four to a room in Paris's thirteenth arrondissement or London's Chinatown, where they can operate in their native tongue and eat cheaply. Meanwhile, they are bidding millions of Euros on art. The contrast can be startling.

Before the bidding began, I took a moment to examine the bowl. It was more wonderful in person than it had appeared online. It was very large, fifty-two centimeters (about twenty inches) across, and it was clearly not a common piece. It did indeed appear to be from the Kangxi period, and it was beautifully made.

Cloisonné is a type of decorative metalworking that has been popular for thousands of years; the Pharaohs wore cloisonné jewelry. This piece was a particularly lovely example. It featured a design typical of the Kangxi period called "cracked ice" which is a series of fine lines in geometric shapes, meant to mimic the look of crazed, smashed ice. It had gilt on the bottom and on the rim, and amazing fretwork.

It's very difficult to find intact cloisonné in sizable and unusual forms. Dense and sturdily built, it was everything a collector could want in a piece like that. Of course, it wasn't perfect, but I knew I wanted it the moment I saw it.

I was glad I had decided to visit my friend's shop, and very glad I had raced over from the Left Bank. Recently, I had bid on a fifteenth century cloisonné vase at another small auction in Paris. The estimated value of that piece was $60,000 to $80,000. I bid $550,000, and it wound up going for $650,000. Once you add the auction house's 25 percent premium, the price tag went close to a million dollars and I still didn't get it.

Great things aren't cheap. This is true whenever it comes to making a significant purchase: you will always pay for quality. Even more important, you pay for that strong affinity you feel for a great piece, which is something that can be neither predicted nor quantified. As a collector, I stick to two rules: buy the very best that you can afford, and only buy what you love.

Obviously, I still had a limit on what I was willing to spend. The basin was lovely, but I wasn't going to spend a million dollars on it. Nevertheless, I was fairly confident I would be able to outbid the many other interested parties.

I took my seat as the auction was about to begin. Beside me, I could see that my son was just as excited as I was, if not more so. Derek speaks perfect French, so he had no trouble following the proceedings. I was feeling confident, but still a little wary because no one can ever truly predict what will happen at an auction. I've seen auctioneers goad buyers into overpaying for trivial items, just as I've seen the market undervalue some that were exquisite. The energy in an auction is hard to engineer. Every piece has a low and high estimate attached to it, but even

with those estimates, there's no surefire way to know in advance how the room will go.

When a bidding war does break out, it can get out of hand fast. Even so, the collecting world is very small, and auctions are often full of people who not only know and work with one another, but who also consider themselves friends. People try to avoid rancor and bad blood because, in the end, their relationships with one another are more important than any one item.

That doesn't mean, however, that competition can't get heated. Auction houses keep estimates low to avoid scaring off people who might come in and get caught up in the excitement. An interested buyer could very well imagine that an undervalued piece could slip through the cracks and the dice could tumble in their favor.

If the estimate is comfortingly low, you may find two friends—and rivals—who drive the price far beyond that original figure. This sort of thing happens all the time at auction, usually until one (or both) of the parties pauses for a moment to take a big-picture look at the situation. If the bidding has escalated far beyond the initial estimate, there are three possibilities:

1. The other person wants this piece more than you do.
2. The other person thinks it's a better piece than you do.
3. The other person knows something that you don't.

Any of those conclusions can make you doubt yourself and second-guess your instincts. *Maybe I'm being too cautious and losing out on a real opportunity*. Suddenly a reasonably valuable object becomes a huge investment. This is the collective psychology of auctions. Auction houses are well aware of it, and they often exploit it to their advantage.

The cloisonné basin carried an estimate of $30,000 to $40,000, but I knew it was going to go for much more. More than likely, my own presence in the *salle* actually influenced the bidding. I was an unknown quantity, racing in at the last minute, family in tow. Amid the tension and elevated adrenaline of an auction, the other bidders couldn't help but notice me.

I waited to see where the price would level out before I jumped into the fray. "Dad!" my son said urgently. "Don't lose it! Don't lose it!"

I laughed. "*Pas de problème, mon ami*! Would you like to do the bidding?"

He shook his head shyly, "No, no, I don't want to bid. Just don't lose it!"

I took his advice, and we wound up grabbing the basin for $60,000. I'm sure the dealers and the young Chinese men were wondering who I was, the guy who came out of nowhere. It was a great piece in a catalogue of mediocre items. They probably expected to get it for a reasonable price. But at the last minute I arrived, a stranger, and snatched it up.

Today the basin is getting the careful cleaning it deserves from one of the world's finest conservators and art connoisseurs. I cannot wait to see it again.

The "Hoover Man"

It was 2005, and I was in New York for Asia Week, now an annual tradition, and I was visiting one of my dealers. He's a little avant-garde, but very nice. Colorful, large, and fun, in an offbeat way. I picked up a few items from him, and as I was about to leave, he brought out a beautiful jade depicting two deer. The jade was very small, but that made the perfection of the carving all the more impressive. The piece was wonderful, but the price tag was high. Or at least, it was high for the time: roughly $10,000.

I was buying up such a large amount of art that I'd earned a nickname: the "Hoover Man." They thought of me as a powerful vacuum, sweeping through and picking up everything, leaving the ground clean in my wake.

Even though I was buying in volume, I was still very selective about which items I purchased. I was wide-ranging, but not indiscriminate. And I certainly did not want to overpay. The jade market was very different then. In general, Eastern art was undervalued in the market when compared to Western art. Overpaying for a piece then was still underpaying in the grand scheme of things. Today the decision would be a snap, and $10,000 would be a bargain.

Whenever I find a piece I'm interested in, I examine it and look for reasons not to purchase it. Is this up to my standards? Is it beautiful enough? Is it rare enough? Is the quality high? When it comes to jade, these questions are especially important, because there are so many aspects to consider. Jade is a stone, a mineral, so before anything else happens, someone has to select a special piece of jade, one with a distinct color and clean transparency.

Jade is incredibly hard. It isn't carved with a knife; instead, the artist realizes his vision using a complex array of tools including wires and even sand. Hours upon hours of labor went into the jade I was considering. Some ancient artist had spent time and energy meticulously carving these deer figurines. What value can you put on this process?

Every decision, every purchase, is a push-pull between my rational and emotional evaluations. In general, I give my emotional response to a piece a lot of weight because I trust my instincts. Looking at this particular jade, I knew it was a treasure.

But as enchanting as jade is, it has unique perils and pitfalls. One must be very careful, because fakes are incredibly common. I am meticulous about vetting the items that I buy, and my attention to detail has paid off in the form of a large collection of jade.

Recently, Christie's came to my home to evaluate my entire collection—over a thousand pieces. I was particularly curious to see what they thought of my jades. With my penchant for "Hoovering" (and the rampancy of forgeries), I assumed I had been duped at some point. I was surprised and delighted to discover, however, how few items were in fact questionable.

I am always very cognizant of the real consequences of making an error: spending thousands of dollars on a piece with no value. Trusting my eye and being cautious has served me very well.

I decided I wanted more time to make a final decision on the jade deer. This was a Friday, so I asked the dealer if I could take the weekend to think about it, and he kindly agreed to hold

Jade carving (two small deer)

it until Monday. Before I headed out, I assured him that I really liked the piece and that I would be sure to get back to him with a decision by Monday.

Even so, I wasn't really expecting a phone call at five thirty Monday morning. I am not a particularly early riser, so the phone call found me groggy, and sadly not very receptive.

"Hi, Robert. It's Michael."

My mind was still a bit fuzzy, and I'd completely forgotten the New York jade dealer's name. "What?" I managed. "Who?"

"Michael."

Ah. It was coming back to me now. *Michael with the jade deer.*

"Michael," I said, "why are you calling me so early?"

"Well, it's not that early in New York," Michael pointed out. Undoubtedly true, but not terribly relevant to me in Los Angeles.

"I have someone here," Michael continued, "and he is really, really pressuring me to sell him this jade."

This wasn't an unusual situation, and normally I would have simply committed to buying the piece and gone back to sleep. For some reason, however, I reacted differently that morning. Maybe it was the early hour, or maybe I was just having a fit of grumpiness.

"Michael," I said, "you're bothering me. It's too early in the morning for this."

"Okay, but I'm going to have to sell it to this guy because he

is really pressuring me. He definitely wants this thing, and you seem undecided, so …"

He was right. I hadn't quite made up my mind yet. I didn't necessarily want to lose the piece, but I certainly didn't want to be pressured into making a purchase when I wasn't certain. "I don't know what I'm doing yet. Could I …"

"No. No, there isn't time."

"All right, Michael. Do whatever you want to do. Go ahead and sell it to him."

And he did.

For the most part, I put the interaction out of my mind. It wasn't uncommon to ultimately decide against a piece, and it was just one item among many that I'd looked at that week. I was reminded of the incident about six months later when I was in Hong Kong. A well-known dealer approached me and said, "I'd like to compliment you."

"Well, thank you," I said politely, "but what exactly are you complimenting me for?"

"When I was in New York, I stopped in Michael's shop and saw that beautiful jade deer. He told me he couldn't sell it because Robert Blumenfield was going to buy it. I wanted to congratulate you; it's just such a stunning little object."

It had been stunning, but I wasn't owed any congratulations. I was too embarrassed to correct her, so I just thanked her and brooded over the lost jade for the rest of the day. I should have been more decisive on that early morning call; it really was an excellent piece.

Nearly ten years later, I came across a photo of that long-lost jade. I was struck by the polish of it, the color, the detail in the carving. "Oh my God," I thought. "This is the thing! What was I thinking?" The beauty of the piece was so obvious, I couldn't help but kick myself for allowing it to slip through my fingers.

I've never seen the piece again. I assume it's languishing somewhere in a private collection. I'm sure one day it will come to auction, and it will probably command a considerable sum. More than losing out on an investment, however, what really galls me about losing the jade is the feeling of having missed my chance to be part of the chain of custody for such an outstanding piece.

I get an infinite and almost indescribable joy from simply having these things, being able to hold them in my hands and share living space with them. I consider myself their custodian, and I know that they are someday destined to return to the marketplace so others can have the opportunity to feel that unique joy. I'm only part of the long history of a given piece, and unfortunately in this case, I missed my chance to write a new chapter.

Chinese Porcelain, Chinese Buyers

Like many people, both collectors and casual admirers, I find the classic blue-and-white Chinese porcelain incredibly appealing. For years, one of my dreams was to own a perfect blue-and-white garniture set. These decorative vase or urn sets usually have five separate pieces. Finding them is not impossible, but finding one with no missing pieces (including lids!) and no cracked, broken, or repaired pieces is an entirely different prospect. To find an intact set of high quality from the Kangxi period is nearly impossible. But that is why it's called a "wish list" and not a grocery list!

I was particularly interested in a set like this because I had acquired a wonderful eighteenth-century English cabinet of the type that might have appeared in a genteel family home. During that period, it was fashionable to own blue-and-white Chinese garniture sets and to display them on top of these cabinets, so I thought it would be very appropriate to put period porcelains on top of my period cabinet.

When it came to hunting for Chinese art and artifacts, the deck was somewhat stacked against me. In earlier centuries, China was (quite literally, in some cases) pillaged by European collectors, and objects of every type flooded out of the country. Asian art in general and Chinese art in particular were very *en vogue*, particularly in England and France. Demand was incredibly high, and what wasn't acquired by Westerners was sold in the relatively open Asian marketplace.

The turmoil of World War II and China's civil war imposed a new set of challenges on collectors. During the Cultural Revolution, when "bourgeois elements" were to be rooted out of society, a great many objects of unknown and incalculable artistic, cultural, and monetary value were outright destroyed. No doubt many of the finest examples of various art forms from certain periods were lost forever.

Fortunately, countless individuals secreted pieces to protect them from the purge. Whether these were personally significant items that belonged to a family or simply beautiful things that compelled someone to save them, these specimens were protected and preserved.

After the Revolution, China remained closed to the West. Collectors seeking elegant jades, rich lacquer work, and blue-and-white pottery had to look to Europe, where those items had been collected and hoarded for generations. For more than forty years, outside collectors could not comfortably visit China and could certainly not expect to be allowed to browse ancient artifacts.

In the last twenty years or so, China has opened up to the West and to global commerce. The country represents one of the fastest-growing economies worldwide, which has been reflected in the Chinese approach to collectors and collecting. Similarly reflected is a certain level of national guilt about the widespread destruction of art and artifacts during the Cultural Revolution. Many Chinese citizens regret the loss of those priceless pieces of their nation's history, and they are now desperate to preserve what remains.

To that end, Chinese collectors have become a huge force in the Asian art world. Mainland dealers and their agents are interested in acquiring any and all examples of antique Chinese

Blue and white garniture set displayed in the British (Kensignton) Royal Palace on top of the cabinet

artwork and crafts. They are paying top dollar to regain these objects, and they have little interest in ever reselling them to collectors in the West.

Many individuals in China dedicate their lives to finding and securing these objects, and they are very meticulous in their search. I have visited the smallest, most rural villages in China, and have seen people glued to the Internet, searching tirelessly for these items.

No matter where the auction is and no matter what its size, if Chinese collectors are interested, they will send representatives to bid. I recently bid on a jade vase and lost it to a dealer from China. The auction was held in an extremely small venue, but the vase must have caught someone's eye, so a representative was dispatched to fly all night and bring it home.

The Internet has left us with no secrets. Nothing of value slips through unnoticed, and someone is always watching for the next great find. I've been to tiny estate clearings in the English countryside where you might find one or two English dealers, maybe one American dealer, and ten or twenty young Chinese buyers ready to outbid us all.

Chinese collectors have reshaped the market around themselves and are now major players. Their willingness to pay huge prices has encouraged Western dealers to buy and hold Asian objects. Dealers know that they can almost always make a profit on these items, either because they personally know a collector or simply because China is so eager to have them.

As someone who has been immersed in the world of Asian art for decades now, I've seen the market's many changes firsthand. I've actually lost a few objects to dealers, which was virtually unheard-of a few years ago. Previously, I knew I could buy anything I really wanted at auction because dealers always had limits. They had to leave room to sell the piece and make a profit. These days, a dealer can spend a million dollars and still be confident in a solid return on the investment.

For example, I was outbid on a lacquer box in Paris and afterward I asked the dealer why he'd bid against me.

"I bought a half share with someone."

Blue and white garniture from the Kangxi period

"I know that." There are no secrets in the trade and you can almost always find out when dealers are splitting a piece.

"Well, we both think that the market for lacquer is still cheap, relatively speaking. It hasn't reached its pinnacle the way porcelain has." So he and his partner were willing to pay a million dollars for the piece, and now they were putting it away with the intention of one day selling it for five or ten times that amount. In all likelihood, they will get it.

Another dealer friend has amassed an enormous Chinese lacquer collection, and he rarely sells anything. On occasion I can wheedle one or two things away from him, but if he thinks an object has a future, or even if he just doesn't fully understand it, he sits on it. He considers this collection to be his retirement. Instead of buying stocks and bonds, he buys lacquer.

A person can, in fact, retire on the strength of a solid collection, particularly if he has the advantage of years in the trade. A good friend of mine has a collection of Chinese pieces that he literally bought for a few pounds in the early-morning markets in and around London's Portobello Road. He socked them away for years and then, just recently, he took them to Hong Kong and sold them for a huge profit. He got millions in return on an investment of pocket change. Some of his pieces had even been given to him gratis, as at the time they were considered useless junk. His experience is a lesson to all collectors.

As changed as today's collecting landscape is, if you are savvy and quick and have the right connections, there are still interesting objects out there. With that in mind, I put the word out, particularly among Asian art dealers in London, that I was looking for a garniture set. James, a young dealer who does an excellent job of keeping his ear to the ground and personally getting around and looking at various objects, had heard about a complete set at, of all places, an English furniture shop called Mallett Antiques on Bond Street.

At the time, Mallet was one of the major furniture dealers in the city, though they have since been sold. My dealer friend investigated and called me up. "There's a superb eighteenth-century, blue-and-white porcelain garniture," he said. "They have dome covers with molded collars and finials and a number of other wonderful attributes."

They dated from the Kangxi period and were in superb condition. There is a well-known triad of characteristics that any collector looks for in an item: rarity, beauty, and condition. This garniture set hit all three notes.

"I've got to see them," I said.

"I don't need to act on your behalf and make a commission," he told me. "I've looked at it. I've vetted it. Call up Mallett and let them know I told you about the porcelain. He knows that I'm giving you this information."

I asked him a few more questions about what he thought the asking price would be and what he thought I should pay. His input helped me considerably, which is partly why I consider him a valuable friend.

When I called Mallett to negotiate, all I had to go on was a photograph and my friend's assessment. Thankfully, he was spot-on. Never before have I encountered a set of this size and quality from the Kangxi period. Each of the individual pieces is quite large. The flare vases are twenty-two inches, and the covered base is twenty-three inches tall; for pieces of porcelain that large to make it through the centuries unharmed is practically a miracle.

It was an excellent buy, and the set of five sits today on top of a cabinet, where I admire them regularly. To this day, if you mention my name at Mallett Antiques, they say, "Oh, Mr. Blumenfield, who stole those vases from us!" I certainly got them at a fair price, and I consider it a stroke of luck that I found them at all.

$700,000, Sight Unseen

In the summer of 2010 I received an e-mail about a large Chinese lacquer dish from an English dealer visiting Tokyo. This dealer operates differently from most of his competitors in that he doesn't keep a large stock of objects on hand. Instead, he acquires treasures and places them directly into good homes. When he traveled to Japan and found the lacquer dish, he was thrilled.

I buy from this dealer often, which puts me at the top of his customer list. Most of the time, though, I have to refuse him because his prices are astronomical (in part because they include his commission). His e-mail about the dish had no picture attached, which speaks volumes about the experience of purchasing objects in Japan.

There were no photos because the Japanese dealer wouldn't allow him to take pictures. A photo could be e-mailed to a total stranger, or worse, posted online, which would violate their notions of relationship and formality. The Japanese certainly want to make deals, but on their terms, both financial and social.

"You're asking me to buy the dish without seeing it?" I asked, surprised.

"Yes," he said.

"So I have to trust you."

He said, "Robert, this dish has the best diaper pattern that I have ever seen on a seventeenth-century dish." A diaper pattern is a carving that represents waves in water.

"Describe it to me," I said.

Then, as the English dealer described the item to me, I sat back, closed my eyes, put my feet up, entered the "zone" in which I visualize objects, and saw the dish in my mind's eye. He began to paint a picture with his words; he described a very large foliate-shaped dish with intricate carving. It was red and black, he said, which is also unusual. If the craftsmanship was as beautiful as he said it was, then there was every chance that the dish originated from a temple. He went on to fill my imagination with copious details about its appearance and condition.

I have a gift for visualization. When I design a building, I work closely with the architects and I know exactly how the building will look. I close my eyes; I see the building, the colors, even the details of the furniture. So I could picture the object's foliate edge, the diaper pattern, and the rich black and red hues of the lacquer exactly as the dealer had described them. And this is how I fell in love with the dish.

"Is there anything else for sale?" I asked. (That's a question I always make sure to ask.)

The dealer said, "Well, we have another dish. But we don't know whether it's right for you. It's a small, yellow dish."

He explained that both dishes were filthy, which is the normal condition of discovery for antique lacquer. Then he said that the smaller dish had a small mark on it … let's see if he can make it out … yes! It is a Wanli imperial mark, which indicates that the dish came from the Chinese emperor's palace. The dish

Very large lacquer dish

was so dirty, he said, that he could hardly see the mark, but that is not uncommon. The mark was finely etched—as if carved by a thin needle—on the back of the dish near its edge. In today's art market, any Chinese object with an emperor's mark is highly desirable.

"Why do you think I wouldn't be interested in this dish?" I asked. "It sounds wonderful."

I wanted to give the purchase some thought, but I knew that time was of the essence. If an interesting object comes up in an auction, then as many as twenty or thirty people will climb on a plane in the dead of night and at a moment's notice just to bid on it in person, whether it's in Rome or Paris or New York. Imperial porcelain was the hot item twenty years ago, and imperial porcelain pieces are now worth many millions of dollars. I believe that lacquer is today what imperial porcelain used to be: the wisest investment a collector can make.

The Japanese love Chinese lacquer, and they carefully store these objects in wooden boxes, which is how they stay in such great shape. They'll take them out for their tea ceremony and then gingerly replace the dishes in the boxes; the Chinese don't handle them nearly as carefully. Although lacquer is delicate, it is sturdy enough to survive centuries. It will dry with only a few cracks as long as it's taken care of and stored properly.

I wanted to negotiate a fair price for the dishes, but I knew that the Japanese dealers weren't inclined to negotiate. My go-between said quietly but firmly, "We've got to do this fast. It will be gone otherwise. What do you want to do?"

That pressure was enough. I said that I would buy both dishes.

"You will?" he asked, surprised.

"I will," I said. "It's the only way we can negotiate with them."

If I said that I wanted the one dish for a discount, they would never agree. But if I decided to buy both, they might be willing to settle for a deal. So the English dealer managed to negotiate a price with the Japanese dealers and then offered the two dishes to me for $700,000, of which the dealer probably took a very small cut.

Without having laid eyes on the dishes, I authorized the deal. Only then was the English dealer allowed to snap photos of the dishes with his phone and send them to me. I wired the money right away. Bear in mind, I still had never seen, touched, or smelled the dishes. But again, I know when I've come across something valuable. I very rarely make a mistake.

Soon after I made the deal, I shipped the lacquer to my brilliant restorer in England. He cleaned them and helped further reveal the imperial mark. The dealer who helped me on this purchase also happens to be a lacquer aficionado, and he did some research, finding that one of the dishes is one of only three known of its kind. One sits in the Sumitomo Museum in Kyoto, the other is in the Tokyo National Museum, and the third is in my possession. Because of that provenance, at an auction, that dish alone would probably make double the $700,000 I paid for both.

But the real magic is the mark on the smaller dish, which also has an imperial dragon. Imperial dragons usually have five claws, but in many cases, one claw is taken off when it leaves the palace. In centuries past, it was considered illegal and immoral for anyone outside the palace to possess an imperial piece with a five-claw dragon. If I look closely, I can see where the fifth claw probably was, which adds to the allure.

Did I really buy the pieces sight unseen? Not if you consider the power of the mind's eye.

Imperial yellow lacquer dish

Chinese lacquer boxes

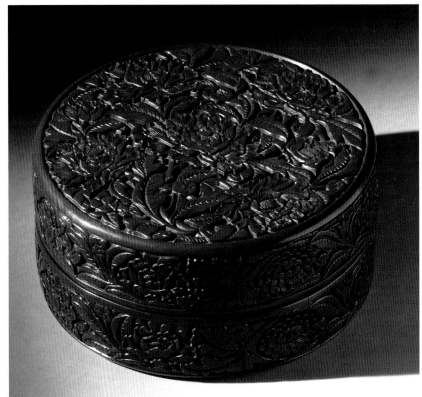

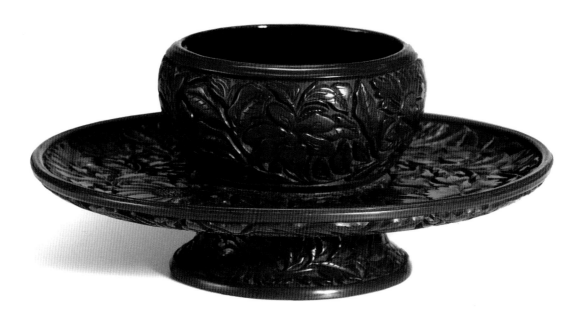

One of a pair of Chinese stemcups from the Ming Dynasty. The bowls with rounded sides and slightly everted rim are supported by a slender stem with out-turned foot. Made of cinnabar lacquer, the bowls are carved with complex landscape scenes in finely cut diaper ground. The stems wound around with a single band of earth diaper.

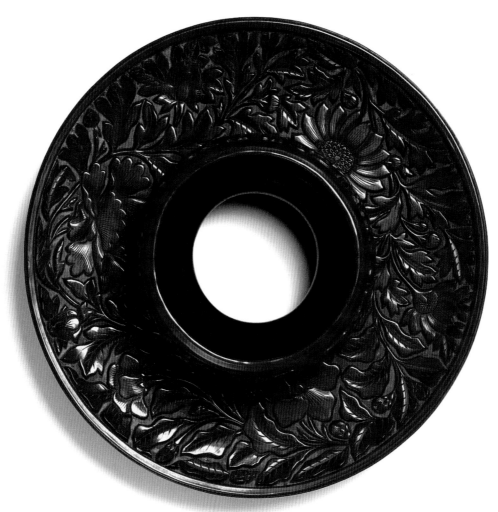

Detail of Cinnabar lacquer stemcup holder

A Big Haul for the "Hoover Man"

Once again, it was Asia Week, this time in London, so naturally I was there on the hunt. I ran into my friend James, who had alerted me to that amazing blue-and-white garniture set.

"James," I asked, "is there anything at the dealers?"

"Tony Carter has some interesting things," he replied.

I knew Tony Carter. He is Canadian by birth and has lived in England for many years. He has a house in the country and maintains a flat in London where he works. He sets up a select few small items in his living room there; imagine a desk covered in small treasures. He had a few jades and a small assortment of other items. A pair of wonderful lacquer stemcups particularly drew my eye.

"I highly recommend these," Tony said, indicating the cups.

"Okay, I'll buy them," I said. "What else do you have?"

I was living up to my "Hoover Man" nickname, hoping to scoop up everything I could. Tony paused, clearly thinking through his inventory for anything that would be appropriate for me.

"Well," he said reluctantly, "I do have this one piece. But I have a man coming in from Hong Kong to see it. If he wants it, I'm committed to giving it to him."

It was hardly a wide-open door, but I knew that he wouldn't have mentioned the item if he were completely opposed to selling it to someone other than the collector from Hong Kong.

"Can I see it?" I asked, and he agreed. It was a white jade *jue*. A *jue* is a vessel, usually designed for ceremonial purposes,

Chinese lacquer stemcups

that stands on three legs, like a tripod, and is generally made of bronze.

"This is a treasure," I told him.

That trip was even more of a buying spree than usual. I had kicked my mission to collect everything great into overdrive, and had come to London specifically to purchase just these kinds of things.

In fact, the *jue* was even more of a treasure than I first realized: a small area at the apex of the legs had the four-character mark of the Qianlong Emperor in a seal script. The term seal script refers to a form or style of Chinese character writing

Imperial white jade jue

used in the Bronze Age, and widely used in seals in later dynasties. Many imperial marks are written in seal script; these can be used to authenticate a piece to a specific period. Seal scripts were more or less popular during various periods in Chinese history, but the Qianlong Emperor was a well-known patron of the arts, and creative enterprises flourished under his reign. The marks associated with the Qianlong period are perhaps the most common amongst Chinese collectibles, simply because it was such a productive age for art.

However, the seals can also impart more information. In this case, the marks indicated that it hadn't simply been created during the Qianlong period, but that it was actually made for the imperial household. No wonder it was such an exquisite piece—it was crafted for the emperor himself.

I looked at Tony, sitting behind the tiny table that served as his desk, and he was looking at the jade. "How much is it?" I asked.

He looked surprised, but dealers often do when I am very frank.

"I just bought this lacquer," I pointed out, "I'm here already. How much would you want for it?"

He quoted me a very respectable price.

"I really love that, Tony. I'm going to take it."

"Oh, really?" Tony said, clearly surprised.

"Yeah," I said.

"Oh. Well. Quite so. Well done, Robert."

In my experience, I have learned just how highly people value a sure thing. It was true that Tony had another collector coming in to examine the *jue*, and he might have taken it, and he might have paid as much as I would. He might have even paid more. That's a lot of "mights." It's hard to turn someone down when he is right there in front of you, willing to complete the transaction immediately.

After we closed the sale, Tony and I sat and chatted a bit until I noticed a paper grocery sack, half-hidden behind him. An insatiable curiosity has served me well over the years, and this situation wasn't any different.

"What's in the bag?" I asked him.

He waved away my question: "Oh, I don't think it's anything for you."

Of course, that just made me more eager to discover the contents of the bag.

"Can I see?" I asked.

"It's not really your kind of thing, but if you want …"

He opened the bag and emerged with a small jade brush pot. He had just purchased it, which was why it was stashed in a paper bag instead of cleaned and properly displayed. That was probably part of the reason for his reluctance to show it to me.

I was bowled over. A green jade brush pot? Not only was it "my kind of thing," it was something that I'd desired for years. Brush pots were among the "treasures of the scholar," a category that also included calligraphy brushes, ink sticks, and stones. They were designed to be beautiful as well as functional, and often featured intricate carvings. This was a few years before the big boom in jade, which may explain why Tony was so casual about a piece like this. These days, this kind of thing would go for sky-high prices.

"I love this," I said. "How much is it?"

A series of shocked stutters was my only answer.

In one day, I had come in and purchased three amazing items. I didn't find much else of note during the rest of my time in London that week. Apparently, it was all at Tony's apartment!

I'm sure Tony was planning to make the most of Asia Week, mulling over this new piece and finding just the right placement, just the right lighting. He'd wanted to have items to display, and I had come and Hoovered up all his major Chinese pieces in one go. I imagine it was somewhat challenging to process.

Tony and I became good friends after that. Not many buyers come in and write a check in real time, so it established me as a top-notch client. Since then, I have happily purchased many great pieces from Tony, though perhaps never quite as spectacularly.

Carved spinach green jade brush pot

Art: A Love Story

Audrey and C. Ruxton Love had the kind of love story you read about in, well, an auction house catalogue. Audrey was a Josephson by birth, part of a wealthy New York family with a storied history of collecting. Her uncle was Solomon Guggenheim, the man who founded the museum of the same name with his own formidable collection.

Ruxton (the C. was for Cornelius) worked on Wall Street and as a diplomat. Shortly after graduating from Yale, Love took a position as secretary to the American ambassador to China. Audrey was also heading to the Far East for a wedding. The two met and connected literally on a slow boat to China.

Both of the Loves nursed a passion for collecting and they filled their houses (one in Palm Beach and one on Park Avenue) with the fruits of their labors. They had excellent taste and they bought voraciously, building an amazing collection of cloisonné, imperial pieces, and screens of all types from lacquer to coral.

They lived intimately with these objects and made them a part of their home and their lives. They weren't overly concerned with preservation and were more interested in having a functional relationship with their collections. Similarly, they never remodeled the homes they purchased. The way the house was when they moved in was the way that it remained.

They had two children, including Iris Love, a well-known archeologist. Then, one night in 1971, Ruxton Love set off across Park Avenue and was struck by a car. He passed away but Audrey lived on into ripe old age, becoming one of the doyennes of New York society. She continued to collect on her own for decades, furthering and expanding her already incredible collection.

When Audrey died in 2003 at the impressive age of one hundred, the executors of her estate began auctioning many of her collections and personal items. I first encountered the Love estate when some of Audrey's jewelry was put up for auction. Mrs. Love was a diminutive woman, like my wife, Sharon, so I thought that we could perhaps pick up a few pieces of jewelry that would be to Sharon's taste and size.

The Love sale was held at Christie's in Rockefeller Center, the entire first floor of which had been cordoned off exclusively for this auction. Everyone in the collecting game relishes one-owner sales because they offer a chance to acquire items that the market hasn't seen in years. In this case, we are talking about a couple who started collecting seriously in about 1925. One-owner collections are special, but top-quality one-owner collections that span two-thirds of a century? That's a once in a lifetime opportunity.

Not surprisingly, the sale was very well attended. Hundreds of would-be buyers crammed into the room and there was the usual contingent of long-distance buyers bidding by phone and online. Excitement was high. The Loves' very fine cloisonné collection was probably the most touted element of the sale, particularly an enormous ice chest. It was Chinese, imperial, and gilded. This was originally designed to be a functional item; in the hot summer months, ice was brought down from the mountains to cool the palace rooms. Huge blocks of ice were placed in these

chests, which generally had vents or openings in the top to allow cool air to escape, while servants fanned the air to cool the room. Sometimes these chests were even placed under tables to keep guests comfortable as they dined.

I don't know which came first, the Loves' physical presence in China or their fondness for Chinese art, but they had a vast and diverse collection.

When they began collecting in the mid-1920s, China was embroiled in the beginnings of its civil war and the nation needed money desperately. The government put up art and other artifacts as collateral to secure loans from Western banks. When the loans could not be repaid, the banks suddenly had this large collection of art on their hands that they didn't want. Ruxton Love, in his capacity as an aid to the ambassador, had entrée to these banks and he was able to buy up some of this art. And it had remained in their possession ever since.

Naturally, this meant the usual contingent of Chinese dealers and representatives, who were all excited for the sale. They were especially interested in things like the ice chest and also two cloisonné tables that were simply incredible.

I myself tried to grab those tables because you simply never see things like that at auction. Unfortunately, I didn't get them, but a friend from Boston did. Similarly, I saw an enchanting panel screen inlaid with precious stones depicting European subjects. I've never seen another screen like it, before or since. That same friend picked up that piece.

Emotions grew more heated in the auction room. The sale featured many very fine items and a great deal of competition for all of them. As a collector, it is important to maintain clarity in such an environment. I had to be determined and focused on what I was there to buy. The worst thing I could imagine was missing out on something, not because I was outbid, but because I neglected to make the attempt. I wanted to be sure I didn't leave a potential treasure behind.

Auctions are frenetically paced. Decisions have to be made in moments, with no hesitation. At a big auction like this, you may be competing with hundreds of other people, some on other continents, for a single object. And it all happens at lightning speed. "Lot number 27," the auctioneer will say, and the game begins. "Let's start the bidding at $50,000. $50,000, I have $60,000, $70,000 …"

The auction houses have a predictable and established way of increasing bids. It starts out, "$70,000, $80,000, $90,000 in Taiwan," and she points to the alcove where the phone bids are coming in, "$100,000 with Julie at the phone." It continues to rise: "$120,000. $130,000 in Hong Kong. $150,000 in Beijing. Against you, sir, in the room." All this happens in mere seconds and the excitement swells as the price escalates.

Eventually, it begins to slow down a bit and the bids become less frequent. The tension is slightly defused. "We're at a million against the room and against you in Taiwan and against Susan on the telephone, and selling in the room for $1 million."

Often, there is a brief lull to let everyone catch their breath and evaluate their positions. Usually there is some talking on the telephones. "I can't hold it any longer, Susan. $1.1 million. With Susan on the telephone, and against you in Taiwan, and against you in the room." Then the room's energy reaches a crescendo; the climax is imminent—the inevitable is coming. "Against you in the room … all done. And selling, on the telephone, for $1.1 million." She pauses for an eternal moment to see if there are any other bids. Bang. She slams the gavel down.

It's easy to get caught up in the fast pace of the auction, lose concentration, and get sidetracked. The best way that I have found to avoid this is to have a clear idea of what you are looking for before the sale even begins. In the days and weeks before an auction, I pore over the previews and the catalogues to identify the things that interest me most. Then I mark the catalogues so I know when each piece is scheduled to come up. I make it a point to be present for my sales, but I don't hang around the auction house between sales; not being around to hear the white noise of the other auctions shields me from the excitement. There is no need for me to stick around when I'm not bidding—and in fact, there's every reason not to.

Instead, during the downtime, I visit small exhibitions

around town. When a large sale is held in a major city, dealers (many of them from abroad) often rent out gallery spaces for the week so they can piggyback onto the frenzied excitement of the main event. They bring a portion of their catalogue and sell to the collectors who came for the auction, and at the end of the week they pack up and head back home.

New York was peppered with such midnight operations during the Love sale. I attended many, but the Love auction was never far from my mind. I went in and out over the course of the multiday sale. I missed out on some items and brought others home. I remained in control, only bidding on items that would enhance my collection, and kept my money intelligently focused on my passions. Only items that thrilled me got my bid.

Because I have spent so many years in the collecting world, I tend to see a number of familiar faces at events like the Love sale. Like me, these collectors and dealers were all hoping to get their hands on that one special treasure. What precisely constitutes that treasure varies from collector to collector and from dealer to dealer. But for people with very good taste, there is often significant overlap.

One person in particular, Priscilla Chak, frequently bids on the same items that interest me. Priscilla and her husband, William, are very well-known art dealers in Hong Kong. William represents a lot of big buyers, and his company mounts several antique shows. Priscilla is hardworking and knowledgeable. I often see her at events like the Love sale because she's always on the move, always looking for that next great thing. I like to think that Priscilla and I share an always-questing nature and a drive to find wonderful objects, wherever they may be.

At that very sale, in fact, indulging my curiosity served me particularly well. In this enormous room it was easy to spot the big-ticket items—and those that were just plain big, like the large ivory screen I later purchased. The smaller things, however, required a bit of searching.

Prior to the sale, I was meandering through the room and there was a small curio cabinet on display. Guided by instinct, I opened it to investigate the interior. Most people wouldn't think to do this—they would see and evaluate the cabinet as just a cabinet, then decide whether or not to bid on it. But curio cabinets are made to hold treasures!

I was rewarded with an astounding piece. It was a cloisonné crane-form box complete with its cover, standing only three-and-three-quarter inches in height. I opened it up, and was immediately dumbstruck. Clearly, this little box had come out of the Peking Palace workshops—that is to say, it had been made on order for the emperor. I would happily compare a work such as this to any work done by Fabergé for the Russian royal family.

I took it out of the cabinet and held it delicately in my hands. The clarity and beauty of the composition bowled me over. The crane is seated, its long legs tucked underneath its body, and its head turned sharply to one side. In its beak, it holds a stalk of *lingzhi* fungus, associated with longevity and even immortality. It is a very popular motif in Chinese art, especially in animal scenes—like the scene on the little box resting in my hand.

The stalk along with the crane's folded wings, formed a handle of sorts. The colors were incredible; a rich blue on the crane's tail perfectly complemented areas of black and white modeling called *ares*. Plus, there is just something compelling about boxes. Perhaps it has to do with psychological associations with hiding and protecting but, in my experience, we as humans seem to be drawn to boxes and the mysteries they promise. I am certainly no exception. I knew then and there I wanted to own it. Everything about it delighted me.

Priscilla, of course, had spotted the crane box as well, and I knew that she was recognizing the same features that had struck me. But the curio cabinet hadn't given up all its secrets yet. There were also a series of miniature gilt bronze figures, each only about three inches tall, depicting Guan Di, a semi-legendary general who likely lived in the late second and early third century (d. 220). These objects were extremely exciting. The bronzes depict Guan Di in his military aspect on a throne between two figures. He wears a large hat, bears an incredibly precise wirework beard, and his right hand is positioned to hold a staff or a weapon. The two other figures, attendants, project

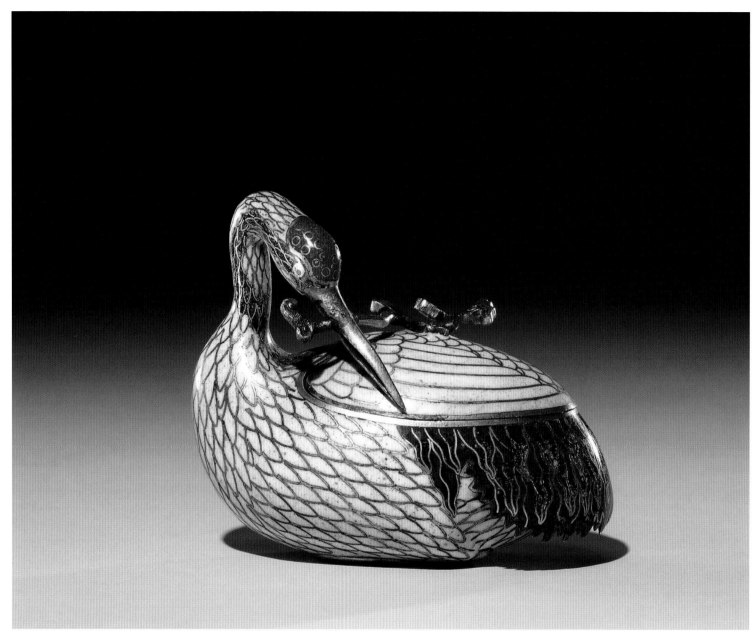

Imperial cloisonné crane-form box, from the Old Summer Palace

Small gilt bronze group

from either side. All three figures were exquisite. For me these objects were hugely exciting. I knew, however, that many others at the sale would consider them mere tchotchkes. Of course, this was ten years ago and those tchotchkes are now selling for huge prices on the open market.

Priscilla, meanwhile, was also sizing up these same two objects. But because she is a dealer, she was considering them in terms of their resale value. She wanted to purchase them, but only if doing so was going to be profitable for her in the long run. At the same time, she was also bidding on specific items for clients at the sale, so these were not her first priority. Because she needed to maintain her profit margin, I was able to top her in the bidding for both the box and the bronze figures. She put up a fierce fight, however, and no one could say that I got them for a song!

I paid somewhere in the neighborhood of $20,000 for the box alone which, at the time, was quite a price tag for Chinese cloisonné, even very high-quality imperial stuff. Today, its value is virtually unknowable, considering the incredibly high demand from Chinese buyers.

Of course, just because I love the small things doesn't mean I don't also appreciate some of the larger, flashier items. In fact, one of the first things to catch my eye at the Love sale was the large, carved-ivory wall screen I mentioned earlier. Somewhere between a tapestry and a painting, wall screens are decorative panels designed to enrich a space. This particular panel, with its complex inlay design, was the very apex of this art form. Like the crane box, it featured a bird motif, this time an elegant kingfisher among the rocks. It also had two incredibly desirable details: a gold imperial inscription and an imperial Qianlong inscription, all against an eye-catching blue background.

What really struck me about the piece, however, was its familiarity. I had seen this screen before, in an art book. I never

Imperial carved ivory wall panel (before)

Imperial carved ivory wall panel (after)

imagined I would see it in real life, let alone have the opportunity to own it.

The panel stayed in the back of my mind even as I bid on a number of other things. I had to have it, but I was starting to worry. I was facing stiff competition from Chinese buyers who were making sure that I paid dearly for anything I wanted. I could only imagine what kind of price something like the ivory panel would command.

I was so caught up in the excitement of the sale that I didn't even notice we were creeping closer and closer to our flight's departure time. My wife said, "We have to go the airport or we're going to miss our flight." I didn't know the auction would take this long, and the ivory panel had yet to be featured, but I knew Sharon was right.

I found the head of Christie's Asian art department (Tina Zonars, who is a very good friend) and I explained my situation. "I have to go," I told her, "but I'll be on my cell phone. Call me in the car, and we'll bid."

I spent the whole drive to the airport bidding on a number of items that I didn't get. In addition to the Chinese dealers, I encountered considerable competition from representatives of Ned Johnson, a fellow Chinese art enthusiast, owner of Fidelity Investments and a major patron of the Boston Museum of Fine Arts.

That I could not be there for the auction in person placed me at a disadvantage to be sure; one cannot accurately gauge the energy of a room remotely. But one of the things I did have going for me was a small flaw in the ivory panel. The blue background had a small issue, and the frame needed a bit of work. Perhaps this would make the piece less desirable to others at the auction? For me, these flaws did not seriously impact my love of the screen.

I got more and more anxious as we made our way to the airport. Not only was I losing out on a great many pieces, but I was waiting and waiting for the ivory panel to come up, and it just wasn't happening. At this rate, I was going to be thirty thousand feet in the air before the screen appeared at the auction block.

I stayed on the phone while we boarded the plane and settled into our seats.

"The panel is up in two lots," Tina said in my ear.

"Mr. Blumenfield," the flight attendant said, "you need to turn off your phone. We're taking off."

She was polite but she clearly meant business.

"I can't, I'm bidding in an auction," I said, desperately trying to carve out just a few more minutes.

I had been waiting for this panel since the moment I saw it. I was now minutes away from potentially taking it home.

"I'm sorry, but you have to shut off your phone. We're closing the door," the flight attendant said.

I turned my attention back to Tina. "I have to turn my phone off," I told her.

"What do I do?"

"Get it bought," I said urgently.

"I can't do that!" Tina sounded bewildered. "I need a number. How high can I go?"

The flight attendant was standing over me, all but tapping her foot.

"Just get it bought," I said.

"Sir, either shut your phone off or leave the plane because we need to take off."

"I'm sorry, Tina," I said, over her sputtering protestations, "but I have to go now. Good-bye. Get it bought!"

Needless to say, it was a very long flight.

I'm sure it was similarly nerve-racking for Tina. What if she overspent a limit she didn't know existed? Thankfully, Tina didn't need to spend a million dollars, and I didn't need to regret my instructions. I got the piece, and although it wasn't cheap, it was an acceptable price for such an outstanding item.

As soon as it was mine, I addressed its imperfections. I spent about a year restoring the piece. Wall screens are somewhat unusual because they combine a number of different artistic techniques. Therefore, any restoration attempt must necessarily be a team effort. The portion with the imperial inscription had originally been printed on paper, and I had

make sure that the paper itself was properly preserved and cleaned so the entirety of the inscription could be exposed. There were a couple of small pieces of the inscription missing, so I found a restorer who could both speak Mandarin and read classical Chinese, and who could therefore tell me which characters had been lost. Similarly, I had to find a specialist to clean all the ivory. I suspected no cleaner's brush had ever touched it, and my expert in ivory restoration confirmed those suspicions.

Truly, this restoration project was Herculean. The end result, however, was worth the hard work. Every aspect, from the poem in the inscription to the painted sky in the background to the minute ivory carving, is spellbinding in its beauty. I hung the finished piece on my wall where I admire it regularly, one of many reminders of what was surely one of the most incredible sales of my lifetime.

A side note: Apparently, the estate's trustees had been watching me during the early phases of the bidding and had decided that I reminded them of C. Ruxton Love himself. I took that as a compliment. I've seen pictures of the man; he was tall, handsome, and well dressed. Most of all, he was very elegant. There are certainly worse comparisons!

For the sale, all of the items had been photographed in situ, in the Love homes. "Where's their house?" I asked the trustees, my interest having been piqued by the catalogue photos.

"Park Avenue," they told me, "directly opposite the armory."

"Oh, I'd love to see it," I told them. At the time, the property was for sale. For a collector who is also a real estate dealer, this was an ideal situation. Finally, I could indulge my two major passions at once.

There was a hiccup, however, when they called the broker. She felt that she was very close to making a sale and didn't want to show the place. "Listen," one of the trustees said, taking the phone, "this is the vice president of Christie's speaking. We have one of our biggest clients here, he's buying a lot of things. You need to show this house to him."

So they showed me the house.

As mentioned, the home probably hadn't been touched since the day it was built. There were no showers, only bathtubs, and some of them were wooden. The house was four stories tall, and had a dumbwaiter but no elevator. There was a large marble staircase and a number of other attractive features. Overall, the place had great "bones."

Had I lived in New York, I would have bought that house, spent about five years restoring it, and would have ended up owning one of the greatest homes in the city, right on Park Avenue. But I knew it wasn't feasible, with my entire life on the West Coast. Nevertheless, I fully enjoyed my tour of the house, looking into every nook and cranny and imagining what I would do with the house, were it mine …

"Where's all the closet space?" I asked the broker, thinking that perhaps there was a walk-in hidden somewhere.

"Oh, here," she said, opening a series of doors to reveal closets containing dozens upon dozens of high-end outfits, each Chanel dress and Blass blouse hanging neatly next to another of similar quality. Mrs. Love was a Lady of a Certain Age in New York, part of a culture that was shrinking all the time, where women went to lunch in silk suits and spent the afternoon browsing boutiques before spending their evenings at charity galas. I imagine that none of those outfits had been worn more than once or twice.

Meanwhile, I had unintentionally excited the broker with my murmurings about what I would do with the house if I owned it. For me, that sort of talk was just idle chitchat, satisfying my own curiosity. For her, however, it was a sign that I was interested in buying the place and she was thinking that she had another potential buyer on the hook.

Of course, as I wandered through the house thinking about the guy I know in Astoria who could really do some magic with those windows, or the company I know that expertly restores stone flooring, I had almost started to talk myself into it. It wasn't just the quality of the house or even its associated backstory. Restoring a place offers a pleasure of its own and I could see that this was the kind of house that I would love to fix up and enhance.

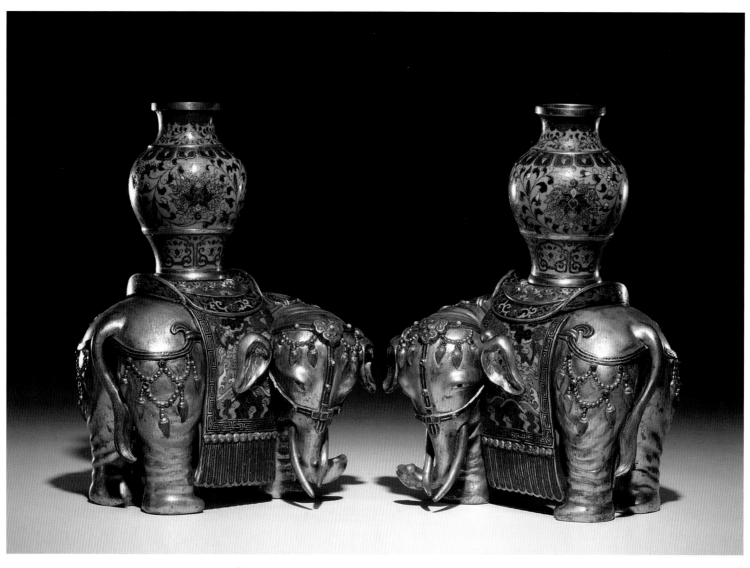

A pair of Chinese imperial gilt bronze and cloisonné enamel elephant group

From a purely fiscal standpoint, it was an interesting proposition. They wanted something like $17 million for the place, which is certainly not pocket change. However, considering its location and history and the high quality of the existing structure, the home would be worth something like $50 million after renovations.

"Are you buying this?" my wife Sharon asked, having picked up on my enthusiasm.

"Oh, no," I replied.

"It sure sounds like you are."

I chuckled, coming back to reality a bit. "No, I'm definitely not."

The broker, however, was still trying to make the deal happen. She eyeballed Sharon as we all stood in front of the closets and noticed that my wife was of a size with the late Mrs. Love.

"We have all these clothes," she said, "they're wonderful, and we really don't know what to do with them. You should take them!"

Before Sharon could respond, let alone protest, the broker was piling high-end garments into her arms. "Oh, this would look great on you!" she enthused, holding up a suit jacket.

"What do I do?" Sharon whispered to me. "I don't want to insult her."

"Take it!" I answered.

These gifts didn't sway me to buy the Love home, but I did leave the place loaded down with clothes. We felt a bit ridiculous walking down Park Avenue with tens of thousands of dollars' worth of couture in our arms.

We headed straight for our hotel and directly to the concierge. "Here," I said, gratefully unloading the clothing on him.

"Do you … want these dry cleaned?" he asked, no doubt a little bewildered by the sheer amount of fabric I'd just dumped into his lap.

"No," I said, "just send them to my home."

And so Audrey Love's wardrobe traveled across the country to my wife's waiting closets. Even if I couldn't justify buying the Loves' house, we could still own some of their legacy.

Qianlong imperial mark

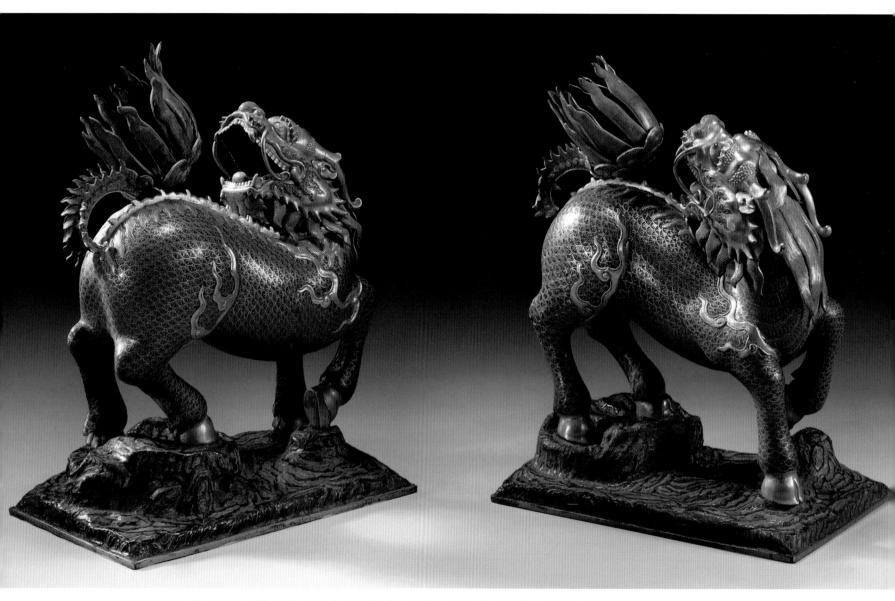

This rare pair of large Chinese cloisonné and champlevé enamel figures of Qilin is made in sections as mythical beast shown standing with one hoof raised on a rockwork base as it turns its head backwards towards the tufted tail and opens its mouth in roar. It features a pair of horns, spotted pink nose and bulging eyes while the body is covered in scales, all artfully enameled in shades of bluish-turquoise, greenish-turquoise, blue, yellow, pink, red, white and black.

These are the largest known Qilin imperial figures. C. Ruxton and Audrey B. Love purchased many of the imperial pieces in 1972, Beijing. It is more than likely that these objects are from a sale of imperial pieces by the banks in Beijing, that were put up for collateral loans that were never repaid. It is also interesting to note that Sir Percival David purchased his imperial pieces in 1926 from the same bank.

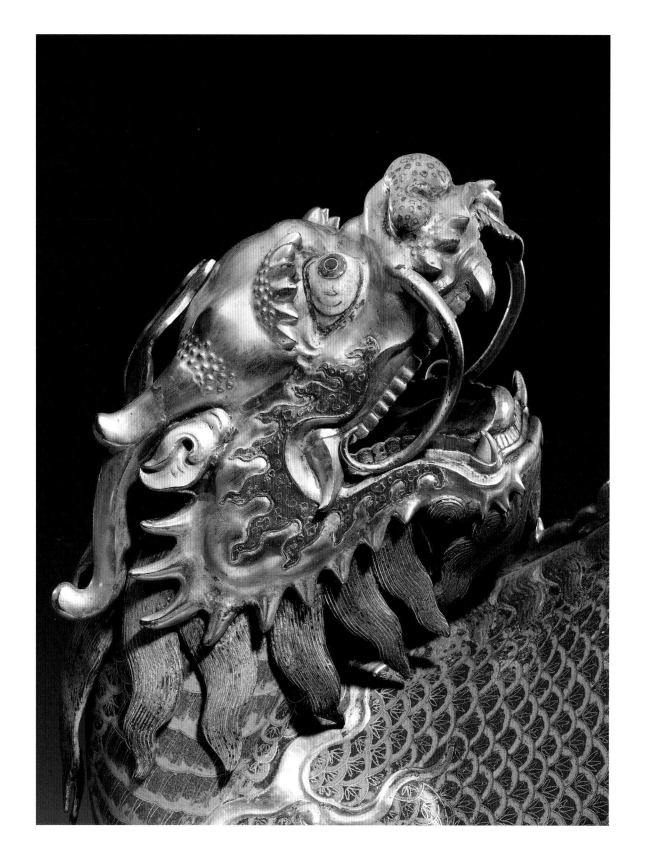

Cloisonné detail

The Sack of the Old Summer Palace and the Return of the Stolen Bronzes

As a Western collector of Chinese art, I recognize I am part of a long and occasionally tense history between the East and the West. Occasionally, this relationship is transactional (between a seller and a buyer) and sometimes it is intellectual (between an artisan and an appreciator). Unfortunately, at other times, it is more like the relationship between the pillaged and the pillager.

No one would ever willingly let go of something beautiful, unique, compelling, and universally awe-inspiring, unless forced by some unfortunate turn of events. Even now, I know that incredible things usually only come to the market through some catastrophe—illness, death, dire financial straits, incarceration, or divorce. We as collectors must take responsibility for the fact that many of the objects we seek are only available through the old and ugly tradition of looting treasures from the nations that produced and rightfully owned them.

When it comes to Chinese art, one particular incident looms large over the entire field and affects sales even today: the sack of the Yuan Ming Yuan (the "Gardens of Perfect Brightness"), the Old Summer Palace, in 1860.

In the mid-1800s, the relationship between China and the West (specifically Britain and France) was extremely contentious. As Britain pushed for greater access to China, China struggled in turn to maintain the integrity of its borders against this imperialistic onslaught. These nations were locked in a conflict that would come to be known as the Second Opium War, a reference to the British desire to expand its opium trade within China.

In 1860, an Anglo-French diplomatic delegation under a flag of truce approached a retinue representing the Chinese royal prince in order to negotiate a détente and favorable trading terms. These colonial envoys were seized, imprisoned, and led to Beijing, where they were mercilessly tortured. Ultimately, about twenty of these Europeans died. News of this incident outraged the European public and the colonial command alike; eventually, this action precipitated the reprisals that culminated in the sacking and burning of the Old Summer Palace.

Yuan Ming Yuan was really more of a compound than a palace, composed of more than one hundred distinct buildings, many made of wood. The palace was not a primary residence, but rather, as the name suggests, a summer home for the emperors since the early eighteenth century. It was also a vast repository of cultural treasures. Virtually every art form, from painting to architecture, pottery to horticulture, was exquisitely represented there. The French novelist Victor Hugo described it beautifully in a scathing letter to a certain (presumably British) Captain Butler:

Imagine some inexpressible construction, something like a lunar building, and you will have the Summer Palace. Build a dream with marble, jade, bronze, and porcelain, frame it with cedar wood, cover it with precious stones, drape it with silk, make it here a sanctuary, there a harem, elsewhere a citadel, put gods there, and monsters, varnish it, enamel it, gild it, paint it, have

architects who are poets build the thousand and one dreams of the thousand and one nights, add gardens, basins, gushing water, and foam, swans, ibis, peacocks, suppose in a word a sort of dazzling cavern of human fantasy with the face of a temple and palace, such was this building. The slow work of generations had been necessary to create it. This edifice, as enormous as a city, had been built by the centuries, for whom? For the peoples. For the work of time belongs to man. Artists, poets, and philosophers knew the Summer Palace; Voltaire talks of it. People spoke of the Parthenon in Greece, the pyramids in Egypt, the Coliseum in Rome, Notre-Dame in Paris, the Summer Palace in the Orient. If people did not see it they imagined it. It was a kind of tremendous unknown masterpiece, glimpsed from the distance in a kind of twilight, like a silhouette of the civilization of Asia on the horizon of the civilization of Europe.

《 《 《 《

How exactly the looting began is a topic of some controversy. It may have been due to the unchecked aggression of French soldiers, or it may have been ordered by British decree. Once it started, it almost immediately raged out of control. Because of their similar experiences colonizing India, the British army had developed a system for collecting and distributing plunder. Individuals pooled their finds, items were evaluated, and the soldiers were paid for their "share" of the hypothetical revenue from the collected items. The soldiers who looted Yuan Ming Yuan received about £40 each, a considerable amount of money back then.

The French, by contrast, had no centralized system for looting. Instead, French soldiers were allowed to take only what they could carry. Often, this meant that they had to enlist the aid of local Chinese peasants to tote the goods. French soldiers often resold their booty to any willing buyer, either within China or back in Europe. What could not be carried was often simply destroyed. We hear accounts of soldiers shooting at mirrors and chandeliers. Some, they say, smashed ancient and priceless vases, apparently for no other reason than the sheer anarchic delight of destroying something so strongly symbolic of a decadent, despotic emperor.

Perhaps the only saving grace of this atrocity was that the Old Summer Palace was simply too big and contained too many treasures for the relatively small invading Anglo-French force to empty it completely. Instead, they looted and destroyed only the items that appeared most valuable to the Western eye. For example, they took a great many pieces of pottery and lacquer work, but virtually no calligraphy or paintings. Similarly, they despoiled the statuary, but had little interest in the vast libraries of rare volumes. Most critically, these marauders had no interest in the ancient ritual bronzes, some of which were thousands of years old.

Burning Yuan Ming Yuan did accomplish British goals, as China reluctantly opened to foreign interests. Many of the palace treasures were immediately placed in European museums or among the personal collections of various monarchs. Others were dispersed, changing hands multiple times and passing around the world almost unnoticed.

The palace, which took three days to burn, was the subject of considerable national debate within China, and a few abortive attempts were made to rebuild or revitalize the ruins. Forty years later, however, most of the surviving (or repaired) Old Summer Palace was burned once again by Western troops sent to quell the famed Boxer Rebellion. Before the arrival of foreign troops, the Old Summer Palace was completely closed to anyone outside the imperial family. Though it existed in the time of photography (and indeed, many people at the scene of the sacking were photographers) there are no known photographs in existence. Apart from one exquisite book of Chinese etchings, a good chunk of what we know about the palace and its many chambers comes from the awestruck reports of Westerners. Even

Imperial gilt bronze vases taken during the sack of the palace by British troops (prior to cleaning)

the objects that were taken—and thus preserved—tell us more about Western tastes and values than they do of the emperors'. Interestingly, the ruins of the Old Summer Palace also reflect Western contributions to the preservation of Chinese heritage. The only structures that survived the purge were those made of stone, mostly later additions modeled on Western buildings and designed by Giuseppe Castiglione and Michel Benoist—Jesuit visitors to the court.

The Old Summer Palace has been a sore point for China since the proverbial first match was struck. Today, UNESCO estimates more than one million individual objects from the sack of Yuan Ming Yuan are held outside of China in forty-seven countries worldwide. China estimates the number is even higher. Many of these items are housed in museums or private collections, and some are still floating around the open market. Some haven't been seen for decades. Palace remnants have become a potent symbol of China's increasing desire to repatriate art and other cultural artifacts. From this vast trove of lost treasures, a few pieces have emerged as remarkably precious or significant—the ones that are bigger, older, rarer, or more extraordinary. Both private collectors and government officials have been very explicit about their desire to return these items to China.

Above: Imperial white jade brush washer taken during the sack of the Old Summer Palace

Left: Bottom of the washer

China does not pursue the low-profile artifacts quite so aggressively, and individual collectors are still buying up even the smallest pieces. After the Cultural Revolution, there was a time when people in China were forbidden to own these objects. Now that they can legally own them again, they want them badly. Chinese interest, in turn, has hugely inflated the market, making this type of art an excellent financial investment for any collector.

These days, an imperial mark adds incredible value to any piece. Some people, including Chinese fabricators, have gotten into the lucrative replica and forgery industry, trying to capitalize on the fever for things that can be traced to Yuan Ming Yuan. Items from the Old Summer Palace are certainly rare, but not impossible to find; I own a few pieces myself. Of course, fewer and fewer are in circulation now, and the chances of finding one for a reasonable price are slim. Hungry collectors would immediately flock to any such item and drive the bidding sky-high.

There was, however, a long lull between the initial sacking of the Old Summer Palace and the concerted effort to return its contents to China. In the intervening years, China experienced tremendous tumult and crushing poverty. Many individuals and institutions were extremely willing to sell artifacts to wealthy foreign buyers. For certain short periods of time between 1860 and the 1940s, China was a very fruitful hunting ground for serious collectors.

In the 1920s, for example, a collector might take a grand tour of the East and visit the ancient tombs dedicated to long-dead emperors. These tombs would be filled with beautiful carvings and ritual bronzes, grave goods designed to allow the deceased to greet their ancestors with the appropriate offerings. On a tour of these amazing burial chambers, a guide might politely suss out which of the stunning artifacts you found most attractive. Later, that artifact would discreetly show up at your hotel room, all prepared to go home with you … in exchange for a suitable sum, of course. These transactions were very common in the years leading up to the Chinese Civil War, and resulted in a great

amassing of Chinese art within Europe and the United States, some of it acquired for relatively small amounts of money.

The most remarkable story from the Old Summer Palace is that of the bronze animal heads. There were twelve heads, designed to represent the twelve animals of the Chinese zodiac: rat, ox, tiger, rabbit, dragon, snake, horse, ram, monkey, rooster, dog, and pig. Made of a corrosion-resistant bronze alloy, they were crafted by Castiglione as part of a grand clepsydra, or water clock, for one of the gardens within the Old Summer Palace. The bronze heads were affixed to humanoid bodies made of stone. Every hour, a jet of water spewed from each of their mouths in turn. All of these heads disappeared during the sack of Yuan Ming Yuan.

For a long time, the bronze heads changed hands and traveled from collector to collector and from nation to nation, until they eventually resurfaced. As the story goes, they were discovered by a pair of renowned decorators named Blaine and Booth, who specialized in buying and refurbishing French furniture for the homes they worked on. They were scouting in France when they stumbled upon large bronze sculptures of a rabbit head and a rat head. They had the idea to mount the heads, perhaps on marble. They probably bought them quite cheaply; were I in the same position, I probably would have bought them too.

Many years later, the decorators had retired in Los Angeles, and they were considering selling off some of the pieces they had held onto over the years, including the bronze heads. As soon as auction house representatives got a look at the animal heads, they recognized them as part of the Yuan Ming Yuan water clock. This was still a bit before anyone was making an aggressive attempt to reunite the pieces, so Yves Saint Laurent, a noted collector as well as a world-famous fashion designer, was able to pick up both heads at auction. And that is where rat and rabbit remained until Saint Laurent's death in 2008, and the subsequent massive sale of his incredible collection.

By 2009, various individuals and groups had been making a concerted effort to buy back the complete zodiac. In 2007, Macau casino billionaire Stanley Ho made headlines when he bought the horse at auction for $8.9 million—twenty-two times what the previous buyer had paid in 1989. Meanwhile, China Poly Group was specifically formed to find and secure lost antiquities. They got the ox, tiger, and monkey in 2000. Unfortunately, that was the end of the known bronzes. The rooster, ram, dragon, snake, and dog have not been seen or sourced since the destruction of the palace itself. In fact, the only known bronzes left outside China were the rat and the rabbit.

When those two items turned up in an auction catalogue, Chinese advocacy groups immediately launched a formal protest, urging Christie's to stop the sale of what they regarded as stolen property. Christie's was managing the auction on behalf of the executor of Saint Laurent's estate, his partner, Pierre Bergé. As the sale moved forward, more and more parties became entangled in the issue. It even threatened to tarnish international relations between France and China. Without this controversy, the Yves Saint Laurent sale was already one of the biggest and most significant in recent memory, but this conflict added an entirely new level of tension and drama. Christie's and Bergé decided to go ahead with the auction, bronze heads included. Naturally, they became a focal point of the auction, and everyone was waiting to see what would happen when they finally came up to the block.

The auction was conducted on a gloomy, rainy night in Paris, and although I had a ticket, I regret I was not able to attend. Even with a reserved seat, I would have had to squeeze in along the side of the room because it was so densely packed with people. The bidding was off the charts. I tried to bid on a handful of items by telephone, and I could barely get a hand up, as they say. When the animal heads finally appeared, the bidding spiraled even higher. The heads eventually sold to an anonymous buyer for €28 million.

Engraving of zodiac fountain at Yuan Ming Yuan

Almost immediately, the mystery buyer revealed himself as Cai Mingchao, an adviser to China's National Treasures Fund. He issued a provocative statement: His bid was a protest, and he had no intention of paying a single euro for those heads. Instead, he believed that Christie's and Bergé had a moral obligation to return the artifacts to their country of origin.

Of course, this threw everyone into an uproar. This was the first time anyone could remember a bidder backing out of a winning bid on such a high-end item for political reasons. The Chinese government distanced itself from Cai, and though he advised a group dedicated to repatriating stolen Chinese objects, he insisted that he was acting as an individual, doing what any other patriotic citizen would do. Perhaps unsurprisingly, he appeared to have a great deal of popular support in the Chinese media. Bergé meanwhile, offered to give the heads to China, if China would "declare they are going to apply human rights, give the Tibetans back their freedom, and agree to accept the Dalai Lama on their territory."

Naturally, the People's Republic of China refused, instead issuing an official statement condemning the sale of the heads and refusing to purchase them for any price because to do so would be to tacitly acknowledge that the heads had been taken legally. Famed scholar of Chinese cultural relics Xie Chensheng summed up the Chinese position succinctly: "If your belongings are stolen, and you see them in the market the next day, you do not buy them back. You call the police."

Meanwhile, the bronze heads themselves were in limbo. Christie's would have been within its legal rights to sue Mingchao, because bids are legally understood to be binding contracts. Or Christie's could have chosen to sell the heads privately, either to the next highest bidder or to any other competing individual. Because this was such an unprecedented situation, any choice Christie's made would have serious ramifications for the global collecting community.

Into this moment of crisis stepped François Pinault, the head of Christie's and the founder of Kering Group, which encompasses many luxury brands like Gucci, Balenciaga, and in a delightful coincidence, the house of Saint Laurent. He quietly purchased the bronzes in the period between the revelation that Mingchao had no intention of fulfilling his bid and the ensuing media fracas. His actions were taken as a private citizen of France, and also as someone with a proprietary interest in the fortunes of the auction house.

By this time, the fortunes of the auction house were certainly in play. Though the Chinese government had made no endorsement of Mingchao or his tactics, they had begun leveling sanctions and assorted bureaucratic roadblocks at Christie's wherever it operated in mainland China. Christie's, as well as the other major auction houses, had long been prohibited from actually opening locations in China. Of course, with Asian buyers becoming such a force in the industry, there was more pressure every day to open a satellite office in China. It would be easier, and considerably more lucrative, to have permission to conduct auctions inside China—Christie's sales in Hong Kong, $450 million that year, indicated as much.

Pinault used the bronze heads as leverage to quietly strike a deal with China: he would return the heads, and in exchange, China would become more accommodating to Christie's, allowing them to set up an office there and perform auctions without undue interference. Of course, the heads were presented as a private gift from the Pinault family to the country of China, but it was more or less an open secret that a more businesslike exchange had been made. The Shanghai Christie's office is thriving and looks poised to expand its auctions in the near future.

My Bronze Age

Ming-era gilt bronzes, covered with a fine layer of glinting and glittering gold, have always captivated my attention. For a long time, however, I was in relatively sparse company.

China has one of the longest consistent histories of bronze work in the world. Archaic bronzes, rare and splendid as they are, have always been highly sought after. Accordingly, they command astronomical sums whenever one hits the market. I appreciate the fine craftsmanship of these ancient pieces, but I'm more interested in the later work. Ming bronzes were always valuable, to be sure, but they never commanded interest in the way porcelains could. Recently, however, this situation has changed dramatically.

Chinese collectors have their own cultural reasons for coveting these gilt bronzes. Though most of them are quite functional and quotidian—I have a large collection of bronze scholar's objects like brush pots, brush rests, and incense burners—some depict deities or holy figures from the major Chinese faiths: Daoism, Confucianism, and Buddhism. Many of these objects once belonged to temples or other hallowed sites, making them considerably more desirable to devotees of those faiths. Today's collectors will pay a lot of money to own a significant artifact that also reflects their own faith.

Religion has also boosted the trade in Nepalese bronzes, well-known for the fineness of their casting. Many of them were intended to occupy places of worship and to aid practitioners in their veneration of significant religious figures like the Buddha.

Consequently, these depictions needed to be nothing short of marvelous.

Bronze gilding was also used for more mundane subjects. Some of these objects were simply decorative, and still others can only be described as whimsical. One of my favorite gilt bronze pieces is a statue that I call the lion bronze. It was purchased many years ago at the late Christie's East. Christie's used this secondary location to auction pieces that they deemed less significant or less likely to fetch high prices. Accordingly, a prudent auction-goer frequented this house in search of deals on undervalued pieces.

My lion bronze was one such undervalued treasure. It's rather large and on its original stand with *champlevé* enamel elements. *Champlevé* is a stunningly beautiful enameling technique in which portions of the piece are scored, and the resulting depressions are filled with colorful enamel.

Much of its charm comes from the unique dynamism of the figure, a man pulling along a Chinese lion—frequently called a foo dog in the West—on a chain. When the bronze appeared at auction at Christie's East, it was improperly identified as a Japanese piece, which may have contributed to its undervaluation. An astute dealer attending the auction, however, immediately recognized the bronze's true provenance and purchased the piece. He then sold the lion to a London dealer, who sold a half interest to a dealer friend of mine by the name of Gerard Hawthorne. And that is where I entered the story.

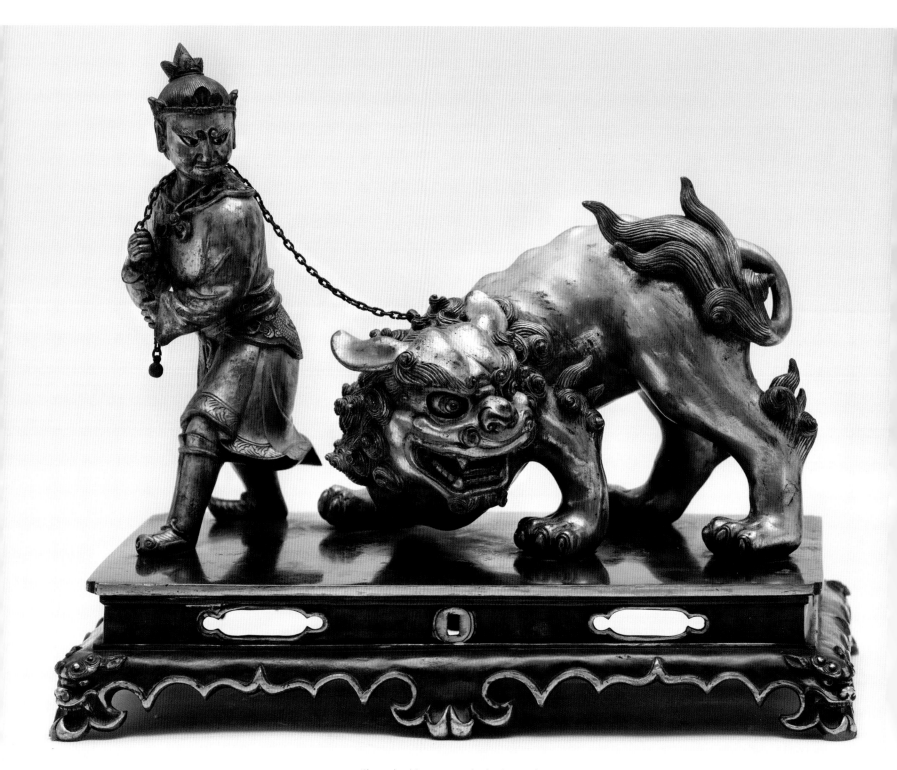

Champlevé (as seen on the back cover)

Knowing my tastes, Gerard showed me the bronze. Indeed, I did appreciate the thing; as soon as I saw it, I wanted to buy it.

He quoted me a sum that was considerably more than I was prepared to pay.

I countered, but he stood firm.

"I can't. I have a partner in this."

As it turned out, I knew his partner too, though not as well as I knew Gerard. His partner is a fascinating character named Jeremy Mason, a quintessentially British chap. He has a prodigious red beard and a love of Bob Dylan, and I've never seen him wear anything other than a rumpled three-piece tweed suit.

Mason is also a scion of an old, well-established English family and had a membership to Boodle's, perhaps the most famous of the English gentleman's clubs. It was exactly what I hoped it would be: an old world atmosphere with wood paneling, well worn leather sofas and the smell of great food and drinks. Boodle's has become a part of the British consciousness; its name is often used as shorthand for the affluent lifestyle.

I made it a point to ask Mason about the lion bronze the next time I saw him. As it happened, I ran into him at Olympia, a huge annual antiques fair held in London. I brought up the lion bronze, but I also seized the opportunity to invite myself to do something I'd always wanted to do: get a look inside one of those terribly exclusive English clubs. "Since I may buy this bronze from you," I slyly asked the dealer, "would you be willing to discuss it at Boodle's?"

The dealer, as it turned out, was more than happy to entertain my request for an invitation. Once we arrived, we got down to business.

"I really love the piece, and I really want to buy it," I said. "I'd buy it today for X. But Gerard tells me that he can't do that price because you have a half share."

The London dealer paused thoughtfully, stroking his red beard. He agreed to talk to Gerard about the deal. He was as good as his word—with his assent, Gerard was willing to sell the piece at a price much closer to what I considered reasonable. As soon as I took it home, I borrowed a page from the furniture dealers' playbook and displayed my lion bronze amid my English furniture.

With time, I've put together a large group of gilt bronzes—over 20 of them so far. Like everything I collect, only the finest pieces interest me, and I constantly rearrange and reevaluate my objects to ensure that I have room for new delights.

Maybe I like the bronzes so much because they bring me a whole new opportunity to learn. Right now, I'm really enjoying a piece depicting a *lohan* (enlightened person) or perhaps an emperor. The figure is seated, wearing a sumptuous silk robe adorned with imperial dragons (such robes were permitted only for the emperor). I was drawn initially to its exquisite casting. The extraordinarily high quality, combined with the telltale five-dragon design (five and nine are numerically symbolic of the throne), led me to suspect the piece was imperial. It is also very large, which always makes a piece that much more striking.

I actually bought it after a friend (who was considering buying it) showed it to me. It was very dirty at the time and maybe that held my friend back. I wasn't afraid of a little grime! After an expert cleaned and returned the bronze to me, I examined it in more detail. Though I initially thought it dated to the Ming Dynasty (fourteenth to seventeenth centuries), now I believe it is much older, perhaps even dating to the Yuan Dynasty (thirteenth to fourteenth centuries). I mentioned my doubts about the piece's age to the head of Christie's.

"There's been a lot of debate about the exact age of that statue," he confirmed. "Some people do think it's earlier." This admission sent tingles down my spine. It's always exciting to encounter a mystery like this. In fact, it's one of the great joys of collecting. These objects are so fascinating precisely because the deeper we dig into them, the more they have to offer.

This type of surprise is intrinsic to collecting, and it happens more often than you might think. Many years ago, I purchased a particular bronze that I've always considered myself lucky to own. I was on one of my trips to Hong Kong, and a friend who lived in Taiwan invited me to come visit her there.

Bronze lohan

"You should visit the National Palace Museum in Taipei," she said.

I jumped at the chance, of course. The National Palace Museum happens to house one of the finest collections of Chinese art in the world. After I toured the museum, my hosts were kind enough to take me to visit several private collections and a few significant dealers. One of the dealers we visited was a well-known and highly respected man named Mr. Lin.

Mr. Lin showed me around his shop, and we chatted about our mutual interests. His English is virtually nonexistent, and my Mandarin is just as limited, so he asked his shop assistant, a young girl, to serve as interpreter. Her service was necessary and important, because—as with any encounter between a collector and a dealer—there was much chatting and schmoozing to be done.

Almost immediately prior to my Taiwanese excursion, an exceptional bronze figure had come up while I was attending an auction at Christie's Hong Kong. It was one of a series, a group of eighteen *lohans*, and I was very taken with it. I wasn't the only one, however, and I watched as the bidding ratcheted higher and higher, the figure finally reaching hundreds of thousands of dollars.

So imagine my surprise when Mr. Lin showed me the second floor of his gallery where he had three more *lohans* from that set of eighteen. They were just sitting there, casual and unassuming, as though they had been waiting for me.

Gerard was there as well, and we exchanged knowing looks. We had both been following the Hong Kong sale, and we each knew without saying anything that these figures were incredibly similar to the one that had sold for that large amount. I examined the statues more closely, turning each of them gingerly. Though I remained stoically poker-faced, I nearly shivered in anticipation, eager for the thrill of discovery. Sure enough, there on the back was a long inscription indicating the date of fabrication (sixteenth century) and the location of the temple. In terms of provenance, these pieces offered everything a collector could want.

I tried not to let my excitement show, however. I simply pointed to the first figure and asked Lin: "How much is this one?"

"I'm sorry, it's been sold," he told me.

Undaunted, I pointed at the second figure, which was the one that I preferred, aesthetically speaking. "Okay, how about this one?"

Mr. Lin shook his head. "I'm sorry. It's also been sold."

Finally, I pointed at the last bronze. "What about this one?"

Lin brightened. "That one's okay," he said cheerfully.

Yes! But I still wanted to appear noncommittal as I asked about the price.

"$25,000," Lin said.

Clearly, Mr. Lin hadn't been following the Hong Kong auction scene.

I decided to push him a little but Lin stood firm, and I bought the third *lohan*.

The *lohan* is seated in a cross-legged position. It's hollow inside and there is a cutout on the bottom of the piece, so it needs a place to rest. Mr. Lin had this and the other bronzes on a rickety wooden bench. The bench was pretty unremarkable, but I could tell that it was old.

"What are you going to do with that bench?"

"Oh, that I don't want," Mr. Lin said. "You are welcome to take it."

I paid him immediately, as I always strive to do even when doing so is less than convenient. Your reputation as a customer is really only as good as your last deal, so it pays to settle up promptly.

I then had the challenge of finding the right place for the bronze in my home. I've had to move it around a few times over the years, and it never quite fit my space. A piece as exquisite as this bronze needs a dedicated place, so I built one. At this very moment, just as it will for many years to come, this bronze resides in a recessed alcove with special lighting. Though it continues to sit on the same wooden bench it occupied in Taiwan, both are now bathed in light.

As is common with really special pieces, the story of this particular bronze doesn't end with its acquisition. A few years ago a friend of mine told me that the head of the Freer and Sackler Galleries in Washington, D.C., was visiting Los Angeles. These galleries represent the Asian art collections held by the Smithsonian. The core of these collections was built on a generous donation from collector Arthur M. Sackler. This distinguished visitor and his team were very interested in my collection, and they wanted to know if I would be willing to give them a tour.

I told my friend that I would love to have them over. I always enjoy showing my collection to new people because every person experiences it differently, and hearing their varied interpretations of the pieces is always enlightening. Sometimes, someone even finds something I'd never noticed before.

In this case, the head of the Freer was particularly drawn to this bronze *lohan*. He asked, "Did you notice that he's wearing a Jesuit robe?"

I had never really paid that much attention to what the figure was wearing. As soon as he mentioned it, however, I could see that the expert was right. The traditional robe design used at the time (called *hanfu*) consisted of two parts: a skirt (called a *shang*) covered by a coat (called a *yi*), which was then tied with a sash. The Jesuit robe of that time looked quite similar in many respects, but it was of a single piece and did not have the sash. The dead giveaway, however, was the collar.

This insight was exciting. Why was this Buddhist figure, a *lohan* designed to occupy a Chinese temple, wearing a Jesuit robe? So far, no one has formulated a compelling answer, but I'm enjoying the investigation. These questions make this piece one of my personal favorites.

Buying the Jesuit bronze was a result of sheer luck. These days, with more buyers, more money, and more information freely available, luck plays a huge role in nearly every successful purchase. For example, in 2008, a medium-sized Kangxi bronze depicting a figure venerated by Buddhists came up for sale at Christie's Paris. Gilt bronzes are popular, Buddhist art is popular,

and the Kangxi period is popular; it was an obviously desirable item. The bronze depicts the Buddha Amitayus, a central figure in the Pure Land tradition of Mahayana Buddhism, historically popular in Japan, Korea, China, Vietnam, Taiwan, and Tibet. His name can be translated as "boundless light," which led to his association with longevity and eternality.

A friend in the Asian art world, James Hennessy, called me to discuss the upcoming sale in Paris, and told me that he didn't think he was going to be able to make it.

"You know," he said, "you should buy this gilt bronze. It's really superb. It's Kangxi and relatively large—almost thirteen inches. It's a real gem."

I trusted James and took him at his word. I bid on it by phone and was able to buy the piece for a reasonable sum. When I spoke with the head of Christie's after the auction, even he admitted that he thought the piece was going to go for a lot more.

I am convinced that this piece would absolutely go through the roof at auction today. Christie's knows this as well. As I write these words, Christie's is preparing a large sale, sourced from many fine collections, intended to represent the *crème de la crème* of such works. To that end, they approached me about the bronze, which I keep on display in my powder room.

"No," I told them without hesitation, "you can't have that."

"We are confident that it would do very well in our upcoming sale," one of the representatives pointed out.

"Listen," I replied, "I'm not a dealer, and I'm not looking for money right now. It does more for me to keep it than to sell it."

The representatives recognized my intransigence and moved on, and that was the end of that.

Were I to sell this piece now, I probably would double if not triple my original expenditure. People typically hold onto things for decades, sometimes for most of their lives, hoping for a return like that. Now, however, with tastes changing so quickly and with so much money floating around, a buyer can flip these pieces for massive returns in a short amount of time.

I adopt a different approach. Certainly, I am not opposed to selling parts of my collection. Yet a large part of the pleasure of this pursuit is living with the objects, just occupying the same space as them. Seven or eight years is not enough time to get to know most pieces, and it certainly hasn't been enough time for me to get to know my bronzes.

Since collecting isn't my primary business, I can afford to approach it as a pursuit of passion. It's not subject to a cost-benefit analysis, so I can allow myself to be governed by my feelings. And of course, there are myriad other rewards from collecting, none of which have anything at all to do with a balance sheet.

Collecting has been both a great education and a great joy, and as my son, Derek, grows older, I've been delighted to experience the wonder of it all over again. My daughter Jenny is a graduate of the Rhode Island School of Design and an artist, so I'm happy she can enjoy the collection on another level.

After ten or fifteen years, I often feel that I have reached the end of my time with an object. When that feeling comes, I send it back to the market for someone new to discover it, to learn about it, and to enjoy it as I have. I like to think that I'm not just making room in my home but rather that I'm giving the Dereks and Jennys of the world a chance to find and own these treasures.

Back in the Neighborhood

Throughout my career as a collector, I've been fortunate enough to meet a great many individuals with incredible collections. I'm always interested in connecting with other collectors, partially because it's nice to be able to talk with someone about mutual interests (and, in many cases, mutual friends and acquaintances) but I also relish any chance I get to take a tour of other collections. This is a common feature amongst people who love antiques and art pieces: we enjoy looking at such things, whether they are in a museum, on the auction block, in our own home, or in someone else's.

One such memorable visit, to the home of a woman I'll call "the Grand Lady," took me just around the corner from my own home.

The Grand Lady was an intelligent and cultured woman who married into a very wealthy family. I lived for a time relatively close to them, though both of our houses also had large swaths of land attached. Their house was a massive, beautiful place of the sort that has not just a name, but a foreign one at that. It was also unique, having been designed and built by the occupants themselves (though I suspect that the Grand Lady had a guiding influence in most of the design elements).

The Grand Lady was also a collector and, by all accounts, she had incredible taste. Her passion was high-end European art and furniture and she spent most of her life filling her home with amazing pieces. By the time I knew of the family, she'd had several decades to amass one of the finest collections of European art in the country; a collection so vast that even their huge,

magnificent house wasn't large enough to display everything.

I dearly wanted to get a look inside that house. Eventually I managed to broker a meeting via a mutual contact in the art world. The Lady herself was very gracious and kind and she offered to show me her collection and her home. I only really got that one look inside the place, but I've always remembered how dazzling it was. Everything was beautiful and carefully curated. Even the things that weren't to my taste were just brilliant in terms of quality. She had an incredible nose for great pieces and, over the years, she had developed very close ties to all the best dealers and auction houses.

I also appreciated the house on an architectural level. It was customized in every possible way and the Grand Lady had brought the same meticulous eye to the creation of the house as she had to her collection. It really was a singular place that absolutely reflected the tastes of the occupants.

The problem, as it so often is, was money. Complications with business holdings and inheritances, and legal issues amplified existing problems in the family. The Grand Lady's collecting quickly became a flashpoint. Her husband had never really appreciated what she was doing and, as he saw it, she was throwing money away on useless objects when they were in ever-increasing financial trouble.

Relations between the two deteriorated until, finally, divorce proceedings were initiated. Obviously the house was a huge asset and establishing ownership of the estate was going to be a big part of the settlement. Lawyers on both sides of the conflict

advised their clients to stand their ground and stay in the house to prevent the other party from claiming that their spouse had abandoned the home.

This made for an interesting living situation as one spouse staked a claim to the upstairs while the other remained downstairs. Even in a massive home, however, a divorcing couple living together is no picnic. At the same time, the Grand Lady was forced to sell off large portions of her collections to cover the legal fees and other bills.

She sold it in bits and pieces, using an astute advisor to find the best buyers and get excellent returns on her purchases. Over the weeks and months of her protracted sale, something incredible happened: Her husband began to prick up his ears. He watched as things he thought of as the useless indulgence of a woman with too much money and time on her hands sold for incredible sums of money. To him, these were simply furniture and knickknacks. Perhaps they were prettier or older than others but essentially of the same character. To the collectors who purchased these things, though, they were treasures.

For the first time, he began to see what his wife had been doing all these years. He was a businessman, first and foremost. He did not have an eye for art or antiques. What he did understand was investments and it now seemed clear to him that his wife had been making very good investments.

It takes a big man to reverse his opinion (especially when that opinion was particularly vehemently expressed) but the Grand Lady's husband eventually had to admit that he had been wrong. His wife had not been throwing their money away; instead she had been slowly growing it, in case there was ever a time just like this when they would need additional assets.

Just as it was her collecting that had, at least in part, precipitated their separation, it was her collecting that actually allowed them to reconcile. I have always loved this story because it so perfectly illustrates the divide between collectors and non-collectors, and it has nothing to do with money. The Grand Lady did not come from the kind of incredible wealth that she married

into, but she had a sensitivity and a passion that her husband, who had had money all of his life, couldn't really understand. Collecting is more than just buying things, it's a way of looking at the world. It's about looking at an object and seeing its cultural and aesthetic value, rather than just a price tag.

I actually wound up with a couple of pieces that had been a part of this famed collection. When the Grand Lady was selling her things, I of course was interested—there were many areas where our tastes overlapped. Plus, as a scrupulous buyer, I knew that virtually everything she had was of very high quality.

But I didn't actually purchase anything directly from the estate. Instead, it was years later, when I was drawn to a Regency-era black lacquer cabinet in an auction catalogue. I have a particular fondness for the "japanned" furniture from Western Europe because it fits so smoothly into the rest of my collection: European furniture with Asian grace notes.

In this case, the construction of the cabinet reminded me of Chippendale, which I always love, while the beautiful black lacquer gave it something a little unusual. I thought of it as a "Chinese Chippendale." It also had these interesting little doors on the front, done in *pietra dura*, a type of stonework where the stones are cut and shaped and fitted together to form a mosaic. The work can be incredibly detailed to the point where the work is nearly indistinguishable from a painting.

I love delicate artisan work like this as well as the unexpected mix of elements. It was a beautiful mélange of styles and techniques and it was very much to my taste. I quickly decided that I would like to get a better look at it, as I had been looking for a piece like it for my living room.

The only problem was that the auction was in New York and I needed to remain in Los Angeles. As much as I liked the little cabinet, I wasn't about to buy it sight unseen. I wanted a trusted expert to lay hands on it.

I was in luck, because my dealer friend Richard Coles was heading to the New York auction, hoping to find some unique

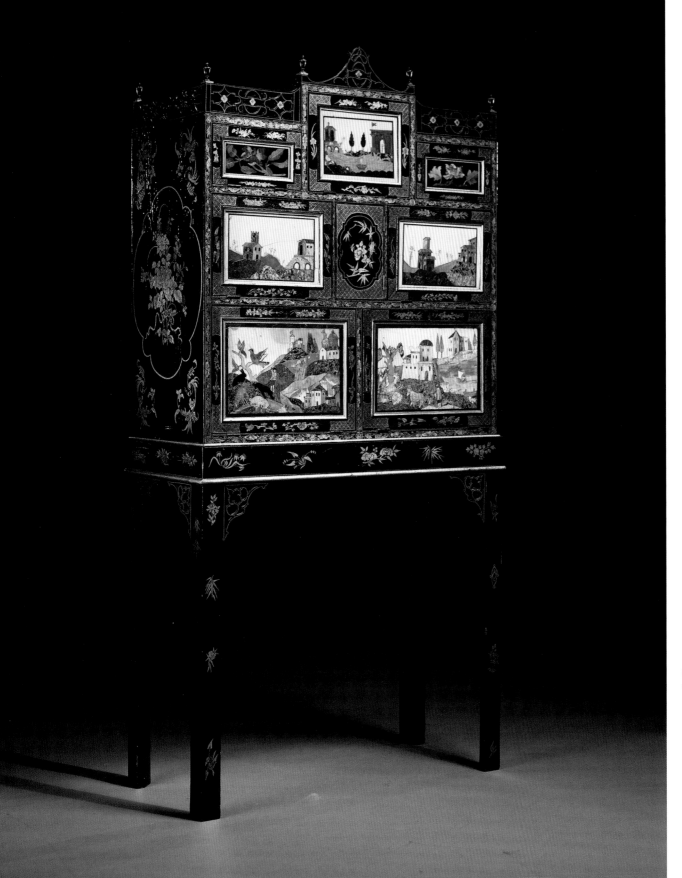

Regency black lacquer
"japanned" cabinet

items that he could sell in his London shop. I asked him if he could do me a favor and check out the cabinet for me and give me his thoughts on it.

As a dealer, Richard has a different method of examining objects than I do as a collector, and there's also the issue of separate tastes. Generally, however, if Richard okays a piece, I'll buy it and pay him a commission for looking at it, advising me, and restoring the piece. In this case, it was immediately clear that the cabinet was in near-pristine condition and would not require any of Richard's restoration services. So he was appraising it simply as a favor to a good friend (and client), which I appreciated.

He examined the cabinet thoroughly, taking it from its stand and looking at it from every angle. When he reported his findings to me, I could tell that he wasn't very excited by the piece.

"It's … curious," he told me. "The *pietra dura* panels open up; they're actually the doors to a smaller cubby hole which has a lock …" He went on about the hinges, which he apparently had trouble with, but for me such details were secondary. I was most concerned with the design and decorative value, not construction issues like hinge placement. As a furniture dealer, though, Richard naturally had a different perspective.

"I'm not so sure about it," he pronounced finally. It surprised me, even though his tone had been less than impressed. I thought the cabinet was a strong enough piece that he would recommend buying it, even if it did have a couple of unusual features that gave him pause.

"I'm surprised you don't like it," I admitted. These types of situations don't come up very often. Usually when I ask someone to check into an item for me, they wind up confirming my initial instincts.

"I do like it," I told Richard, "and I'm going to go for it." At this point, it was simply a judgment call. I had heard Richard's reasoning for his pass on the cabinet and, to me, it didn't outweigh all of the things I liked about it. So, in this instance, I chose to go with my first instinct.

I'll admit, though, that Richard had planted a seed of doubt. I wished that I were there and able to examine the piece for myself to confirm my feelings. So I did the next best thing: I got a second opinion.

Will Stafford, of Christie's, was also in attendance at the auction and he was familiar with the cabinet. "Are you buying it?" he asked, when I got him on the phone.

"I am. Would you be willing to take a look at it, though, and tell me what you think of it?"

"Sure," Will said, "I'd be happy to."

He went off to find the cabinet and when he reported back to me later, I could tell immediately that he was more excited than Richard was. "I think it's wonderful," he said. "Frankly, if it was in a Christie's sale, we would have started it much higher than this. I'd love to have something like that in one of our sales."

Bolstered by his effusive words, I purchased the cabinet and brought it back to Los Angeles. It was only then that I found out that the piece had once been part of the Grand Lady's impressive furniture collection. It had been sold off along with a flurry of other items from the house and now, years later, it had returned to the neighborhood.

The cabinet fit perfectly into a corner in my living room where I'd kept a piece of Chinese furniture. To make room, I offered the Chinese piece to Christie's. After evaluating it, they decided to put it in a sale, upcoming at the time of this writing. And so the lifecycle of great art continues—new items come in and displace the old, pieces pass from owner to owner, and, occasionally, wind up exactly where they started.

Or just around the corner.

Export Silver: Where East and West Came Together

I've been collecting Chinese export silver for many years, so I've had ample time to gather a very large number of superb pieces—it is perhaps the largest such collection anywhere in the world. But the real reason my collection is so large is that these exquisite pieces have been mostly ignored by other collectors.

Chinese export silver is, as its name implies, silverwork made in China but intended specifically for the foreign market. Generally speaking, it is somewhat "younger" than many of the other objects I collect. Its youth should be unsurprising; as an industry, export silver was born out of prolonged contact with Western Europeans. The earliest examples of export silver date to the eighteenth century, when a conspicuous Western presence in China began.

In the earliest days of the silver trade, Chinese artisans focused mostly on precise recreations of European silver goods. The Europeans would furnish an example, and Chinese master craftsmen would recreate the piece down to the minutest detail. Chinese-produced silver objects were valuable primarily as a cheaper alternative to European silver goods. As time went on, however, Chinese artisans introduced more of their personal and cultural sensibilities into the objects they produced. Eventually they began to produce fascinating works that presented a wonderful mix of cultures and ideas.

These pieces are awe-inspiring. Each one was carefully planned and handcrafted by master artisans who painstakingly hammered, etched, and polished every intricate flourish. I find the designs of these objects to be their most compelling aspect.

Although these artisans were attempting to recreate the silver services of the British Empire, they included tiny touches that hinted at a richer and more complicated genesis—a bamboo handle here, a carved dragon there. These little details are what make these pieces really eye-catching and unique.

Nevertheless, these pieces faded into obscurity, which never ceases to amaze me. From the time they were made, they enjoyed more than two centuries of immense popularity and were found in the grandest estates in Western Europe. But somehow they became relegated to a historical footnote, barely warranting mention, let alone collection. In fact, most collectors had no idea that the industry even existed until 1975, when H. A. Crosby Forbes published his magisterial book about these objects, *Chinese Export Silver, 1785 to 1885*.

Since the publication of Forbes's book, interest in export silver has been steadily growing, but appreciation is nothing like some other varieties of Chinese art. I think that this bear market is likely because export silver lacks the nationalistic hook that attracts Chinese buyers to other art forms. These pieces were not a part of the Yuan Ming Yuan spoils, nor were they associated with any Chinese cultural or religious practice; the only links to Chinese history that these pieces have are colonial. They were designed to cater to the tastes of people outside of China, and many Chinese collectors do not find export objects compelling. This lack of interest results in lower prices for those of us who are interested. These pieces are simply too exquisite not to be noticed, however, and I fully expect that their prices will increase.

Until that time, I will continue buying pieces and enhancing my collection.

After my initial discovery of these items, I resolved to find all the export silver that I could on subsequent trips to London. To my surprise, there was just one dealer who specialized in these treasures: Brian Beet. Brian passed away at an early age a few years ago, but he was the source of my education in Chinese export silver.

Brian was a devoted, bookish man whose depth of knowledge was unparalleled. He found me many treasures—splendid, exquisite pieces of silver. When he died, I purchased a good deal of his personal collection at auction. One of the pieces I purchased was the cutlery from a silver service. Most of the knife blades, being made of steel and therefore perishable, needed to be replaced, but the bulk of it was in fine shape. To this day, when I host a dinner party, my guests use Brian's silver.

Fine silver suites never fail to recall a lifestyle that is virtually nonexistent in the modern world. These pieces, perhaps originally at home in a manor house in the English countryside, speak in the vernacular of opulence, luxury, aristocracy, and leisure. I like to think that, by bringing some of these beautiful items into my home, I am bringing some of that lifestyle to my home as well.

In fact, every piece of furniture in my dining room (except the dining table) was produced in eighteenth-century England—Chinese export silver lends an air of authenticity because it was designed to adorn that furniture. But more than that, export silver always offers a little something extra, if one looks closely enough.

One of my favorite examples of export silver is an *epergne* I recently acquired. Usually, *epergnes* consist of a number of small bowls or saucers orbiting a larger bowl, meant to be the centerpiece of a table. They can be constructed from almost any material, but silver was particularly popular. People frequently use them to display desserts, fruits, or flowers. The word *epergne* comes from the French verb *épargner*, meaning "to save." Because these objects were designed to make food centrally available to everyone around the table, an *epergne* thus "saved" those dining

around the table the task of passing multiple dishes among themselves. Most of these pieces are quite hefty, and my *epergne* is no different; it weighs about 139 ounces, or roughly nine pounds. It also has six smaller display dishes, all decorated with grape leaves, a very typical motif for European silver. I believe this flourish was probably intended to reference Greco-Roman art.

According to an inscription on the central bowl's belly, my *epergne* was actually commissioned as a horseracing prize. The inscription reads: "Hankow Spring Meeting, 1870 champion stakes, won by Mr. Williams. Usury, ridden by R.W.W." So this piece is essentially a very fine, and highly valuable, trophy! For a collector, this type of inscription is as invaluable as it is incontestable: we know exactly who made this piece, where they made this piece, and why they made this piece. It's incredibly rare to have so much information about any given object, and even rarer for it to convey its own provenance!

However, this item is also interesting for the lies that it tells. Like many examples of export silver, my *epergne* is accompanied by a pseudo-hallmark. In England, silverwork was a tightly regulated craft, overseen by various guilds and trade unions. Each of these guildhalls or trade-houses impressed their pieces with their own "hallmark." These hallmarks achieved three related goals: first, they were a mark of authenticity and a guarantee of quality. Houses jealously guarded their reputations using the strictly controlled hallmark system. Second, silversmiths stamped certain marks on their work when it met a predetermined purity standard. Finally, artisans would mark the date and often the region or even, occasionally, the city where a given piece was produced.

In the earliest years of the export silver trade, European merchants would often bring examples from Europe for Chinese artisans to duplicate. The Chinese artisans saw the hallmarks, but of course they had no idea what they meant, nor any inkling of the information they conveyed. They simply assumed that those marks were a part of a piece's design. So, when duplicating the archetype, Chinese silversmiths would also duplicate the item's hallmark. Frequently, however, these insignia are just a little bit off. They approximated symbols like the Lion Passant—a mark

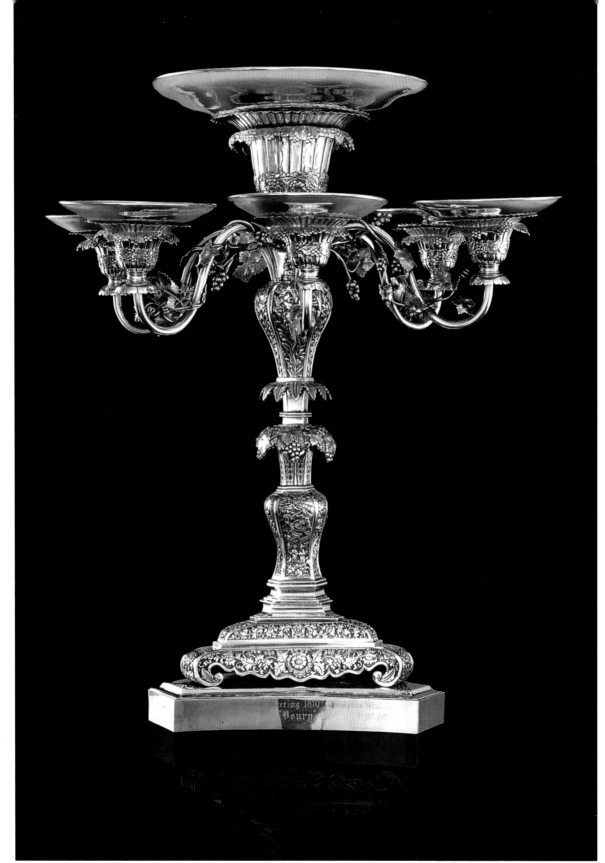

Chinese export
silver epergne

indicating that the piece met the standard for "Britannia Purity," or a silver of 95.84 percent purity—and the thistle, which marked Scottish silver. The Chinese artisans regularly mangled lettering with all manner of curious alterations. For some export silver, especially the earlier pieces, these pseudo-hallmarks are one of the few ways collectors can readily tell the difference between a European example and its Chinese copy. In the case of my *epergne,* the mark is an example of the Chinese copying the European design down to the smallest detail.

Just as British silversmiths developed their hallmarks, Chinese silversmiths of renown eventually began putting their own marks on the pieces they produced. Today, collectors can have a reasonably good sense of which artisans worked on which pieces, and they can track their work thanks to this practice. These marks can serve as benchmarks of quality, indicating which pieces are the best executed, and therefore the most interesting. In the Chinese practice, these marks were called chopmarks, or simply chops. A claret jug in my collection features an L mark, indicating that it was produced by Leeching, an early and very skilled silversmith.

Despite these marks, however, considerable mystery persists about the identity and personality of these silversmiths—including the famous Leeching. He worked in Hong Kong from roughly 1840 to 1880. Beyond that location and those dates, however, very little is known about him—if, indeed, Leeching was even a "him"!

In China at the time, selling wares using a trade name was very common. Sometimes these trade names were not even proper names at all, but an abstract concept or aphorism, usually designed to elicit good fortune. Leeching was almost certainly not the artisan's birth name, and in all probability, Leeching wasn't even a single person.

As often as not, these trade names stood for the assembly line of a whole shop. Many diversified craftsmen could be employed at a single firm, and multiple people could serve in various capacities, each contributing something to the production of a piece. Nevertheless, the sum of their collected handiwork would bear the name Leeching. Indeed, a Western visitor to the shop would address the person behind the counter as Leeching, no matter who that person actually was. Thus, we have no way of knowing for sure exactly who made these beautiful pieces.

But this communal approach to production does not impugn the quality of the pieces that it produced. The claret jug is most certainly beautiful. It's a faithful copy of the work of a specific English silver producer, and it is unique in that no other colonial examples of this style of claret vessel have yet been discovered. Like many export silver objects, it is large and heavy—fifteen inches tall and weighing forty-one ounces. It can accommodate a full two liters of wine. My favorite feature of the jug, however, is the handle, which replicates gleaming bamboo. It's that little detail that really sells the jug to me. Though this vessel is otherwise a perfect copy of an English item, this small detail belies its origins.

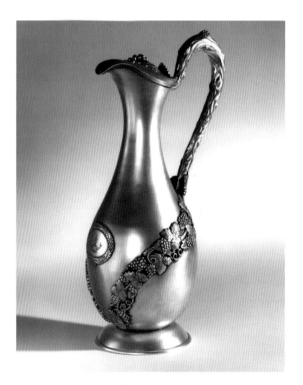

Silver claret jug

It proudly bears the crest of the Millers, a Scottish family from Glenleigh, a clenched fist raising two fingers surrounded by the words *Manent Optima Coelo*—"The Best Things Await Us in Heaven."

When I won the claret jug at auction, researchers determined that only one member of the family had been abroad at the right time to have commissioned or received such a piece: James Miller. James, however, was not in China. He received his commission into the colonial forces in India in 1855, and this claret jug very likely was a gift from a friend or relative on the occasion of his marriage in 1871. It was very probably imported by Anglo-Indian retailers in Bombay, where there was a brisk business in imported silver from China.

You can compare this claret vessel with the work of William Edwards or Walsh and Sons, both famous British silversmithing firms working at around the same time, and the export piece would blend in almost seamlessly. Upon closer inspection, however, you can actually see where the Chinese piece has been subtly adapted and changed by the artisan.

In general, I favor earlier export silver. I once purchased a remarkable silver champagne cooler that includes all the design features that attracted me to Chinese export silver in the first place. It is amazingly filigreed, featuring a fine silver mesh overlaid on an enameled body, and includes a number of distinctly Chinese decorative elements such as phoenixes and pagodas. The enamel is richly colored in greens, blues, and yellows, and it depicts a sumptuous and magnificent landscape design. Best of all, the hallmark indicates that the famous Chinese silversmithing firm WE WE WC was responsible for its creation.

WE WE WC was most active at the same time as Leeching (1820 to 1880), and were perhaps the most advanced Chinese silversmiths working at the time. The WE WE WC hallmark more than likely descends from the very similar hallmark of the extremely well-regarded British silver firm William Eley, William Fearn, and William Chawner. The Chinese artisan probably mistook the F of Fearn and rendered it as an E. An Eley, Fearn, and Chawner hallmark would have been incredibly desirable, and a Chinese silversmith would certainly have been aware of that prestige. Maybe this unknown artisan first copied the hallmark for purposes of accuracy, or perhaps he simply wanted to enhance the profile of his products or pass them off as those of a fashionable English firm, thereby enhancing the value of his own work. Whatever the case, the mark quickly became associated with some of the finest Chinese export silver.

The champagne cooler was produced relatively early in WE WE WC's production history, probably around 1820. It's an object without peer—a true original! Though I purchased it at auction for a very reasonable price, this piece has likely shot up in value more than the other examples of export silver in my collection. The renowned silversmith, the clearly Chinese imagery, and the high quality of the silver are beginning to interest many Chinese collectors.

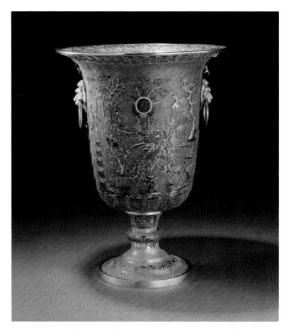

Enamel silver champievé champagne cooler

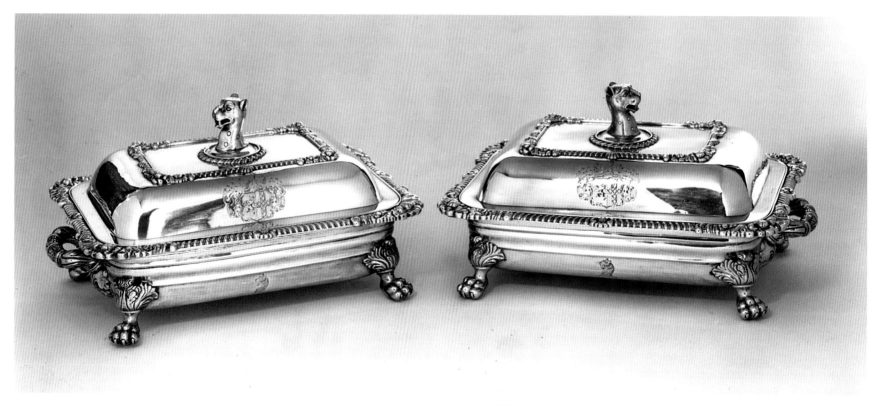

Rare vegetable dishes with maker's mark "L" for Leeching

Not too long ago, finding exquisite examples of export silver was as simple as taking an early morning stroll. Whenever I was in London, I found many wonderful pieces simply by walking up and down Portobello Road on Saturday mornings. You can find just about anything there. Like the Drouot in Paris, it's a jumble, so those who come regularly and have a discerning eye can be richly rewarded.

I used to get there early, around seven in the morning, before the other shoppers. But rarely did I arrive before my friend Gerard. He had a penchant for getting out on the street by 5:00 a.m. His dedication certainly paid off; eventually, he retired on the profits from selling objects he purchased literally for pennies. Thankfully, he wasn't interested in export silver, leaving that haul to me. He was on the hunt for overlooked Chinese imperial objects. He had a well-trained and discriminating eye, and he knew all the marks and indicators of great quality. He

was often able to spot something a hundred people would have walked right by.

Once, I was out to dinner with Gerard and his wife at a fashionable restaurant in London. I noticed he was carrying a small bag. He often showed up with whatever he had just found, so I asked him what he had in the bag. He pulled out a tiny ivory book, perhaps four inches tall, with a four-character imperial mark on the cover. He had known immediately what he was looking at when he saw this book, but luckily for him, the dealer hadn't.

"Gerard," the woman had said, "here's a Chinese thing for you."

Gerard opened the tiny book to reveal minuscule paintings. Page after page of pastoral and wilderness scenes unfolded. It was truly delightful, and I was enchanted.

This was another one of those slightly awkward situations

that comes when you mix business and pleasure. I wasn't entirely certain if Gerard and I were simply two aficionados sharing an appreciation for this new, fine item, or if Gerard was attempting to sell me something, dealer to client. If there were even an outside chance he would sell this marvelous piece, however, I wanted it!

"Is this available?" I asked him. "Will you sell it to me?"

Gerard has sold me many excellent things over the years, but alas, this ivory book wasn't one of them. I certainly can't blame him for keeping it; he knew its value and he knew he could sell it for much, much more at auction—which he did. Eventually this book sold for hundreds of thousands of dollars.

Gerard's success in selling the ivory book demonstrates that prudence and patience while combing through a jumble of items can yield great rewards. I adopted the very same practice, but I was focused on silver. I stalked all the dealers and all the vendors, asking them for Chinese export silver.

Once I was met with a most welcome greeting:

"I have something for you, Robert," the dealer said. "I think it might interest you."

He smiled as he produced an incredibly rare silver-mounted tortoiseshell desk set. I had never seen its like before, and I've never seen another one since. Desk sets were a popular and indispensable part of any professional office suite. Usually these pieces were composed of one or more inkwells, a pen box, and a caster for spreading the sand used to make seal marks.

This set in particular dated to about 1830, making it a very early example. One of the set's three silver pots is hallmarked LEO, a rare silversmith. The tiny, incredibly precise details are striking and the set's beauty is enhanced by floral designs, painstakingly carved into each tortoiseshell. The silver that adorns these shells both protects them and adds to the breathtaking beauty of the set. The price the seller sought was higher than I would have liked, but I knew that I would never see anything like it again. And indeed, I have not.

The most compelling pieces of Chinese and English art were forged from the collision of these two cultures. Export pieces are neither wholly Chinese nor wholly English; they bear elements of each and reveal fascinating details about how these two empires interacted with one another. I can think of no other type of art that so powerfully speaks to such a unique historical circumstance, or that so forcefully argues for the importance of aesthetic plurality. That's a large part of why I adore these objects the way I do. When two very different things are blended together, they often produce something entirely new and startlingly lovely.

Export silver provides an appropriate pivot point to my other great passion, English and Continental art and furniture. The next part of the book features the portion of my collection that hails from Western Europe.

ADVENTURES IN EUROPEAN ART AND FURNITURE

A Million-Dollar Birthday Present

Maastricht is a small town in the Netherlands near the border with Belgium, and it hosts *the* premiere fair for antiquities and art. Called the European Fine Art Fair, and known as TEFAF, this ten-day event occurs in March. Every serious and affluent art collector in the world attends this fair. On opening day there are more private jets in Maastricht than anywhere else in the world.

One early March day a few years ago, my friend Geoff Palmer, who owns a Boeing 727, phoned me and said, "I'm going to Maastricht, and I'm taking Michael Govan." Michael Govan is the director of the Los Angeles County Museum of Art. "Do you want to come?"

"When are we going?" I replied

"Next week."

Geoff, Michael, and I arrived at the fair on opening day. The venue was gigantic—several hundred dealers with several thousand works of art—and attended by many thousands. I had attended TEFAF once before with my wife, and my excitement to pursue great objects remained overwhelming. This time, Geoff, Michael, and I split off hunting in three separate directions.

I ran first to a friend of mine, a dealer of Chinese art from Hong Kong, and then ventured over to some of the furniture dealers. Then I just wandered around while talking to Geoff and Michael via cell phone. It was impossible to find anybody in that vast crowd!

I met up with Geoff, who had found some superb Picasso prints. Then we ran into Michael, who told us he had just bought a fabulous triptych for the museum from Emmanuel Moretti, a famous antiques dealer. I said that I would love to see it, so Michael led us to Moretti's booth.

As soon as we arrived, I saw a round, 800-pound, 106-centimeter, white Carrera marble sculpture of the Roman goddess Charity. It was staggeringly beautiful. At first blush, because of its high quality and artistic mastery, my guess was that the piece was Renaissance. Because I collect blanc de Chine, my eyes are trained to look at sculptures, but I was completely overtaken by this marble beauty. Any attempt to articulate here the thrill I felt wouldn't do that moment justice. The piece absolutely took my breath away.

In that moment, it crossed my mind that my birthday, March 29, was approaching; I entertained the idea of treating myself to this sculpture as a birthday present.

As usual, the first question I asked myself was, "What's wrong with it?" Nothing can be as perfect as it seems at first glance. So I reached out to Moretti: "Emmanuel, tell me the story of this piece."

He said, "What do you think the age of it is?"

"Well, it looks Renaissance," I replied.

He nodded. "I know," he said. "But it's not. It's from the eighteenth century."

White Carrera marble sculpture of the Roman goddess of Charity
(as seen on the front cover)

He showed me the signature and the date on the bottom: *Laurent Gérard, 1772*. Then Moretti began to dissect it for me. The piece was almost 42 inches in diameter. It came with a documented provenance stretching back to 1917 in Italy.

I couldn't shake my trance. I'd never seen anything like it.

I turned to Geoff and said, "Am I crazy, or is this one of the greatest things I've ever seen?"

Geoff, who collects sculptures, said, "Yes. It's beautiful."

So I said to Moretti, "I'd like to buy this."

"All right," said Moretti.

"How much is it?" I asked, hoping it was a figure I could justify to myself. I knew a great piece like this would not be inexpensive.

Moretti said, "We're asking $1.4 million."

That was much more than I was willing to spend!

We continued to discuss the piece nevertheless. The longer I talked to Emmanuel, the better I got to know him. When you talk to people face to face, as opposed to communicating by e-mail or text messages, your ears become trained to a person's words and can tell which ones are true. Emmanuel told me that he couldn't negotiate the piece down past a million dollars because it belonged to his father, who owned it with a few other dealers. He said, "That's as far as he'll go."

I said, "So if I tell you I'll take it and pay you a million dollars, we have a deal?"

He said, "Yes."

"You can make that happen?"

"Yes."

A million dollars. It was their magic number. At that price, they felt that they could make enough of a profit that they could say to themselves, "This is a treasure, and we've owned it for long enough, and we're ready to pass it on." The sculpture was one of those showstoppers that a dealer saves to bring to a giant show like Maastricht to draw people into the booth, with little hope of actually selling it. Every dealer waits for the show at Maastricht to flaunt his very best pieces, so if a dealer wants to sell a gem, he's not going to let it go for lower than his asking price. If the piece sells, that's great. But if it doesn't, he's happy to keep it.

I left the sculpture knowing that I was taking a chance, that it might be gone by the next morning, and I mulled over the decision for the rest of the day. Basically, I had to talk myself into spending a million dollars.

"I'm at a stage in my life where I can afford this," I said to myself. "I've been collecting art for thirty years, and this would be an incredible treat for my birthday." I asked myself whether I would rather use the money to buy another piece of property or to secure this treasure that I would live with in my home. "If I don't buy this now, I may never be able to set my eyes on it again." I had to make a decision, and I had to make it fast. Rare objects don't stay on the market very long.

I slept on it. The next morning I ate breakfast with Michael, and said, "Michael, I'm going to buy that thing. I've made up my mind."

Luckily, when I arrived at Moretti's booth, the sculpture was still there. In Yiddish, this purchase was *bashert*—meant to be. At the booth I saw a painting of the triptych that Michael had just purchased for LACMA. It was a preparatory painting that laid out what the triptych would look like before it was made. I asked whether the museum had purchased the painting alongside the triptych, and Moretti said, "No, but they'd love to have it."

I said, "All right, I'll tell you what. I'll make one offer. One time only. Today. This moment, and that's it. One million dollars. But you give this painting to the museum." It was a small painting priced at a meager $17,000.

Moretti agreed.

As soon as we made the deal, a few people from the Rijksmuseum in Amsterdam came to the booth and asked to buy the sculpture. The director of the museum was retiring and they

wanted to gift it to him for the museum. Moretti said, "I'm sorry. It's sold."

Moretti didn't know me from Adam, but because I had shown up with the director of LACMA the day before, he associated me with the kind of people who can make seven-figure verbal agreements to buy art. So I bought the glorious piece, shipped it home, and hung it in my house.

A year later, the Louvre asked to borrow the sculpture for an exhibition of imitative eighteenth-century art, primarily sculptures, that meant to replicate Renaissance styles. They said that my sculpture would be the highlight of the show, that they would pay for all the shipping and handling, and they gave me a few papers to sign. But I wasn't too keen on the idea. I'd come to love this piece so much that I couldn't bear the possibility of anything happening to it. I know they ship art all the time, but this sculpture weighs eight hundred pounds. If something were to happen to it, I would get my money back, but even that promise wasn't worth it. I simply couldn't take the chance that something might happen to it. I wasn't ready to live without my sculpture.

People tried to convince me to loan out the piece. They reckoned, rightly, that having the Louvre exhibition listed in its provenance would add great value. But I figured that if or when I sold the piece, the Louvre would more than likely buy it. In the meantime, I admire it in my home every day.

The sculpture is a rare treasure, and I'm relieved I didn't hesitate a moment longer before biting the bullet and buying it! I don't spend a million dollars on myself for every birthday. But I'm glad I did it for that one.

A Love for Lacquer

Lacquer is a passion of mine, and lacquer furniture in particular blends my love of Asian and Asian-influenced art with my strong affinity for English furniture. But I love lacquer on its own merits. I admire the richness of its colors, particularly scarlet, and its smoothness. To enjoy lacquer is to have a full sensory experience.

I made my first major lacquer purchase in Hong Kong many years ago. I was in town for Asia Week and attended a gallery opening, where I discovered a little *guri* lacquer box. *Guri* is a Japanese name for a Chinese art technique that involves layering different colored lacquers upon one another and then carving designs into the collected surface. It produces intricate, colorful work that is instantly captivating.

At the time, I was just learning my way around the art form. Lacquer has much in common with jade carving, another deceptively simple artistic technique that has hidden depths. Lacquer is very earthy. It is, in fact, the product of a tree, a resin that comes from what is commonly called the lacquer tree. Another variety is derived from the excretions of certain insects. So much goes into the creation of a lacquered object, and the manufacture of these pieces encompasses a history that goes far beyond the provenance of a given item.

It is very difficult to develop an eye for quality work. You must train yourself to find the best amid a field of impressive examples. You might look at a hundred—or a thousand—pieces of lacquer work before you develop a real sense of what makes one truly valuable. It is not unlike learning to ski. You begin on the bunny hills and then, before you know it, you are schussing down a mountainside. The key is to go out and do it as often as you can.

As my ability to recognize quality lacquer pieces grew, so did my affinity, and I developed a stronger, more detailed sense of the type of pieces I wanted to own. The English-made bureau cabinet, essentially a bookcase-like cupboard perched atop slender legs, was particularly appealing to me. I wanted a lacquer version not just because there are many beautiful examples, but also because it would fill a specific void in my home's decor.

I searched many years for just the right bureau cabinet. During that time, many came to market, but none of them gave me that immediate, electric sense of "rightness." I was looking for the best of the best, and for a long time, the items that I was seeing at auction just weren't up to snuff.

While I was longing for the perfect lacquer cabinet, the High Museum of Art in Atlanta had a piece of furniture that was rapidly becoming more of a burden than an asset. Museums continually walk a fine line between maintaining an attractive collection and having enough money to purchase new items. It is a choice between tradition and dynamism, between old familiars and new attractions, and it's a difficult balance to maintain. Museums are constantly reevaluating their collections and determining what can be jettisoned, and occasionally they make a bad decision—like selling off treasures to buy contemporary paintings. The High Art Museum was about to make just such a misstep.

I subscribe to a number of newsletters and circulars about upcoming auctions. This is yet another way of keeping my ear to the ground and getting a sense of what's available on the market. One periodical, the *Antique Gazette* from England, had a very small note, a blip really, about an English lacquer cabinet that had recently been auctioned off. Accompanying the notice was a tiny, grainy picture. Despite the picture's lack of clarity, I immediately recognized the cabinet for what it was.

The blurb explained that the cabinet had been sent from Atlanta to a small auction house in Chicago. Both the museum and the auction house had dated it to the nineteenth century, and mainly because of this, they had tagged it with a very low estimate. Just looking at the picture, I knew it was datable to the eighteenth century, and thus far more valuable.

Indeed, it had sold for a not-insignificant sum of money to, as the blurb stated, "an anonymous London dealer." The collecting community is smaller than it seems, however, and when I compared the item to the interests of the people I knew in the English trade, there was only one person I knew of who would have been drawn to such a thing: my friend Richard Coles.

Richard is as fine an English furniture dealer as any I have ever known. He has a great depth of knowledge, having trained at university as a restorer, but he also has years and years of hands-on experience. More than that, though, Richard is tenacious and dedicated. It was those very characteristics that allowed him to snap up the lacquer cabinet in the first place.

Dealers spend even more time combing the online and paper listings for auctions than collectors do. Richard happened to spot the cabinet during one of these searches, knew he had to see it in person, and took the next available flight to Chicago to personally inspect it. In the flesh, it was clear that this was a high-value piece and something Richard had to have. Committed to getting the cabinet, he grabbed a hotel room for the night and stayed in Chicago to bid on the piece.

While Richard was booking last-minute flights and hotels, the rest of the trade was putting forth considerably less effort. Many other dealers have runners comb the listings for them. The runners didn't have Richard's keen eye, which, combined with the low estimate and the incorrect dating, meant that most dealers were getting a lukewarm assessment of the cabinet.

Instead of personally inspecting the item, the other dealers sent these runners to Chicago with a bid limit. By representing himself, Richard maintained flexibility—if he found the piece really compelling, he could commit more money to it on the fly. Richard paid a hefty sum for the cabinet, but it could have fetched much, much more if his colleagues had done their homework.

I called Richard as soon as I read the description of the cabinet, determined to add it to my own collection. I could barely get through the customary pleasantries before inquiring about the piece.

"So, you bought the scarlet bureau cabinet in Chicago, at Leslie Hindman?" I asked him, all in a rush. There was silence on the other end of the phone for nearly a minute. As small as the antiques community is, Richard still hadn't expected to be "outed" as the mystery London buyer.

"Well, uh, you know, uh …"

"Richard, don't deny it."

"Well, Robert, well, well, uh, yes. I bought it. How did you know?"

"I know you," I said simply. "Remember that great cabinet I bought from you? I know how much you love lacquer furniture."

Now that we had established his ownership of the cabinet, I had to somehow convince him to sell it to me.

"You know I've been looking for a red lacquer cabinet," I pointed out. Lacquer cabinets also come in black, blue, and green, but I find the scarlet specimens the most appealing. Coincidentally, they are also some of the rarest.

"Well …" Richard said slowly. He could obviously tell what was coming.

"So I have first dibs on this." I knew better than to phrase it as a question. I didn't want to give Richard any room to wriggle away.

Richard was quiet on the phone, clearly reluctant. "Well, you know, I, I want to take it to the fair."

The fair he was referring to is called Masterpiece, which is held every June in London. It is undoubtedly one of the largest and most important auction fairs, especially for people like Richard who are in the English trade. It's also a delightful experience with fine food and gorgeous flowers everywhere. Dealers and collectors dress up and stroll through the venue, examining treasures of every variety.

It didn't surprise me one bit that Richard was planning to take the cabinet to Masterpiece. Even more than a potentially huge profit, Masterpiece is the chance for dealers and auction houses to impress their colleagues, friends, and rivals. Everyone wants to bring that one amazing piece that people leave talking about.

"Richard, I don't mind if you take it to Masterpiece," I assured him, "but I am buying it."

I could tell that Richard was still dragging his feet, so I guilted him a bit. "I'm your best client, Richard. I buy so much from you. How long have we been friends?"

"I have to have it," I added, after several more moments of silence.

On the other end of the phone, Richard sighed, and I knew that I had him. "Well, it's not going to be cheap," he cautioned.

"It shouldn't be cheap. I don't expect it to be cheap; it deserves to be expensive."

The cabinet had been passed around among various people who were ignorant of its true value for a long time, but I knew exactly how special it was, and I was willing to pay the price for that level of quality and character.

I knew how much Richard had paid for the piece in Chicago, and from that figure I was able to make a ballpark estimate of what his asking price would be. Part of the reason I was able to convince Richard to sell directly to me rather than taking it to auction was the track record I had established with him over the years. He knew me as someone who pays his bills promptly and fully. Any dealer who sells to me knows he isn't going to get cheated. Nor will I ever commit to buying something and then try to re-trade or renegotiate. Trying to carve an extra hundred or even fifty thousand off a sale already made is gauche, as well

as being a bad business practice. Either way, it is unlikely to win you many friends.

As it turns out, the cabinet did turn some pretty high-profile heads at the fair. The designer Valentino came in with his entourage and tried to buy the piece while it was being prepared for shipping. He was informed that the cabinet was already sold. Valentino asked Richard to name any price, and to his credit, Richard stuck to the deal he had made with me.

"Everything's available for a price," the designer pressed. But Richard stood firm.

"I'm sorry, it's been sold to a very good client and friend, and I'm certain he doesn't want to sell it. Thank you very much for appreciating the cabinet."

This story goes to show how appealing the piece really was, and what a stroke of luck it was to have caught it. As we investigated the cabinet more thoroughly, it turned out I was even luckier than I'd imagined.

As I'd suspected, both the museum and the Chicago auction house had misdated the piece. Richard later discovered another cabinet that was virtually a twin to the one I now called my own. It had been created as part of a suite of furniture for Erddig Castle in North Wales by John Belchier. Belchier was a major player in Queen Anne furniture, an English style produced between about 1720 and 1760. He was particularly well-known for producing a series of cabinets using a technique called "japanning," which referred to using a combination of oil and plaster to imitate lacquer in both the Chinese and Japanese styles.

The Welsh cabinet dates to around 1720 and is now housed in Great Britain's National Trust. Once again, Richard went the extra mile to personally examine this new discovery he had made. He traveled to the National Trust, where they graciously allowed him to inspect the cabinet. After making a meticulous study, Richard was certain it had been crafted by the same hand that had made my new cabinet. Richard actually discovered a small stamp reading "RF" on the upper surface of the bureau, the mark of the cabinetmaker, applied to the piece in the same way an artist might sign a painting. My cabinet bore an identical mark.

The new cabinet was precious indeed, then. John Belchier is a huge name in Queen Anne-era japanned furniture, and he is particularly famous for his cabinets. Plus, he rarely worked in scarlet, so to find a red example of his work was doubly impressive.

Of course, the cabinet wasn't perfect. Richard commissioned a variety of specialized craftsmen who took roughly a year to restore the piece to its eighteenth-century glory. It needed cleaning to allow the original clarity and color to show, and some of the gilt had to be fixed. New velvet was added to the interior of the cabinet and the brass fixtures cleaned and polished. The feet were replaced (because cabinets like these often stood directly on a stone floor, the feet are often degraded), but the piece is entirely original otherwise. We were even able to keep the original glass, dating from the early 1700s.

On a personal level, the piece is a triumph because it represents the realization of a dream I've long had. In many ways, it seems as though the cabinet was destined for me; it fits perfectly into my collection. When you enter my home, that cabinet is the first thing you see. Colorful and ornate, it commands your attention, and as the dazzle fades, you begin to see the rest of the details. The cabinet is a kind of welcome mat to my collection. Just as it opens to reveal secret treasures inside, so too does my collection open and become more enticing as it is examined.

Left: English lacquer cabinet (closed)

Opposite: English lacquer cabinet (opened)

From L.A. to the Grand Palais

"Robert."

I knew that crisp British voice immediately. I was speaking with Henry Howard Sneyd, the international head of Asian Art for Sotheby's in New York. I had established a good relationship with the auction house through my years of collecting. They had done me a number of favors over the years, and I was eager to lend any assistance they might require.

"Do you recall the painting hanging next to your piano?" Henry asked. "The one we sold you some years back?"

"Of course!" I turned to admire it. "The portrait is still hanging where you last saw it."

"Quite so, quite so," Henry said.

"Well, I have some interesting news for you," he continued. "I've just been contacted by the Old Master's department here at Sotheby's. They wanted to know whether you'd be willing to lend it to an exhibition at the Grand Palais in Paris in early 2015."

"Absolutely!" I immediately responded. "But how did this come about?"

I had never seen the painting prior to purchasing it; I'd bought it out of a catalogue! I paid $26,000, believing it to be a rather nice example of mid-eighteenth-century portraiture by Vestier, associated with the patronage of Madame de Pompadour. I bought it because I wanted a nice French painting for my living room.

"When you purchased the painting," he said, "we attributed it to Vestier. And that's what the best opinions believed at the time.

But further research has strongly indicated the responsibility of another artist."

I almost dropped the telephone.

"Who?" I implored.

"Well, Joseph Baillio has forcefully—and compellingly, might I add—argued that your painting was actually composed by Louise Élisabeth Vigée Le Brun."

Anyone interested in eighteenth-century European art will eventually come across Vigée's name. Her story is a good one: she was a court painter closely associated with Marie Antoinette. For six years, she worked at Versailles, painting the queen and her family more than thirty times. During the tumult of the Revolution she was, with good reason, considered a Royalist.

Vigée escaped from the conflagration with her daughter, fleeing to Rome, where she was admitted to the Academia di San Luca, and then to Poland, where she completed portraits of key Polish nobles, including Stanisław Augustus, the King of Poland. After that she went to Russia, where she became the official portraitist to Empress Catherine the Great. Truly an exceptional résumé.

"Do you think it's a Vigée?" I asked.

"There is no doubt in my mind," he replied in his clipped, British tone.

"Well, I would be simply thrilled to include it an exhibition of her works."

Needless to say, this news was both shocking and welcome.

Ornate portrait of Jacques-Louis-Guillaume Bouret de Vezelay by Elizabeth Vigée Le Brun

A lesser Vestier, in the space of a phone conversation, had transformed into a premier Vigée. That $26,000 painting suddenly grew to a conservative valuation of between $500,000-$600,000. But it is even more thrilling to add a human dimension to a piece. This woman, a victim of the Revolution as so many others were, had made an exceptional career move. Not only had she made herself a renowned name in the French court, she'd gone on to Russia, a bastion of absolutism in Europe, and again plied her trade in the same superlative way.

People find Vigée's story to be very compelling, but she also represents the apex of the rococo style and has long been regarded as one of the preeminent portraitists of the eighteenth century. Existing as she did in a profoundly patriarchal culture, she transcended the social conventions that bound her. She became much more than simply an exceptional woman by perfecting and redefining the post-Baroque and pre-Romantic styles. I believe this painting to be one of her finest. True, it does not depict the family of Louis XVI. Rather, the portrait presents a bourgeois Parisian gentleman named Jacques-Louis-Guillaume Bouret de Vézelay. And this makes it, for me, all the more appealing.

Bouret de Vézelay, you see, was a real estate developer on the Right Bank of Paris, and he built a number of important townhouses, some of which still stand today. He is recorded in Vigée's appointment book for 1775, so we can firmly date the painting to this moment of composition and this personage. In no small way, he is me—a land developer working in a world-class city, materially building his own legacy. Not only is it altogether appropriate that his portrait should be in my collection, it is, dare I say, a stroke of destiny. I can but hope that my buildings will withstand the vicissitudes of time as well as his have.

The Grand Palais exhibition will feature 160 premier examples of Vigée's work from throughout her career. My painting will represent her early period, and will be among the highlights as it will be presented as a recent discovery; a new attribution that will live on forever. No doubt I will be wined and dined in Paris during this show, but the real satisfaction will be in contributing to the provenance of this piece. I always knew it was highly desirable; I just didn't quite know why.

Showing this piece at an exhibition will change four things. First and perhaps foremost, it will validate my taste. I just knew that I liked the way it looked, and that I wanted it. I own a great piece of art that has been featured in Paris and New York—by request, no less! That is extremely satisfying for a collector, and the painting will get the notoriety it deserves. And if ever I decide to sell my Vigée, this provenance will help it command a king's ransom!

Second, featuring a piece in such a prestigious touring exhibition—being commissioned by the Grand Palais—will enhance and add prestige to my collection as a whole. Third, and this is perhaps the most ethereal point, I will personally appreciate this piece on a whole new level thanks to this new information. Collecting is about learning and acquiring expertise. While I don't claim to be an expert in eighteenth-century French art, I am better informed now than when I purchased the piece.

Owning art has many rewards, to be sure. But the greatest reward is the ability to share it with the world. Loaning this piece will get it out there, to give access to people without the resources to own such a painting. I collect of my own accord and according to my own impulses, but I share my collection in the hope that it inspires others.

A Chippendale Table

Nothing makes you reevaluate your life and career quite like a health scare. In 2006 I found myself at Cedars-Sinai hospital, having an unexpected surgery. During my recovery I spent a good deal of time lying immobile, which gave me a lot of time to think. Naturally, my thoughts drifted toward collecting and my future endeavors.

"What have I always wanted to do that I haven't done yet?"

One thing I had always wanted was a home that completely reflected my identity as a person and a collector. I wanted everything in my house, from furnishings to art, to be absolutely deliberate and wonderful.

Over the years, however, I hadn't really prioritized this goal, and some aspects of my home simply didn't reach my level of expectations. My brush with illness gave me a new sense of determination, and I promised myself I would make my dream home a reality.

Decorating your home entirely with collectibles and antiques presents several unique challenges. First, the scarcity of truly great items is daunting. You can't simply go to a furniture store—not even a very high-end one on Bond Street or Faubourg Saint-Honoré. You simply have to wait for the right pieces to appear on the market.

Once you start to collect significant items and build rooms around them, the range of other possible purchases becomes narrower and narrower if you are attempting a uniform aesthetic. If I want to put something decorative on my lacquer cabinet, for instance, I have to look at eighteenth-century Chinese porcelain, not twentieth-century ceramic pottery. Eventually, certain items make their way onto a list in the back of my mind of difficult-to-find "holy grail" objects that are mates to my existing furniture. It is not unlike putting together a jigsaw puzzle, except many of the pieces are missing or hidden.

The first thing I did was check in with my English dealer friend, Richard Coles, to get a feel for his topflight items.

"What are you taking to Masterpiece?" I asked him.

"Well, I don't know exactly. What you are thinking about?"

"What are the best things you're bringing?" If I wanted him to tell me about his prized pieces, I had to convince him I was his ideal buyer.

"Well," he said finally, "I have this absolutely brilliant Thomas Chippendale table. It was very much like another housed in a famous museum. And it has this fabulous marble specimen top."

"Specimen" here refers to the practice of inlaying tabletops with various types and colors of marble. Generally, the smaller pieces form a pattern, but sometimes they are laid haphazardly to create a dynamic sense of color and shape.

"It was probably made by the Antonini family of Italy," he added. In the eighteenth century, most fine marble came out of Italy from a few well-known families who had been in the trade for generations.

"FedEx me some photos," I said, excited by his description. I was still in recovery, so I had plenty of time to review potential new purchases. I wasn't about to stop with just one possibility, though. "What else do you have?"

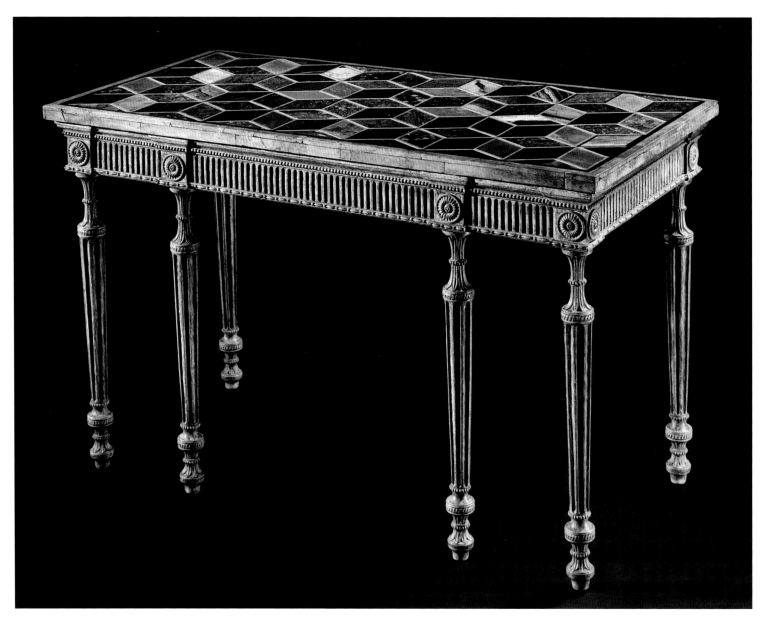

Thomas Chippendale table

"I have this other table by William Kent that is just sublime." Kent was a landscape designer, architect, and furniture designer of the early 1700s. He created furniture for the royal household at Hampton Court and a number of other notable English locations. He became so popular in his time that he even dabbled in designing ladies' dresses (to no great acclaim, unfortunately). His furniture is dignified, characterized by detailed carvings.

"It's really the carvings on it that make it so special," Richard enthused. "Plus, it's retained some of its original gilding."

With Richard, everything comes down to "original." A large part of what he looks for when he's out searching is the degree to which a piece has remained unchanged by the years (in many cases, centuries).

All of this was very exciting to me because I love a piece with good carving. It pleases my fondness for intricacy. Richard told me how he found the table, which had been painted a particularly unattractive shade of brown, perhaps as a sign of mourning, but he had recognized it all the same. It dated to the time of George II and it had a Breccia di Medici marble top. When he chipped away at the brown surface, Richard realized some of the gilding was still intact under the paint. Richard knew that he had something incredible on his hands. It just needed time and attention.

He set a team of students and artists trained in restoration to work on the table. They had special techniques for delicately chipping away the paint layer without damaging the original decoration. In many ways, it was like an archaeological dig. Their hard work paid off, revealing the table as it would have appeared in the early eighteenth century. It was a rich putty color, with visible glints of gold.

All of this was enchanting to me, and I found myself very interested in both tables. Naturally, with a Chippendale on his hands, Richard had a lot of interest and wasn't in a position to give me a lot of time to make up my mind.

I kept hearing those two favorite sayings of my mother's: "You don't regret what you buy; you regret what you don't buy." … "If you see it and like it, buy it; you may never see it again."

As I lay there, trying to decide, I thought about the scarcity of wonderful things, with my mother's advice and passion ringing in my ears. And I made a decision.

"Look, Richard," I said, "I'm going to hang up the phone and this is what I want you to do: have a conversation with yourself and figure out a price for these if I take both. And I'll take them now."

Richard assessed what he had paid for the pieces at auction, plus the time and money he'd spent restoring the both of them. Then he set his profit margin. Twenty minutes later, he called me back with a figure.

I bought them both, and the decision was one of the best of my life. Both tables are in my house now, bringing me one step closer to my ideal living environment, my personal world of beautiful things.

After my recovery, I attended a sale in New York of a collection that had belonged to a very famous dealer whose name I will not mention. Unfortunately, he found himself in financial troubles, which obliged him to put his entire stock up for auction at Sotheby's, which is where I encountered it.

Richard was there, along with several other familiar faces from the English trade. I actually knew most of these other dealers via my friendship with Richard, and I also knew that they were some of the best in the business.

Relationships between dealers are often complex. Obviously, everyone wants to find good things, and everyone needs to earn a living. Dealers are also collectors, and they all have their individual passions. Dealers live and die by the contacts they make and the friendships that they cultivate. If they failed to extend aid to one another, none of them would thrive. More often than not, maintaining a good friendship with a colleague is more important that snatching up that one critical item.

In that spirit of cooperation, dealers often band together during an auction if there is one particular piece that two or more of them covet. They will usually talk with one another before an auction about which objects they intend to bid on. If two dealers are in conflict, one will often offer to buy a "half-share." Thus, the second dealer agrees not to bid, and for his trouble, gets to split the profits of the inevitable sale of the item.

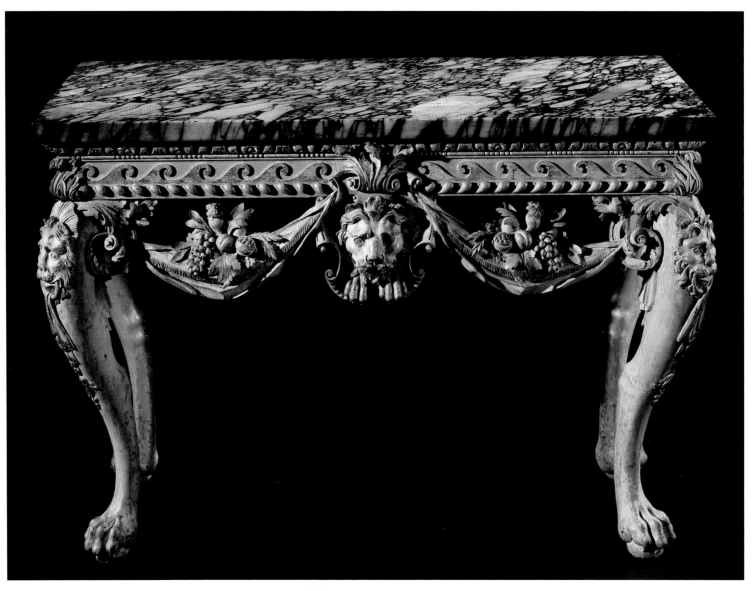

William Kent marble top table

Cleaning the surface of
William Kent table

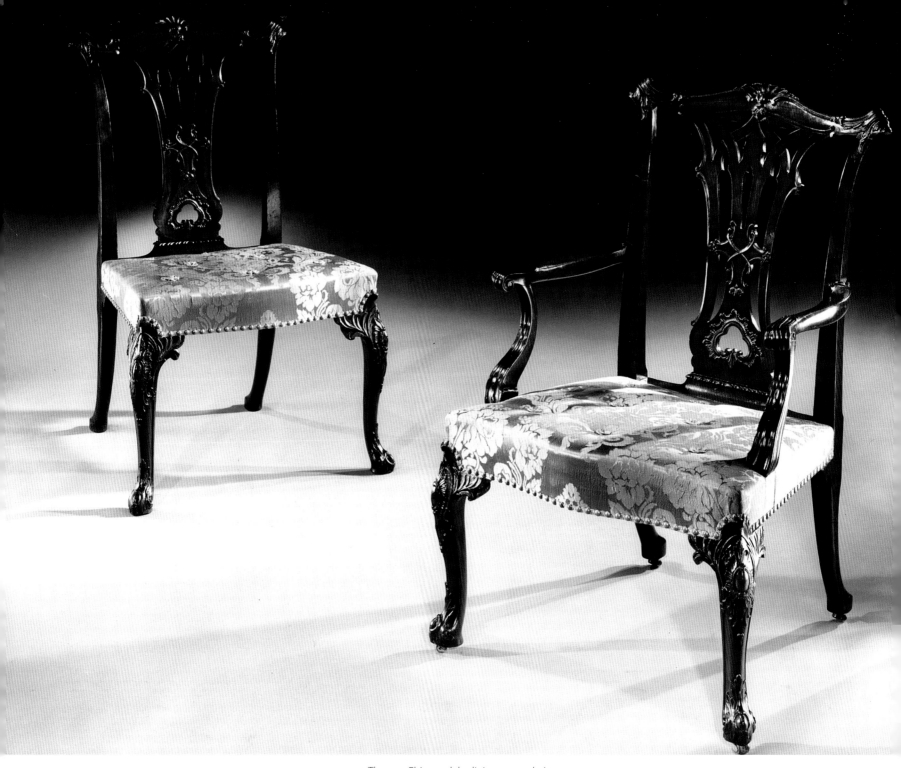

Thomas Chippendale dining room chairs

When multiple dealers are after the same item, or the same type of items, they may form what is called a "ring." Members of the ring buy together and do not bid against each other, and thus avoid driving up the prices.

After a ring purchases an object, the members will have a "bang-out," which is essentially a miniature auction among themselves. There, they will buy out one another until only one dealer is left—whichever one is willing to pay the most to have the item in stock. These practices are not exactly officially sanctioned, but they are certainly common and something of an open secret in the collecting world. As an independent bidder and collector, I need to understand how these deals work, and ideally, to know when they are happening.

At the New York sale, I made sure I checked in with Richard, to get the scoop on who was eyeing what. I was very interested in a set of Thomas Chippendale dining room chairs. His furniture so fully encapsulated a certain style and feeling that "Chippendale furniture" became a design template more than a hundred years after his death. He is considered one of the most important—if not the most important—figure in Georgian furniture.

The chairs were made of Chippendale's preferred mahogany, rococo in style (meaning they are quite ornate), and beautifully crafted with elegant woodwork. Even more significantly, there were a large number of them, what is called a "long row." The chairs were designed to pair with formal dining tables, where the heads of households might entertain up to eight guests.

Unfortunately, very few complete sets of that size remain. There were twelve of the ribbon-back chairs on sale in New York, eight of them original. Four more were reproductions, probably added in the nineteenth century when someone needed a few additional seats. The armchairs were original, however, and those were the most important pieces.

"What do you think of those chairs, Richard?" I asked. "I think I'm going to buy them."

"They're absolutely splendid," Richard pronounced. "But if you get them, you must give them to me. I will take them to London, and I will make them shine." At the time, the chairs required a bit of refurbishing to restore the more vibrant color of the wood. Of course, I would happily hand the chairs over to Richard because I knew him to be an expert restorer with great taste.

You can never really predict what will happen at an auction. I have been to minor sales in seemingly obscure locations where bidders show up en masse and drive prices through the roof. In this case, the collection was lovely, and the venue was storied, but the sale just seemed to lack that critical spark.

Nothing was fetching the kind of prices that the seller had probably expected. He had tagged the chairs with a very high estimate, roughly $150,000 to $200,000. The high estimate and low energy at the sale combined to make dealers wary of bidding. In addition to the estimate, pieces sometimes have a reserve price, the lowest price at which the auction house will still sell an item. The reserve price exists to make sure that the sale is reasonably profitable for the auction house, as well as for the person putting items up for sale. When an item doesn't hit a reserve price, it is often "bid in," meaning the seller will place a bid in an effort to drive up the price. Failing that, the item will be "bought in," meaning that the item is not sold and reverts to the original owner.

Dealers want to avoid items being bought in, and Richard cautioned me on the chairs for just that reason. As it turned out, he was right. The chairs did not hit their reserve, and so they were not sold. But that didn't mean they couldn't be bought.

As soon as a judgment had been made on the chairs, I ran over to the head of the department. "I want to buy those chairs," I told him.

The auction was still going on at this time, so naturally he was loath to leave his position. "Robert, I can't leave the podium. I have to wait until after the sale."

"No, I want you to go upstairs and talk to the guy in the sky booth, the seller. Make a deal."

"I really must wait until the sale is over. But I will go up there, you have my word."

I knew the man, and I also knew that his word was as good as his deed.

"One way or another," he told me, "these chairs will be sold to you."

He even offered to cut the auction house's commission if the seller was unwilling to deal. The sale was falling flat, so it was in the auction house's interest to sell as many of these items as possible. No one wanted unsold collections on their hands.

The head of the department was able to work his magic, and I bought the chairs. Of course I immediately sent them to England for Richard to clean and restore. They were upholstered with a really unflattering fabric, and I asked Richard to find something more appropriate—he is expert at finding fabrics that blend seamlessly into a piece, and he knows all the best upholsterers in England and continental Europe. Perhaps it's the longer tradition of the field, but all the best upholstery work seems to come out of England and France.

I asked Richard to find something in the style of an eighteenth-century silk or damask to recreate the look of the chairs in their heyday.

"Oh, no problem," he said. "Leave it to me."

"And make sure it's tufted." Tufting refers to the practice of dividing upholstery by threading through layers of fabric and then securing them with a button, or other type of roundel. It creates an opulent, textured appearance in a piece of furniture.

"Of course it has to be tufted!" Richard answered.

As I knew he would, Richard returned to me a set of beautifully restored and reupholstered chairs that I use today in my dining room. The chairs were so meticulously restored that I actually cannot tell the originals from the reproductions without some scrutiny. I had Richard mark which were which on their undersides so I will always know.

Ever since I bought the chairs, I have been on the hunt for the perfect table to go with them. I've searched far and wide and have broadcast my desire so thoroughly that I think every dealer in the world knows by now that *Robert Blumenfield is looking for a dining table to match his great English chairs.*

The quality of the chairs has set the bar very high. Whenever I see a possibility and I call the dealer, he invariably tells me, "It's not good enough for your chairs!"

Part of the problem is that the type of English and French eighteenth-century tables I'm looking for did not fare well over the years. In earlier decades, people looked at these tables, with their years and years of beautiful patina built up on the wood, and saw something old and ugly. It's incredibly hard to find a table with its original surface because resurfacing was such a common practice.

In the meantime, I still need a place to eat dinner! A very fine craftsman who specializes in wooden furniture made the table I have now. When he presented it to me, however, it was unfinished.

"I don't do finishing," he told me.

Luckily, I had a tenant in one of my real estate properties whose husband did finishing for the Getty Museum. Perfect!

So I stopped in for a visit. "Excuse me," I said. "I'm Robert Blumenfield. I'm your landlord."

"Oh yes, Mr. Blumenfield. How are you? Is everything okay?"

"I need your husband."

She looked askance at me. "You need … my husband?"

I laughed, I hadn't meant to sound quite so intense. "Yes, I heard he does restoration and refinishing over at the Getty."

My tenant laughed along with me. "Oh, yes. He certainly does."

"Do you think he would be willing to work on a table for me? I've had a reproduction done, but I need a finish that looks like it belongs in the eighteenth century."

My tenant agreed to ask her husband about the table, and happily, he was very excited by the project. I immediately had the table delivered to the Getty.

We worked closely together, developing a great look for the table. I checked in every week to take a look at what he had done so far, suggesting changes and giving approvals. I'm very happy with the final result—happy enough to set my splendid chairs around it.

Collecting Patek Philippe

In addition to centuries-old art, I also collect Patek Philippe watches. Patek Philippe—a watchmaker established in the early 1800s in Switzerland—has a long and rich history, and is famous for the intricacy and complexity of its timepieces. With more than 150 years of production there are, of course, many Patek Philippe watches in circulation, and they are very popular with collectors. Patek Philippe & Co. maintains boutiques in many cities, including a salon in Geneva. You could walk into any one of those stores and find an array of very fine timepieces. If you want an excellent watch, any Patek Philippe would be a good buy. If you want a solid investment, however, you need to look harder.

Often, these watches are produced in limited quantities, and the demand is so high that it's virtually impossible to buy one. The key factors to collecting Patek watches are the same as any collectible: first, a collector must be granted access to exceptional pieces; second, a collector must discover and obtain the really rare examples. Only these will sustain investment and appreciate in value. Third, a collector must participate in a community of fellow collectors to maximize the value of these pieces—both in terms of monetary value and prestige.

As a collector, I always need to understand where the passion is. What pieces are in high demand, and who is doing the demanding? What kinds of objects are the dealers getting? To whom are they selling them? All of this information lets me make more informed choices about the pieces I pursue—or leave alone. Patek watches command a value commensurate with their rarity.

On July 2, 2014, I went to Geneva for two days to meet the directors of Patek. This type of access is earned, not offered. I went not only to cultivate my relationship, but also to look over the pieces they intended to offer for their 175th anniversary sale. If you visit the Geneva Patek salon, be sure to drop in to its museum, where you will see many of the watches produced over the company's lifetime. Pay special attention to the placards that tell you who owned these watches: they're all heads of state, famous musicians, sultans, and the like. It's mind-boggling, but it just proves this company is the best of the best—and its client list reflects that!

The Patek Philippe salon has an aura about it. If a person is especially moved by these watches, as I am, simply being there is its own reward. Here is the hive that produces one of the sweetest things in the world! When I was at Patek, I heard a story about a man who wanted to spend his fiftieth birthday there. He came to the salon, and they took him to the third floor and installed him in an office. There he sat, working on his iPad, just taking in the atmosphere of the place. They brought him champagne, served him brunch, and attended to his needs. And there he sat, celebrating his fiftieth birthday in a watch boutique. He didn't even buy a watch; he just wanted to be there, soaking up the ambiance!

In addition to its regular lines, Patek Philippe also produces watches in extremely limited runs of three hundred pieces or fewer. Each watch is handcrafted, and can take hundreds of

hours—sometimes more than two years!—to complete. In the case of repeaters, when the craftsman is done, the owner of the company, Thierry Stern, personally listens to the chiming to make sure the sound is right. He doesn't want to risk selling a watch unless it is absolutely perfect. Patek produces each limited-edition line for only one year.

Needless to say, these are the really desirable watches, which will not only hold their value but will appreciate as we move further and further from the original date of manufacture. Some of the limited-edition pieces are made only by special order, so you have to have the right relationships to get one.

Patek Philippe jealously guards its reputation, and is circumspect about the clients with whom it does business. In order to be considered to purchase one of these special-order watches, prospective clients must first be approved. The global market is hungry for Patek Philippe because its product represents the world standard of high-end timepieces. Accordingly, demand far outstrips supply, which always drives prices up.

This demand can also have vexing consequences. Unscrupulous individuals will buy rare pieces only to resell them. Patek's limited-run pieces appreciate almost as soon as they are initially sold and there is a regular "rogues gallery" of well-heeled and moneyed persons out there, all chasing the same few watches. As one would expect, the prices rise exponentially.

This is why Patek Philippe is reluctant to have people they don't know purchase their limited-edition watches. Someone could buy one of these rare pieces and immediately realize a profit of at least 20 to 50 percent at auction. As a company of talented craftsmen, Patek Philippe considers this practice to be against its interests. Consequently, the company vets its clients carefully to make sure they won't abuse the privilege of owning these amazing pieces.

I had to be recommended by a friend who works in Bulgaria. He's a big collector, and he frequently meets with Patek Philippe representatives. When they agreed to work with me, Patek investigated me as fully as the FBI or CIA might. It had to be sure that I am, in fact, a serious collector and that I'm not

going to immediately turn around and sell one of these obscure and specialized watches at auction. For Patek Philippe, trust is especially important because it has a brand to protect.

This type of extremely high-end commodity affords the client some design participation. Spending more than half a million dollars on a watch buys a modicum of influence. Even so, Patek Philippe will ultimately determine whether a request—color, materials, etc.—is in line with its design philosophy, and more importantly, its reputation.

I have always been interested in a minute repeater watch, so I requested one. A repeater is any mechanism that allows a timepiece to chime on demand. Repeaters can be made at any intervals of time (most common, of course, are hour and quarter hour repeaters). As the name implies, minute repeaters chime on the minute and are the most delicate and precise of all. The relatively small size of a wristwatch casing dictates that designing and fitting of a minute repeater must be done on an incredibly small scale. Perhaps only twenty-five of them are made in a year— for the entire world. Naturally, these types of watches are beloved by collectors because they represent such high-level work and a huge investment of time, effort, and expertise. In many ways, they are the epitome of watchmaking.

I didn't want an ordinary minute repeater (not that any of them are ordinary!). I told the company I really wanted a 5074R in rose gold; I asked them to include other details, which I'm keeping a secret until I have the watch in my possession. Other than the watch I envision in my head, I've never seen any minute repeaters with my combination of features.

And so I was "acknowledged" by Patek Philippe (the technical term for being approved by the company). Patek understood how serious I am about collecting its watches, and how much I appreciate them. As it turns out, this approval came not a moment too soon, because my year will be the last year of production for the 5074R.

These requests are not taken lightly. Not only are these watches very expensive, not only is the vetting process comprehensive and far-reaching, but requesting these pieces involves a

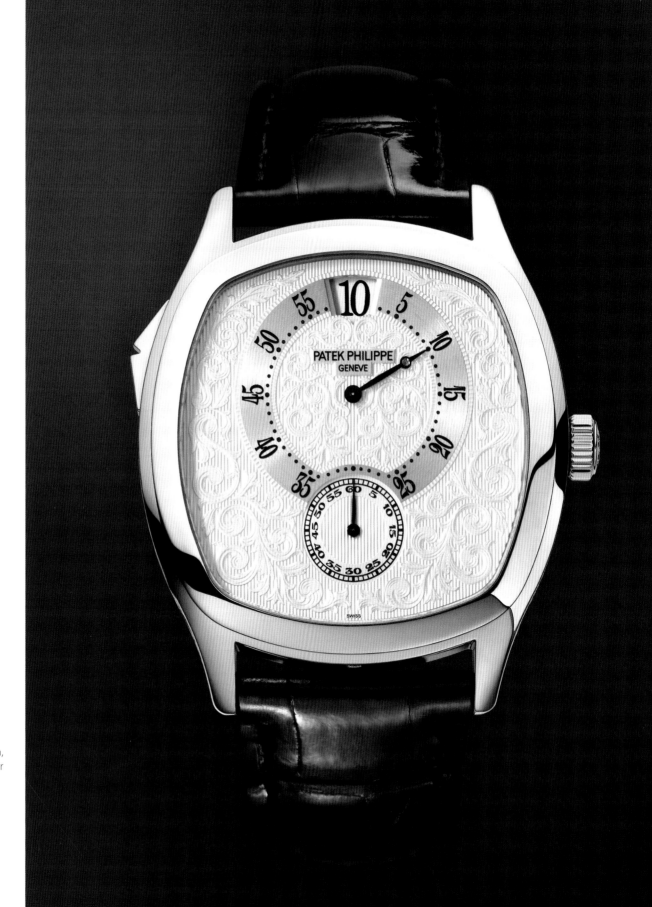

Patek Philippe watch,
platinum jump power

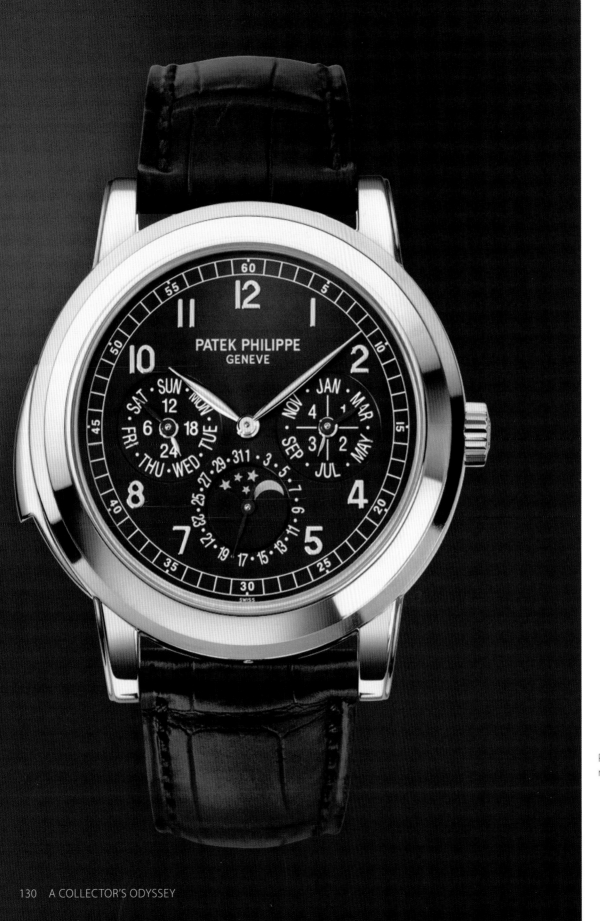

Patek Philippe watch,
rose gold minute repeater

substantial waiting period. For a custom commission, several departments—engineering, design, production, conception, development, and creation—have to meet in order to approve the decision. Every time Patek Philippe creates a made-to-order watch, everyone has to sign off on it, including the company president.

They all approved my somewhat uncharacteristic design requests, and it will be the only one like it in the universe. It won't just be a superlative watch; it will be a little bit of me.

Last summer, I purchased a Patek Philippe 5960 in rose gold with a black face. Although Patek Philippe produced the 5960 for years, they only made this model in rose gold with a black face for one year. All told, there are probably about three hundred of them, but I didn't know this piece was so rare at the time. As it turns out, this was a good purchase and is guaranteed to appreciate with time, owing both to the rarity of the piece and the quality of the manufacturing.

Part of the fun of collecting these watches is developing a rapport with other watch collectors. Two of my close friends also collect Pateks, and we meet whenever one of us gets a new piece.

Once, I got a call from a watch dealer out of the blue: "Robert, come in. I've got something."

The "something" was one of the models Patek Philippe limited to only three hundred pieces. They are, naturally, very highly sought after.

"What's the condition?" I asked him.

"It's brand-new. Never worn. It was made in '08."

I wound up taking the watch. Had I not previously developed a friendship with a dealer, I never would have had this opportunity. No matter what I am collecting, friendships and objects are hopelessly intertwined. After I acquired the watch, I wore it to lunch with a dear friend who also happens to collect Pateks. He wanted to get a look at this new watch, so we compared: his was gold with a white face and mine was platinum with a blue face. We marveled momentarily in silent satisfaction at our wrists, extended side-by-side in camaraderie. Our shared enthusiasm for furniture or watches or pottery brings us together and gives us a standard discourse, but the real connections we make as friends are truly enriching.

A beautiful collectible is more than just an investment. I buy Patek Philippe watches because I love them. There is very little that men can collect that gives us such satisfaction—watches are a way of indulging ourselves with something that we can wear and get great pleasure from on a daily basis. I enjoy wearing them, and they are as materially useful as they are aesthetically pleasing. Collecting is often a marriage between economic realities and the totally subjective realm of "taste." Things only become valuable when we deem them beautiful, rare, or unique. Our appreciation makes them desirable, and their value grows in direct proportion to our love for them.

At Home with the Rothschilds

Being a collector often feels like being a resident of a very small town. After a while, everyone knows your name and your tastes. Dealers and fellow collectors have a sense of what you like, and when you buy something new, they know about it. This is even truer of the small subcommunities within the larger world of collecting. In the world of Chinese art, for example, I've been around so long that virtually everyone knows who I am and what I buy. I am newer to the world of English furniture, but I have nevertheless established myself in that community as well.

For the most part, everyone benefits from this arrangement. Dealers, auction houses, and other third parties have brought many appealing objects to my attention. In exchange, I am a known quantity—a good customer with consistent interests. When you have a significant reputation as a collector, auction houses will often assign contacts to keep tabs on you and serve as liaisons. At Christie's, for example, I have two principal contacts: the international head of Asian art and the international head of European and English furniture. Together, they cover all my bases.

When I do buy something, they are immediately alerted. Their computer will actually get a message telling them that their client Robert Blumenfield just bought a piece of English furniture. They will know which piece I bought and how much I paid for it, and they will generally call to check in and to see if there is anything further that I need. This is especially helpful if a piece needs to be restored or professionally photographed.

Even the most assiduous representative, however, can't know everything. My buying history reveals a lot, but it can't account for those objects and styles that I've always been attracted to but have never bought for whatever reason. This is one of the drawbacks of the system: no one can alert you to the things they don't know you want.

In my case, that means French furniture. I am not known as a "French furniture guy," but I've always loved it. I don't mean the fussy, over-the-top baroque pieces that many people imagine when they hear the phrase "French furniture." Louis XIV certainly had lovely furniture, but I wouldn't want my home to look like Versailles!

In 2008, I was perusing auction catalogues when I saw that Christie's Paris was selling the contents of a great house—an estate, actually—called Château de Ferrières in the Île-de-France region, near Paris.

Baron James Mayer de Rothschild was the scion of one of Europe's most important banking families. He was born in the earliest days of that family empire, and through his own business acumen, he helped to expand it from its roots in Germany to most of Western Europe.

Château de Ferrières is perhaps the best known of Rothschild's many estates. It was built by famed architect Joseph Paxton, allegedly after Rothschild saw Mentmore Towers (a massive house built by Paxton for Rothschild's cousin Mayer Amschel de Rothschild) and requested "a Mentmore, but bigger."

Château de Ferrières was seized and looted during the Nazi occupation of France, and the grand estate stood empty until 1959, when Rothschild descendant Guy de Rothschild bought and refurbished it. Needless to say, a sale rooted in this amazing property made me sit up and take notice. True, the Goût Rothschild (as the influential Rothschild aesthetic is called) is a bit opulent for my taste, but it's also true that John Mayer de Rothschild was an incredibly shrewd collector of art and objects. I could not in good conscience pass up this opportunity.

I thought back to my mother's wisdom. Even if I didn't immediately know if or how any of these things would fit into my own aesthetic, I wasn't willing to lose out on something potentially great—especially since finding truly special objects is so challenging these days.

Looking through the catalogue, I immediately zeroed in on a set of ormolu *chenets*. Ormolu (from the French "*or moulu*," literally "ground gold") refers to the process of applying high-carat gold in a near-powder form to an object, along with certain other metals. Heat is applied, and the result is a beautiful gold veneer. *Chenets* (or "firedogs," as they are called in English) are mated pieces of metal or ceramic designed to hold logs in place and slightly elevated so air can circulate. As these are basic, utilitarian objects, firedogs have been found in societies dating as far back as 800 or 900 B.C. Of course, the Rothschild *chenets* were far more intricate—they were intended to beautify a fireplace as well as help it burn more efficiently.

These *chenets* were beautifully cast figures about 17½ inches tall, and came with a fascinating provenance: they had first been owned by Camille d'Hostun, the Duc de Tallard, and then by Rothschild. They had eventually been consigned by the Marquis de Lastic from the Château de Parentignat in Auvergne.

I knew right away that I wanted the *chenets*, and I notified them immediately that I would be bidding. They called me back quickly from the auction floor. (I was in the car in Los Angeles.) My *chenets* were going to appear at any moment.

"All right, I'm on my cell phone. If I get disconnected, call me right back, because I'll pick up again," I said.

"No problem. *Attendez un moment.*" The representative put the phone down in order for me to hear the auction; he would pick it up again when it was time to bid.

I was making my way through Beverly Hills with Paris on the line, waiting for these marvelous *chenets* to appear for bidding.

Gilt bronze chenet

Gilt bronze chenet

My heart was pumping with the thrill I feel whenever I find a real treasure, and I was almost jittery with anticipation.

Finally, the representative's voice came over the line: "They're starting the bidding." The bidding started around €40,000, which wasn't too surprising. Over the phone, the representative kept me updated as the bidding climbed: €50,000, €60,000 …

"Let it run," I said. "See how far it goes and then I'll let you know whether I want to bid or not."

"We are at €60,000, do you want to bid?" he asked.

"Why?"

"I don't think we have a lot of interest for some reason," he said. It's virtually impossible to gauge the tenor of an auction from another country; I had to rely on the representative to give me a good assessment from on the ground.

"Okay, we're at €70,000 … €80,000 … are you okay with €80,000?" Of course, I agreed. "Oh my god," the representative muttered.

"What? What's the matter?"

"I don't think there's anyone bidding against you." He was astounded, disbelieving. "You may get this. It's €80,000 with you and against the room—and there's no one on the phones. €80,000! *Incroyable*!"

"This is amazing," he said as the seconds ticked by. "Unbelievable! These are treasures!"

I tried to manage my own excitement. After all, nothing was certain until the gavel fell. I waited for several agonizing moments before …

"It's yours! This is amazing! I'm so happy for you! These are brilliant. I have to get on another phone now, but well done, Robert. *Au revoir*!"

It was an amazing stroke of luck. My competition (probably a dealer) was bidding on the *chenets* thinking that he would put them into stock if he could get them cheaply enough. For whatever reason, however, he wasn't willing to chase them.

I sent the pieces to a restorer who works with bronzes at the Louvre. He gave them a cleaning because, of course, they had been sitting in a fireplace for years. The great houses, much like traditional museums, tend to shy away from this kind of cleaning. When it comes to furniture, this is sometimes a good thing because it helps to build a rich patina. In the case of the *chenets*, however, they needed a little bit of extra attention to really shine. Today, the expert craftsmanship and high-quality materials are just as clear as when Baron de Rothschild himself ordered them for his home.

Never Out of Fashion

The sale of the Yves Saint Laurent collection in 2009 was one of the "great sales," and certainly one of the most significant in living memory. Over the course of three days, the auction made nearly half a billion dollars on more than seven hundred objects, everything from luxury cars to works by Picasso, with the proceeds going to AIDS research.

Saint Laurent was known as a skillful and interesting collector. A true enthusiast, he spent virtually every spare minute shopping for beautiful things. In the weeks and days before the sale, anticipation was high; getting tickets was like getting tickets to the Super Bowl. I was no exception, but though I managed to get an invitation, my wife couldn't get away. I didn't particularly want to travel to Paris alone, so I wound up doing a lot of my bidding by phone.

Unfortunately, I didn't get anything that I bid on, which was perhaps not surprising. This was one of the most successful auctions in history, and items were going for outrageous prices. I was particularly disappointed, however, that I'd missed out on a set of figures representing four continents, which I loved.

Shortly thereafter, there was a small French country sale, and as I was leafing through the catalogue, I noticed a pair of gorgeous Chinese cloisonné boxes. As it turned out, this was more than a simple rural estate. The house had actually been owned by one of James de Rothschild's illegitimate sons.

Rothschild had dispersed some things from Château de Ferrières to his various children and other family members, and this son wound up with the Chinese boxes. This shows just how lavish the Ferrières estate was—these amazing boxes were among the mere remnants.

The catalogue also included a set of four busts of the emperors, made from a beautiful white-gray Italian Carrera marble. I was immediately smitten, but they were hardly the only impressive marble pieces in the house. There was a marvelous pair of Egyptian porphyry marble vases. "Porphyry" comes from the Latin word *porphura*, meaning "purple," and indeed, this stone is known for its rich, reddish-purple hue. These vases in particular were the best examples of their kind I had ever seen.

In addition to the excellent quality of the marble, the vases also had beautiful ormolu work on their mounts. These particular mounts were probably done in the eighteenth century by artisans who also put mats, handles, and a base on the vases. As lovely as the vases were, however, the busts of the emperors were even more desirable because they were sporting their original stands. The busts were actually visible in the Château de Ferrières photo book, so I had a wonderful opportunity to see them in their original context.

As it turned out, Christie's was putting the busts and bases up separately—a practice that never fails to irritate me. Splitting up

Egyptian porphyry marble vases

pieces that were intended to work in concert is very frustrating for me as a collector. What is the point of having the bases without the busts? I bid on the stands but unfortunately, they went for more than I wanted to pay for them. I let them go, thinking that I could always have some reproductions made.

Next, the four figures came up, and I was bidding against a very well-known Paris-based dealer whom I had known for years. He had outbid me for the stands, intending to reunite them with the figures.

The great thing about bidding against a dealer is that their upper limit is generally lower than mine. They have to keep an eye on the profit margin, so they aren't going to buy anything for more than they think they can get by selling it. I was willing

to let the stands go, but I definitely wanted the figures. Because of that, I was able to outbid the Parisian dealer. I had been a bit concerned before the auction, when a representative approached me about the busts.

"You know, Robert," she said, "we may only sell three of these busts."

That was obviously not what I wanted to hear. "I need all four. What am I supposed to do with an odd number of busts?"

As it turned out, the auction house had suspicions that one of the busts actually dated not from the eighteenth century, but from antiquity.

"We have an expert from London coming in to confirm," she informed me. "We'd sell that one in London because it's a much

Bust, Vitellius, 94 cm (37 in)

Bust, Septimus Serverus, 94 cm (37 in)

Bust, Titus, 98 cm (38½ in)

Bust Marcus Aurelius, 100 cm (39¼ in)

better market for antiquities. If it is, as we believe, a fourth-century piece, we could sell that individually for a lot of money."

I could not fault her logic, but I didn't want or need an incomplete set of busts.

"If you're going to do that, I need to know," I told her. "Because, in that case, I'm not bidding on these at all."

I appreciated her candor, and I'm sure she appreciated mine. I'm not sure if the auction house was looking to appease me or felt hemmed in by the fact that they had already advertised all four busts, but they did wind up putting the complete set up for sale. At the auction, they never mentioned the potential fourth-century piece.

The auction house had to make a strategic decision: if they were right about the single bust, they could very well make a lot of money on an individual sale. However, that would mean turning down what amounted to a guaranteed sale from me. As a major buyer with a very good track record, I was definitely the bird in the hand. And there was still a small chance that they were wrong in their assessment of the alleged ancient bust. If they split them up and the bust turned out to be much more recent than they thought, they would have seriously hurt its value.

Thankfully, they decided to go the more secure route, and I was able to buy all four. After the sale, I was approached by another representative who informed me that the dealer who had bought the stands was interested in selling them to me. Without the busts, he had no real need for the stands. He was willing to sell them to me for the price of his bid, which was something like €25,000, which suited me well enough. The stands are beautiful in their own right—black lacquer with gilding metal around the edges—and were actually designed specifically for the country house. I was willing to pay a little more to be able to display the busts on their rightful stands.

I had also bid on the cloisonné boxes and got them, so I was riding pretty high at this point. The porphyry vases were coming up, as well as some lovely *chenets*. I bid on both and got all of them. I left the auction very pleased.

The next morning, I got a grave call from a representative of Christie's Paris. "Robert," she said, "we have a problem."

"What's the problem?" I asked.

"Well, we have a very good client—not that you are not a great client … obviously you are a wonderful client, and we want to make sure that you are very happy—but we have this client who wanted those marble vases so much. Unfortunately, he thought the sale was today, not yesterday. He missed them, and he is just sick about it. Would you consider selling to this gentleman?"

It was a shame that this person had missed the sale. That kind of thing happens to everyone sooner or later, and it is always frustrating. However, I wasn't willing to give up the newest additions to my home.

"No," I told her. "I just bought them. I'm not a dealer."

"He's willing to pay you a 20 percent profit," she wheedled. These were expensive items, so we were talking about $150,000 to $200,000 for what amounted to a day's work. It was tempting, but I didn't want money. I wanted the marvelous vases.

"No," I told the representative, "I need these. I really want to hold on to them. If he is a young man, maybe he'll have another opportunity to buy them one day." Almost everything makes its way back into the marketplace, given enough time.

Princess Diana, Through the Looking Glass

For many years, I hunted for a pair of large, eighteenth century mirrors—or as the English call them, "looking glasses." I wanted to check them off my wish list and install them in my living room, or over my commodes, or above my cabinets. I'm extremely serious about condition and originality, so the hunt for an object of pristine quality is much more difficult than one might imagine. In the eighteenth century, it was common to restore ancient pieces to make them look new, so I rejected most of those items that came my way.

In 2007, I got the phone call I'd been waiting years for. A London dealer spoke the magic words, "I think I found something special for you!"

My heart raced as he told me about a pair of mirrors on display in the dining room of Spencer House, the London family home of the late Princess Diana. They were to be offered for sale at the Grosvenor House Art and Antiques Fair, which was at the time the most famous art fair in England for quality collectible furnishings. With a provenance that included the Spencer House, I knew I would have to act fast. These mirrors would be highly sought after, and in the collector's world, like everywhere else, "He who hesitates is lost."

I took a chance and asked the dealer if he could hold the mirrors for me in case I couldn't get to London from Los Angeles in time.

"Impossible," he said.

In addition to time working against me, the mirrors were also out on consignment in another house in London, where a family was deciding whether to purchase them. So I asked the dealer to let me know if the family decided not to take them. He agreed, and later called me back to say that the family thought the mirrors were too big. At 69½ inches high and 45 inches wide, they were indeed huge, but their size only made them more wonderful to me.

So I took a risk. I said I would buy them—a pair of $350,000 mirrors—sight unseen, on one condition: I needed a second opinion. The dealer agreed to my request because he was confident about their high quality and remarkable history. So I called Richard Coles and asked him to go look at the mirrors for me. I've worked with Richard and he understands better than anyone that pieces in their original state are the hardest things to find, especially from an era when people restored and even over-restored their possessions.

I wanted to make sure that the frame wasn't regilded or re-carved and that the plate—the mirror itself—was also period. Richard agreed to examine the mirrors. I paid Richard 10 percent of the cost of the mirrors—$35,000 for a day's work. I normally pay a dealer 3 percent to double-check an object for me, but Richard is someone whose expertise is unmatched, and he had given me ample reason in the past to trust his judgment.

I needed Richard to verify that these mirrors were as wonderful as I hoped they were, and also that they were authentic Kentian mirrors—that is, made in the manner of William Kent, one of the most famous English furniture makers. These mirrors came with no documentation, but their quality was

One of a pair of gilded, carved mirrors, previously in Spencer house

magnificent, and they were coming from one of the most extraordinary houses of a great, famous family. In Joseph Friedman's 1993 book, *Spencer House: Chronicles of a Great London Mansion*, the mirrors are photographed in situ. This added to my certainty that the mirrors were what they purported to be.

Richard took one look at the mirrors and called to say, in elegantly understated tones, "Robert, they're brilliant." He even Photoshopped the mirrors over an image of a cabinet I'd purchased from him so that I could visualize how they would look in my living room.

That was all I needed.

"They're exactly what I want," I told him.

He added that the surface of the gilding had been fussed with a little, but he would be able to find the right person to get it back to its original condition. So after I had verified their condition, beauty, and rarity, I spent the next twenty-four hours securing the mirrors and finalizing the price.

Those amazing looking glasses never made it to the Grosvenor House Fair. And until this publication, only a handful of people have known the story behind the glorious mirrors that hang in my living room. It brings me joy to walk past them and look into the same glass that Princess Diana and her family must have gazed into. Imagine her in the dining room, standing in front of this massive looking glass and arranging her stunning blonde hair. You can't put a price on that!

Photograph of Spencer dining room showing one of the gilded mirrors

Maurice Segoura: A Unique One-Owner Sale

One of the greatest dealers of French furniture was a man by the name of Maurice Segoura. He was of the old school, a perfect gentleman with superb taste. He maintained a beautiful gallery in Paris, and naturally his stock was incredibly expensive. I admired many a piece from Segoura, but could rarely justify the cost.

Eventually, he and his family decided that the time had come to close up shop. He was getting older and having more and more difficulty maintaining the business. His family was encouraging him to retire, so they made a deal with Christie's to offer the entire contents of his shop in one huge sale.

This is called a "one-owner sale," and it's what many collectors, myself included, live for. One-owner sales usually feature items that were put away for some time—dealers close and sell their entire stock, or are staying in business but have amassed too large a collection and are just looking to clean house. These events occasion a fresh sense of excitement among both dealers and collectors; everyone who attends the sale knows that the collection was gathered by someone who knew what he was doing.

This particular sale had special cachet because Segoura was such a well-respected dealer, and he had such a great eye. I would rank this sale along with the Love sale as one of the greatest that I've ever attended.

Christie's hired New York interior decorator Juan Pablo Molyneux to reconstruct a period French room—heavy on the ormolu, with beautiful wooden paneling on the walls. It was hard to believe that it was just wallpaper! Walking into the room was like stepping through a portal into a French villa circa 1750. They even reconstructed the trompe-l'oeil wall coverings.

The sale's catalogue was pleasantly dense, and many of the items had a "universal reserve," meaning anything that received a bid would be sold. Christie's didn't want to go home with anything. As a bidder, it meant I was in no danger of having a piece "bought in."

I was captivated by the sale, and by one piece in particular: an eighteenth-century clock by Pierre Le Roy of Paris. Frequently considered one of the fathers of modern clock making, Le Roy was the originator of many features that are now considered indispensable parts of a working clock, including the escapement mechanism. Le Roy was perhaps more an inventor than an artist; nevertheless, his work is as beautiful as it is advanced.

This clock in particular featured some lovely ormolu work, as well as some patinated bronze in the Asian style. Le Roy was not the only craftsman to work on the piece, however. The enameler Bodet created the dial, and the clock bears both of their signatures. The estimate was low on the piece, and I knew I wanted to bid on it.

When the auction finally started, people were crammed into the room, all eager for a chance at this amazing collection. Sharon was sitting beside me, and across the room I saw a Japanese woman I'd met before. Years ago, she had dated a friend of mine,

though they eventually split. She was attending with her husband, who grew up in Paris. Undoubtedly, they were both keenly interested in the sale.

Because the estimate on the clock was so low, I wasn't anticipating much interest in the piece. So I was surprised when I found myself opposed in the bidding. In a densely attended auction like this one, it's not unusual to bid against someone for several minutes without determining exactly who that person is. In this case, I hadn't any idea who it was. Bids were volleying back and forth when suddenly my wife nudged me and said, "Look who it is! Alex and Yuki!" Yes, as it turned out, I was bidding against my old acquaintance's husband.

Alex was less invested in the clock than I was, and I finally won it—albeit for probably twice as much as I would have paid otherwise. After the auction, I went over to offer the apologies customary in these situations. It's always slightly awkward when you find yourself in competition with someone you know.

"No, no," Alex demurred. "*I'm* sorry! I didn't realize it was you. I was really only bidding on it for Yuki. She loved the Asian figures. She thought they looked Japanese. I didn't even want it myself."

It just goes to show you that you can never know the motivations of the people around you. Yuki expressed a casual interest in the piece, and that changed the entire auction. Of course, the unpredictable volatility of an auction is an important part of the excitement of collecting. Even if you think you have a solid understanding of what is going to happen, there will always be elements you can't control.

Eighteenth-century clock by Pierre Le Roy of Paris

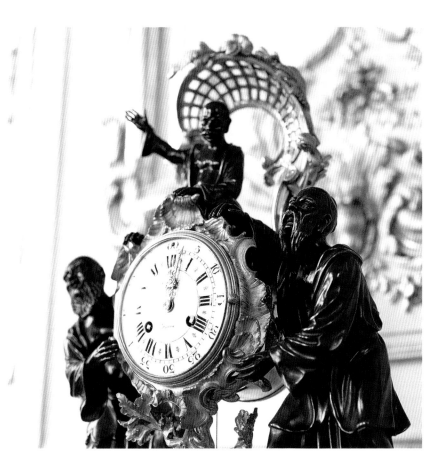

Eighteenth-century clock
Detail of 3 figurines at top

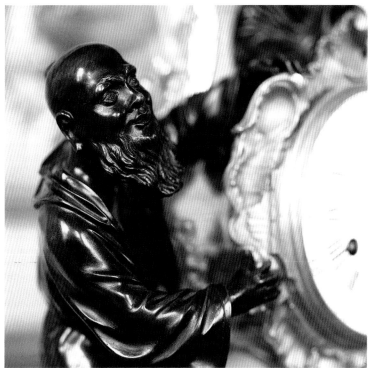

Eighteenth-century clock
Closeup of one figurine

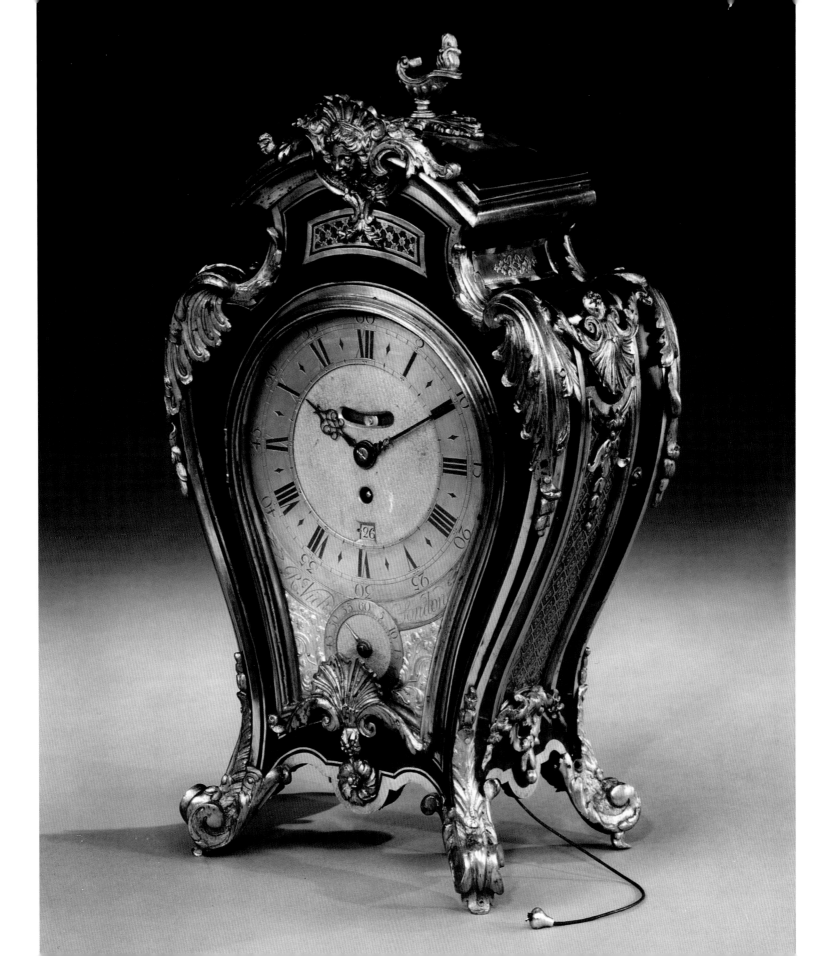

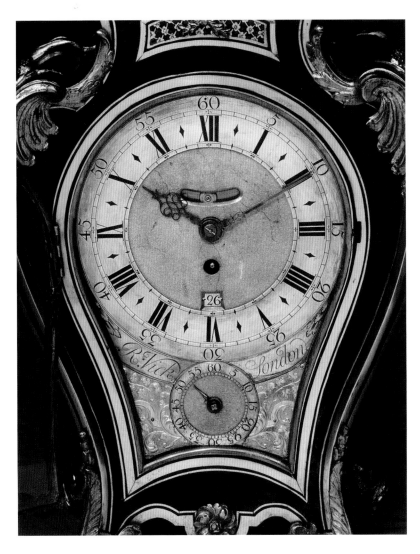

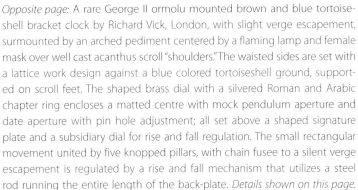

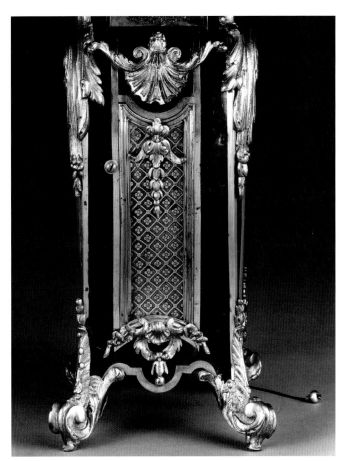

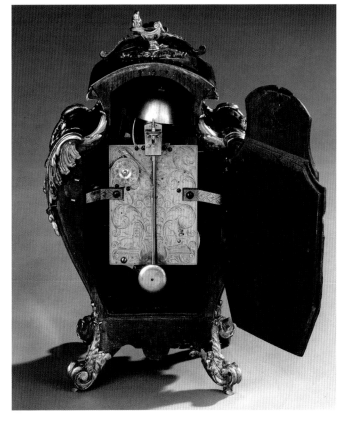

Opposite page: A rare George II ormolu mounted brown and blue tortoiseshell bracket clock by Richard Vick, London, with slight verge escapement, surmounted by an arched pediment centered by a flaming lamp and female mask over well cast acanthus scroll "shoulders." The waisted sides are set with a lattice work design against a blue colored tortoiseshell ground, supported on scroll feet. The shaped brass dial with a silvered Roman and Arabic chapter ring encloses a matted centre with mock pendulum aperture and date aperture with pin hole adjustment; all set above a shaped signature plate and a subsidiary dial for rise and fall regulation. The small rectangular movement united by five knopped pillars, with chain fusee to a silent verge escapement is regulated by a rise and fall mechanism that utilizes a steel rod running the entire length of the back-plate. *Details shown on this page.*

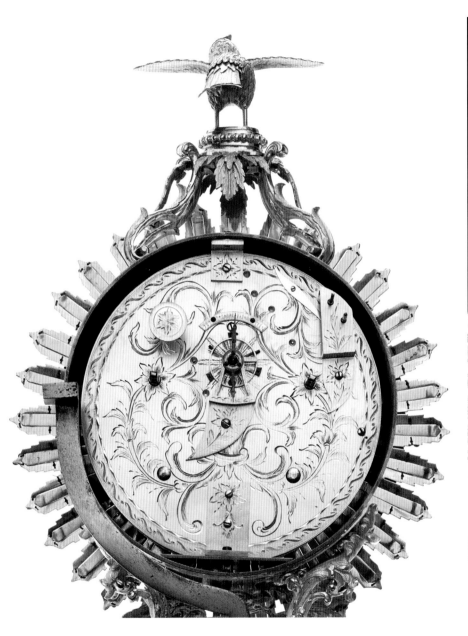

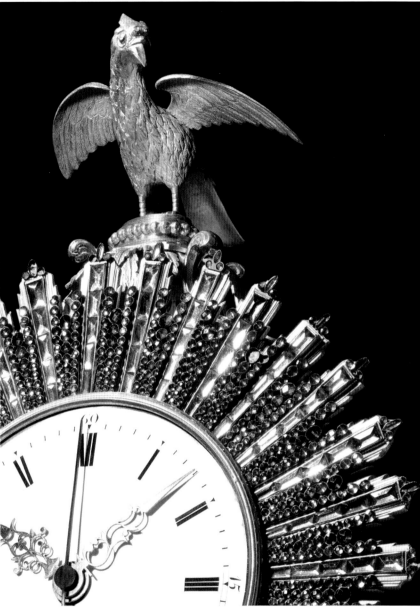

Opposite: Imperial Chinese clock from the 18th century
Left: Detail of back, Right: Detail of top

A Ticking Clock

Many of the things that I collect—most of them, in fact—are functional objects as well as beautiful pieces of art. I have often wondered what it is about humans that compels us to ornament and detail even the most workaday products. I find myself coming back to the simple, universal desire to be surrounded by lovely things that are pleasing to the eye, even if they don't necessarily "need" to be so.

There are some utilitarian objects, however, that I find inherently attractive. I mentioned before that I have always found something intriguing and mysterious about boxes; similarly, I have long been an admirer of unique and well-made timepieces. My Patek Philippe watches are just one aspect of a much broader collection.

Once, in conversation with a friend of mine about my clock and watch collection, we found ourselves wondering what exactly it was that drew me to these objects. My friend suggested that people appreciated timepieces because they remind us subconsciously of our nine months in the womb—the regular, diligent ticking of a clock mimics the sound of a mother's heartbeat.

That theory stuck with me and I think about it occasionally when I look at a particularly impressive clock or watch.

One piece that I return to frequently came from the famous Maurice Segoura sale, which looms so large in my memory. Before the sale, I spent some time with the catalogue, as I always do, trying to get a feel for the items and finding the ones that really captured my imagination. The cartel clock stood out immediately.

I would purchase another clock at the same sale, a fine example of chinoiserie with three sculptural figures. By contrast, the cartel clock (or wall-hanging clock) looked more traditionally European. It is done in scarlet and gilt *vernis* (the French term for varnish or veneer) and it has incredible ormolu details. It was dated to 1748 and is signed both by the enameler, Antoine-Nicolas Martinière, and the clockmaker, Pierre Le Roy.

Flowers are a main design element, sunflowers and roses being the standouts, and a small Cupid presides over the entire piece, clutching a spray of blooms in his chubby, golden fist. Ormolu flowers dominate the outer edge of the clock, wreathing the face and extending outwards in either direction. Underneath the metal flowers, the incredible red varnish peeks through in the form of tole panels. "Tole" simply refers to the material, a thin, flexible metal that was frequently used in decorative pieces. Tole was often "japanned," as Western Europeans called Asian-style lacquering, and these under-panels were coated with a rich red lacquer.

Tole panels are not typical for these types of clocks; "grille" panels were most commonly used. As the name implies, grille panels are simple, grating-like metal panels. They are more unobtrusive but less decorative, though certain clockmakers certainly developed beautiful versions of grille panels.

As it turned out, the clock had started life with these common grille panels and the tole versions had replaced them at some point in the eighteenth century—each of them is signed "Aux Derriere Delouvrage Bar" in ink that has been dated to the

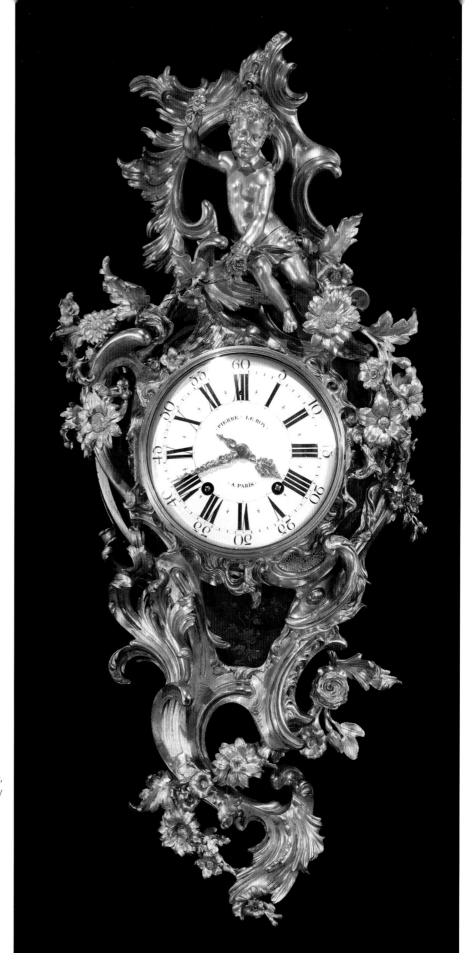

Cartel clock by enameler, Antoine-Nicolas Martinière,
and the clockmaker, Pierre Le Roy

1700s. Delouvrage is a bit of a mystery in the collecting world, though it can be presumed that he was a lacquer artisan of some kind and his other work either went unsigned or the signatures have remained undiscovered. The idea of having one of the few definitive examples of an obscure artist's work is always exciting.

The piece is also quite large—37½ inches tall and 15¾ inches wide—and anything that size that has made it through the ages relatively intact is always going to attract a lot of interest. And, from what I could tell, this clock was in excellent condition. Add to that a signature from one of the great masters of horology, Le Roy, and I knew that this piece would be sought after.

When the sale finally arrived, I discovered that the clock was indeed generating a lot of enthusiasm. None of that dampened my resolve, however. The clock was even more arresting in person and I was committed to bringing it home. I did manage to purchase the cartel clock, as well as a number of other pieces, and I was very pleased overall.

Years later, I asked Will Stafford, of Christie's, which piece from my collection was his favorite. It was quite a question, but Will has a very good working knowledge of my collection—not just the pieces I got via Christie's.

He laughed a bit at the question and said: "You'll never guess."

I played along and named one or two things that I thought suited Will's taste, but he shook his head after each one.

"Which is it?"

"It's the Louis XV ormolu and scarlet gilt cartel clock," he said. Indeed, I would not have guessed that. I thought the clock was beautiful and unique, but his favorite? Out of everything I had accumulated over the years?

"Really?" I asked him.

"Yeah, I've just always thought it was in the most incredible condition." He pointed out the surface of the clock and the gilt, which is all original to the mid-1700s. Beyond making the custom alterations to the panels, no one had tampered with the decorative elements or regilded anything and that's quite rare for smaller pieces, which get handed off regularly over the years.

As it is so often with these objects, the bulk of the value doesn't come so much from the object itself (although the beauty and craftsmanship matter a great deal) but from the circumstances of its creation and preservation. Pierre Le Roy made incredible timepieces and, in turn, his creations accrued extra value. The clock's owners over the years treated it with care and consideration, meaning that the marks and signatures in the spidery hand of several centuries ago can still be read. At any point, they could have decided that a change or update was necessary to make the piece more attractive or more functional and that would have ruined the clock. Instead, it was the weight of time and history, the original expert work and the connection with the artisan, that made the clock such a special part of my collection.

In the end, a clock is a device for telling time. But the Pierre Le Roys of the world see beyond the basic functionality of objects. They infuse art into the trappings of daily life. That is what made him famous in his day and that is what makes his work beloved even now.

Of English Furniture and Scottish Estates

The serious collector must know where the finest and most interesting collections are located, because you're never given warning when those collections are suddenly liquidated and available on the market. Incredibly valuable collectibles tend not to stay in one place forever.

In the area of English furniture, Dumfries House looms large. It is one of a number of eighteenth-century Palladian houses dotting the picturesque Scottish countryside now listed as historical buildings significant to Scottish heritage. Sir William Dalrymple-Crichton, the fifth Earl of Dumfries, began construction on Dumfries House in 1754, and commissioned Robert and John Adam, sons of famed architect William Adam, to design the house.

Having been raised by their father to enter the family trade, the brothers were just beginning their storied career when the Earl hired them. Eventually, they would develop the unique, iconic building design that bears their name: the Adam style. Their work was, in many ways, a response to the baroque and rococo movements popular in the prior decades. It prioritized a feeling of lightness and relative simplicity. The Adam style is frequently associated with pastel colors, curved walls, domes, and classical details including frescoes, urns, and scrollwork.

Approximately one year into this process, Sir William's young wife, Anna, died. As the pair had no living children, his project now took on new urgency. He needed an heir, and for that, he needed a new wife—the sooner the better. He wanted to create an exquisitely furnished estate that would appeal to a young woman. To this end, he personally selected a number of pieces from Thomas Chippendale's London workshop. Chippendale represented everything the Earl wanted his home to project; his work was beautiful, expensive, and au courant. The Earl had a discerning eye—the pieces he bought are universally impressive.

Sir William managed to amass a collection of more than fifty Chippendale pieces. He also patronized furniture makers closer to home—almost all of the major figures in Scottish furniture are represented among his collection. Of course, Dumfries House was hardly the only grand estate of the period to be tastefully or expensively furnished. What made the house a collector's jewel is everything that happened afterward.

Sir William never did get the heir he had hoped for, and thus the house passed to his nephew, Patrick McDouall-Crichton. Lord Patrick's grandson John Crichton-Stuart, second Marquess of Bute, inherited the title afterwards. The Marquessate of Bute also possessed a great estate: Mount Stuart, on the Isle of Bute. For centuries afterwards, the family primarily occupied the Isle of Bute residence, keeping Dumfries House as a secondary estate. Over the years, the family acquired a number of other holdings across the British Isles and remained wealthy enough to avoid the fate of similar estate owners: sale and liquidation. Thus, Dumfries House stood barren of souls but full of unparalleled treasures.

Because it was unoccupied, Dumfries House remained almost totally intact, which is very unusual for an estate from this period. This is not to say that the house went untouched. Each generation left its own unique mark on the place. For

example, John Crichton-Stuart, fifth Marquess of Bute, added the cedar-paneled tapestry room in 1908. But even when the subsequent inhabitants of the Dumfries House undertook changes, great care was taken not to upset the aesthetic regime laid down by Sir William in the mid-seventeenth century. Indeed, each new owner of the house ensured that any changes accorded with the existing character of the house and maintained the totality of the collection it contained. Each new feature blended seamlessly into the existing structure.

For a collector of English furniture, Dumfries House is a kind of Holy Grail. The house is considered perhaps the finest suite of English furniture in situ. Whenever collectors and dealers get together, Dumfries House is a frequent topic of conversation; everyone always wants to know whether the collection will ever be sold.

This is a very real possibility, as in recent decades Dumfries House has encountered the financial problems that have plagued similar estates. These large houses, with their vast acres of attached property, are incredibly difficult to maintain. Even in their heyday, most of them required a small army of maids, butlers, cooks, and gardeners to perform daily operations. In the modern era, with smaller families, smaller staff, and smaller stores of ancestral wealth, these houses are largely unsustainable for private persons.

Dumfries House is no exception. By the mid-1990s, the estate was in the hands of John Colum Crichton-Stuart, the seventh Marquess of Bute—or Johnny Bute, as he prefers to be called. A professional Formula One auto racer, Johnny Bute won the Le Mans 24 Hours in 1988. He had little interest in living on the vast estate, and even less interest in paying for its massive upkeep. He approached several state and charitable trusts with the hopes of passing the house smoothly along to them, thereby preserving both the house and its contents for the public. But there wasn't enough interest, partially because Dumfries was a bit of a "forgotten gem," and partially because some were unable to justify the cost of maintaining it.

By 2007, Dumfries House was teetering on the edge of being sold and, behind the scenes, Christie's was quietly preparing for a potential auction. To that end, Christie's senior vice president Melissa Gagen phoned me with a tantalizing offer: Christie's was arranging a small expedition to Scotland for a tour of important Scottish homes, including Dumfries House, and I was invited.

Of course I jumped at the chance. Part of the allure of the house was its mystery; the house was, for very many years, all but closed to the public. Consequently, very few people had actually seen its interior. Only a handful of scholars, friends of the family, and the rare major collector were admitted. The opportunity to examine these amazing objects in their ancestral home was too tempting to resist.

I flew to London a few days before the Scotland trip began to attend a few auctions , and then met up with the rest of the group in Edinburgh. I was not the only collector that Christie's had reached out to, though the group was small. It was an unusual road trip, to say the least. We moved from estate to estate, spending a night at each one and soaking up the atmosphere. Most of these huge houses were nominally associated with certain wealthy families, but frequently they had been sold or given to the state when the inheritance and property taxes became too burdensome. Some of the houses had been dutifully preserved by the state, while others had essentially been gutted. A few still had occupants.

Melissa wanted to make sure that we saw as many interesting houses as possible, and Scotland is particularly rich with such homes. In the end, we were all very grateful to have had a window into how people lived hundreds of years ago. We even got a close look at Abbotsford House, the residence of Sir Walter Scott. The famous poet and novelist had designed and constructed the house himself in a series of extensions and additions completed over the course of many years.

Early on in the trip, we visited Drumlanrig Castle, the ancestral seat of the Duke of Buccleuch. It's a fantastic and well-preserved seventeenth-century home set back in a large wooded

Elegant Chippedale bookcase. By kind permission of the Great Steward of Scotland's Dumfries House Trust. Image: Christie's

Brought over £ 414 16 3½

To a neat mahogany Shaving table wt. a folding top
& a Looking glass to rise wt. a spring & Rack a Cup-
board & Drawer &— } 4 · · · ·

a mahog: Breakfast table of fine wood wt. a Writing
Drawer & Wirework round & castors & — } 6 8 —

a Jappand Cloaths press wt. folding doors & sliding
Shelves coverd wt. marble paper & Bays aprons & 2
Drawers } 17 · · · ·

Repairing the Carving & gilding of an oval Peerglass · · · 5 —

a French Commode inlaid wt. & Tortoishell & brass · 15 15 —

a large Chimney frame richly carvd & gilt in bur-
nishd gold for a Tapestry picture & a Glass under it } 17 · · · ·

a mahog: Frame to a Tapestry Firescreen the back
coverd wt. Lutstring & a mahogany Pillar & Claw
richly carvd } 4 4 —

2 Do. to match - - - - - - - 8 · · · ·

2 large mahogany oval Cisterns wt. brass hoops
& handles } 4 · · · ·

a Rosewood Bookcase wt. rich carvd & gilt ornamts.
on the top & doors a Writing Drawer in the Underpart
& a Cloaths press & Drawers at each End · } 47 5 —

	Feet	Inches		£	s	d
Glued Packing case	1183	4	at 3½ perfoot			
Thick & thin Do.	213	—	3½	} 20	6	4
Common Do.	797	—	at 2½	8	6	½

Paper deal Nails Cloath & Packthread 2 · 12 —
14 Mats - - - - - - 0 · 12 —
Packing the whole &c - - - 3 · 5 —
} 6 11 —

Carried over £ 573 16 8

valley. The house itself is constructed of a pink-red sandstone, which earned it the nickname the Pink Palace of Drumlanrig. The house featured all kinds of incredible period furniture, including a Louis XV grandfather clock and a cabinet by Boulle, cabinetmaker to Louis XIV. These were pieces that would have been contemporary to the house itself, so seeing them in this context was particularly special. Standing there, one could get a sense of how the house would have felt when it was new—and what it would have been like to live in that world.

Among the nicest aspects of this trip were the meals and conversations we shared with the caretakers of these great homes. It was a very intimate approach to touring estates, a peek into the daily lives of the people who own and inhabit such places. Many of them had very interesting tales to tell. I spoke with one gentleman who had been living in Australia and working as an engineer when he was summoned back to the UK. He was the scion of an old and titled family with an estate in Scotland but they were having a lot of trouble keeping up with the taxes on the place. He was asked to take over the management of the house and to make the estate fiscally solvent—if not profitable, then at least not a financial liability. He accomplished this the same way many of his peers did: by making the house more available to the public.

Many of these grand estates can be rented the way one might rent an event hall or a vacation home. Blairquhan, an early-nineteenth-century castle we visited after Drumlanrig, has been used more than once as a location for films. It was cast as Balmoral, Queen Elizabeth's personal residence, in the 2006 film *The Queen*.

The taxes are so considerable, however, that even renting out the estates can't always cover the cost of keeping them up. When that happens, private owners are frequently forced to sell collections or valuable individual pieces that may be associated with the home. For example, as we gathered for dinner at Blairquhan, we all sat on metal folding chairs and it was impossible not to notice the bare, dark rectangles on the unadorned walls where paintings had, until recently, long been displayed.

Our host apologized: "We just sent all of our paintings to auction in London." Evidently, there had been a series of portraits of former owners of the house and their families. The present owners found it necessary to sell many of the more interesting furnishings—including, we assumed, the chairs that had probably once sat around the table—just to maintain the house. I imagine that when Christie's booked this house for the trip, they assumed the furnishings were intact, but there were still hints of what that house had been like in its heyday. It felt a little ghostly, though—a half-empty house in limbo between the opulent past and the beleaguered present.

Other families strike deals with the state or a charitable trust in an attempt to get some of the benefits of owning a grand house without the crippling financial downsides. We visited one such house, Hopetoun. The house itself is another incredible, neoclassical, quintessential Adam home. Inside, we found several pieces of furniture from Scottish workshops, though there were also a number of pieces from famed London furniture makers. The occupying family had given the home to the National Trust, but their deal allowed them to live in and use one wing of the house. The rest is open to the public so that the state can generate some revenue.

Later that day, we visited an equally grand house, Dalmeny, home of the Earls of Rosebery. The Earls of Rosebery have headed a grand family for a long time, but they became far grander in the early twentieth century when Lord Rosebery married the only daughter of Baron Mayer de Rothschild, Hannah de Rothschild. At that time, Mayer Amschel de Rothschild was the most significant member of the very significant English Rothschild family.

Rothschild himself built a famous estate during the 1850s in Buckinghamshire, a sumptuous Jacobethan mansion called Mentmore Towers. Hannah inherited that estate upon her father's death, and with it came an incredible treasure trove—much of which was transferred to Dalmeny House when the contents of Mentmore were liquidated in the 1970s. Dalmeny therefore had a great number of pieces to explore and

examine—two great houses' worth! These treasures included some amazing eighteenth-century French and English furniture.

But all this scurrying around the Scottish countryside was merely a prelude to the real reason for our trip: Dumfries House, and the promise of one of the last major, intact collections of Chippendale furniture. Appreciating Chippendale as I do, this collection was what I was most eager to see.

As I moved through the house, I mentally catalogued pieces according to my level of interest. The collection was even more astonishing than I had imagined. In addition to the furniture, the house also had a number of bills of sale handwritten on parchment by Thomas Chippendale himself. Alas, these handwritten bills would not be included with any sales of these pieces. Our hosts did, however, allow me to handle them. It was an incredible experience, touching something that Thomas Chippendale had written in his own hand. I couldn't help but compare my handwriting with his, though the two are as different as chalk and cheese, as the English say.

After we had done our tour, we sat down to lunch at Dumfries House with the chairman of Christie's UK, Viscount Linley. He is the eldest son of Princess Margaret (younger sister to Queen Elizabeth) and photographer Antony Armstrong-Jones.

Unlike some of the other estates we had visited, Dumfries House was of a more "normal" size for a family home. Instead of being a castle with more than a hundred rooms, Dumfries House feels quite manageable and almost intimate. It was as though we'd been invited over by a friend. At lunch, Viscount Linley told me a joke that I've shared at the end of every real estate conference I've spoken at since.

"You know," Linley began, "I was at the club just the other day with Sir Honeysett, Lord Godfrey, and Lord Cavendish, and the topic of real estate came up. Sir Honeysett mentioned that he had an impressive three thousand acres attached to his own estate.

"'Oh, very well done,' I said, 'And you, Godfrey? How many acres do you have now?' Lord Godfrey modestly admitted that he had an astounding five thousand acres.

"'Brilliant!' I said. But Lord Cavendish was being awfully quiet. 'And how about you, Cavendish?'

"'Oh,' Cavendish said, 'I have about sixty acres.'

"'Really?' Honeysett sputtered. 'Is that all?'

"Lord Cavendish smiled. 'Yes. But mine are in London.'"

The moral of the story is, of course, that old real estate mantra: location, location, location!

The atmosphere at the table was convivial and delightful. As we all dispersed to go our separate ways, I was sure that we would hear in a few weeks or months that the contents of Dumfries House were coming to auction.

That, however, was not to be. Ever since rumors of putting Dumfries up for sale emerged, arts and conservation groups had been lobbying for the state to take over the property. Eventually, those activists captured the attention of Prince Charles. Just weeks before the sale was set to happen, the Prince borrowed against his own charitable trust and put up a large portion of the money required to buy and restore the house. Seeing this, the Scottish government also agreed to contribute to the effort. Dumfries would remain intact. In fact, Dumfries House would actually be getting something of a makeover, with teams of restoration experts on hand to evaluate, repair, and restore every detail of the great house. Dumfries has since been opened to the public, so everyone can see its marvels firsthand.

On some level, of course, I felt a twinge of disappointment when I heard. The house was so close to being sold, after all, that many items had actually already been packed up to be taken to London! Christie's had already printed the catalogue, and the few existing copies have become collector's items in their own right. Ultimately, though, the Dumfries pieces belong in the house. They belong to Scotland, and to anyone who has an interest in this incredible place. Part of collecting is recognizing that not everything can be obtained, and often, as was certainly the case here, that's how things ought to be.

The Warp and the Woof

When I was a boy, visiting a New York museum during a school trip, I became enamored of a series of seventeenth-century Philippe Behagle tapestries depicting the life of a Chinese emperor (probably Shunzhi, who ruled China in the mid-1600s). There are several such tapestries illustrating aspects of the emperor's court, from the empress's tea ceremony to the harvesting of pineapples. The tapestries' designs were created by four French painters (one of whom was Jean Baptiste Monnoyer), and inspired in part by illustrations in the German Jesuit Athanasius Kircher's *China Monumentis* (1667)—based on descriptions of China by other Jesuits, and Johan Nieuhof's *Descriptio Legationis Batavicae* (1668)—based on observations of China by officials of East India Company.

The tapestries are enchanting, another example of Asian and Western influences blending in a fascinating way. I would spend hours staring at the incredible details in the huge wall coverings—and they are huge, roughly eleven by ten feet.

When I grew up and started my own collection, I always had a desire to own one of those tapestries but the size held me back. I didn't have that much wall space readily available! Nevertheless, I found myself bidding on the emperor tapestries whenever I came across them, including once during the Segoura sale. I could figure out some sort of solution to the display problem if I won them, but I never did, possibly because I was hesitant. (I have since purchased a new home, so there is now enough space for all my collections.)

Tapestries had become a kind of hole in my collection. One of the few things I had always been attracted to but had never acquired. That is, until a Christie's catalogue arrived in November 2006. I quickly zeroed in on a group of tapestries that were coming up for auction, many of them bearing Louis XIV's coat of arms, which meant they were made for display in the palace.

My favorite piece was the Louis XIV *Portière de Mars*. A *portière* was a heavy curtain or drape designed to hang across a doorway to mimic an actual door (thus the Latin root *porta*, meaning "door"). The tapestry prominently features Mars, the Roman god of war, with the figure of Victory across from him, as well as a number of military trophies and the Royal French coat of arms. At the top of the piece there is a crowned sun, obviously a nod to the Sun King himself, Louis XIV.

Like the Chinese emperor tapestries, it is part of a much larger series from Gobelins, the world-famous tapestry factory. Gobelins served the palaces and produced high-end tapestries in large quantities for the king and other officials—records indicate there were more than sixty tapestries in the Mars series in Versailles alone.

Most of those tapestries no longer exist today. The *Portière de Mars* is one of only four still known to exist. Many of them were destroyed through use as door-hangings. Others were taken during the French Revolution when Versailles was sacked and picked clean by revolutionaries. Some of them may have been destroyed then,

Louis XIV *Portière de Mars* tapestry

but most items from the palaces were auctioned off to support the bankrupt nation in the earliest days of its democracy.

Just as, centuries later, China would sell its treasures off to the West to offset the terrible costs of civil war and imperialism, France sold a great number of artistic and cultural treasures to buyers from all over Europe. This particular tapestry was purchased by a wealthy family who apparently held on to it until 2006. I never learned exactly which family it was or why they were selling, but the fact that it had essentially been in their hands since the late 1700s added to the value of piece. They had maintained it as an heirloom and it wasn't subjected to the trials of multiple sales—and multiple owners—over the years.

Like many of the best pieces, these tapestries were the result of a collaboration of great artists. The initial design was from Charles Le Brun, a famed painter of the era whose work came to epitomize Louis XIV style. When one thinks of seventeenth-century French art, one inevitably pictures Le Brun's work. Add to that the prestigious Gobelins factory and a commission by the Sun King and this work had an amazing pedigree.

I was especially interested in the tapestries because I had started out collecting armorial porcelains. These were made in China for Western customers who wanted their coat of arms on a porcelain piece. The Mars tapestry was an armorial tapestry and I had never seen one of such high quality. It seemed a way of bringing my collection full circle: the kind of piece I'd always wanted in the style I'd cut my teeth on.

I flew to London for the auction and went quickly to examine the tapestries in real life. The condition was even better than I had hoped. I was blown away by the vibrancy of the colors. Many tapestries get faded and discolored after years and years of exposure to sunlight in a home. These tapestries looked as if they had rolled out of the Gobelins workshop just yesterday, rather than 250 years ago.

It was also slightly smaller than other tapestries I had looked at over the years, which meant that I could actually fit it into my living room. This was because it wasn't a purely decorative item. It was designed to block drafts in a doorway, thus it had to be roughly doorway-sized, rather than palace wall–sized.

Seeing the tapestries in living color confirmed their incredible value. I was committed to getting them now and I went into the bidding with that mentality.

Not that I was expecting it to be easy. There's an incredible dealer in tapestries out of London called Frances. I assumed they would be bidding on these because they always have the best tapestries (usually at top dollar). They, however, have a firm cap on what they will purchase because they know that there are lots of other tapestries that they will want.

For me, however, this was my first tapestry—my only one up until that point—and I knew it was the one for me. I pushed the Frances representative past their ceiling only to find myself in a bidding war with the wife of a Russian oligarch.

The oligarch had purchased a place in London, a very common practice wherein the English house operates as a kind of tax-dodge for wealthy Russians. Many of these houses are purchased only for the tax benefits and wind up standing empty virtually all the time. In this case, however, the Russian and his wife apparently intended to spend at least some amount of time in the home, as they were working hard to decorate it. His wife had taken a shine to the tapestry, which was just my luck.

She was nattily dressed, as I have generally found the wives of Russian oligarchs to be, and she was determined to have the Mars tapestry. I did end up winning it, but I spent a small fortune to do so.

I can't find it in myself to regret it, however. I hung the tapestry in my living room and it is one of the first things that greets me whenever I walk into that room. Every time I see it, I am impressed. Not only is it a striking piece of art, but I finally have the satisfaction of realizing a childhood dream. I would pay the same price for it all over again.

It was my first real foray into tapestries, despite how they had enchanted me as a boy. Once I had "broken the seal," as it were, I started to collect more of them. I later purchased a pair

of tapestry portraits, also from Gobelins, depicting King Louis XV and his consort, Queen Maria Leszczyńska, a Polish princess who became France's longest-reigning queen-consort, occupying the position for forty-three years.

The tapestries were designed by famed portraitists Jean-Baptiste van Loo and Jean-Marc Nattier, and Cossette, an artisan out of Gobelins, wove them in 1765; they are both signed and dated so we are able to excellently source them. Items like these had a very important role in courtly life in the eighteenth century. Such tapestries were often given to ambassadors and other dignitaries as tokens of respect from one head of state to another and were designed to be displayed by the recipient as a clear way of signaling positive relations between the two powers. They both came up for sale around the same time as the Mars tapestry and I snapped them up eagerly. I've never seen anything like them come on the market.

There is something in the fragility of a tapestry and the enormous amount of effort that went into each one that makes them so intriguing. First someone had to design and paint a detailed, beautiful scene or portrait. Then another expert had to take that design and translate it into silk and wool, picking the materials and color compositions. Then there was the actual weaving, the hours and days and weeks it must have taken to render all of those minuscule details.

All for an end product that is easily damaged by something as unavoidable as sunlight. Not only do tapestries require meticulous artisans, they also require meticulous owners to avoid fading or moth infestation or simple wear and tear. Essentially, a beautiful and vivid tapestry tells more than just the story of its subjects. It tells a story of care and consideration, hard work, and expertise that stretches over the centuries.

Art's Changing Ecosystem

Historically, there has been a well-defined structure in the art market—like an ecosystem—that supplies fresh items for circulation. Whether we are speaking of the famous "English trade," as London dealers are known, or the French *marchand*, the basic organization is essentially identical and has been so since the rise of dealings in antiques and collectibles.

The system started at street level with a large group of people who canvassed a wide area, looking for treasures that had gone unnoticed. In England, these people were called "knockers" because they literally knocked on doors, asking if the residents would be willing to part with any interesting items. In this way, they were sort of inverse traveling salesmen.

A step up from the knockers were the runners, who were slightly more focused and often had a greater expertise. Knockers worked on luck and volume. If they inquired at every house in a given neighborhood, they would probably find at least a few items of interest. The runners were more precise, and they targeted specific venues. They frequented estate sales, house clearings, and "car boot" sales. A combination of a yard sale and a flea market, car boot sales feature large numbers of people selling everything from clothing and jewelry to books and art all out of the boots (or in American English, "trunks") of their cars. These types of events offered a higher percentage of legitimate collectibles and didn't require the same expenditure of energy as going door to door.

Both knockers and runners operated as free agents, with no particular affiliation with any dealer or auction house. It behooved them to cultivate good relationships with many different dealers who specialized in various types of collectibles. That way, they could afford to buy anything that struck them as valuable, be it Chinese blue-and-white porcelain or Chippendale furniture, without worrying about finding a market for it.

An individual could make a reasonable living selling goods to various dealers. The dealers would clean and restore the pieces if necessary, and then attempt to sell them in the relevant market. Naturally, dealers would also buy and sell to one another. Dealers had their own hierarchies, and some were larger and more influential than others. In England, for example, the most significant dealers have historically occupied London's Bond Street. Smaller dealers would often band together with their more established colleagues to gather collectible items together for an exhibition.

Dealers would produce their own catalogues for these exhibitions and hold them at predictable times during the year. London, for example, has a venerable Asia Week, during which all the dealers of Asian art congregate to show their wares. This gives everyone involved an opportunity to circulate catalogues and brochures, and to get their products onto the radar of the art world.

Collectors knew which exhibitions to attend. If you were interested in Flemish masters or Tiffany lamps, there would be little to interest you during Asia Week.

This is the way things were done for many decades. In recent years, however, auction houses have come to dominate the trade worldwide. They are so pervasive and aggressive that many traditional dealers are struggling to remain viable. Those that manage

to stay afloat have to get virtually all their goods through those very same auction houses. Needless to say, there are very few knockers or runners still making a living these days. For a collector, this means that there are fewer options for getting valuable pieces. Instead of a multitude of dealers, collectors are now forced to buy from just a handful of auction houses.

Just this past summer I was in Paris again, on the Left Bank with my son, Derek. We stopped in to visit a man I'd known for years. I'd bought pieces from him before, and I liked to check in with him whenever I could. He is excellent company and has a wonderful sense of the historical context of collecting, in addition to being a useful contact.

Of course, I hadn't come just to make small talk. I wanted to get a feel for his current inventory. "Do you have anything for me?" I asked.

He shook his head, as though I should have known better.

"Robert, why would I sell it to you if I did? If I get anything really great, you know I have to put it into the auctions."

He was right; the auctions are simply too big to ignore. Dealers are always looking to make a generous profit, so they can't risk an undervalued sale on a single item. In fact, they can't risk anything other than a complete success. Their job is now essentially to supply the auction houses. Most of today's dealers wouldn't even know how to price an item for the actual market.

Auction houses now employ the modern equivalent of runners and knockers. These people spend all their time visiting dealers from Japan to New York, and from Paris to Hong Kong. They are constantly working, constantly soliciting new items, because they have to fill at least two catalogues per year. This pressure and the need to fill catalogue space mean that the auction houses are voracious, snatching up virtually everything of value.

As a consequence, the prices of collectibles are being driven through the roof. Part of this, of course, is simply the changing global economy. Multiple recessions and depressions have left people skeptical of the inherent value of money. Growing wealth in traditional financial products is increasingly untenable, and many people are discovering that even the best portfolio managers can only guarantee them an annual return of 2 to 4 percent. Collectibles, meanwhile, are tangible, reliable investments that seem to only appreciate in value.

This type of thinking is hardly new. Whenever we hear tales of hardship, there are always stories of individuals attempting to smuggle physical assets out of terrible situations. From the apocryphal stories of doomed Romanov women sewing imperial jewels into their bodices to Jews fleeing Nazi-occupied Europe with gold hidden in their clothes, humans have a long and storied history of rescuing physical wealth when all other assets have been seized. The reality is that objects of beauty and taste are not just aesthetic delights; there are times when possessing them can mean the difference between life and death.

Today, as this book has demonstrated, the art world is going through unparalleled changes. The Internet gives everyone access to details about pieces that might have been in the sole possession of a single dealer. China's enormous wealth has transformed collecting, not just of Chinese treasures but all forms of art.

The great auction houses, enjoying more market power than ever before, have recently added a 2 percent fee on top of their customary charges for pieces that sell above their estimated prices. The competition for outstanding and rare pieces that are fresh to the market is more intense than anything I have seen in my lifetime.

These changes are certain to accelerate as time goes on, so collectors must find ways to adjust and keep up.

I hope you have enjoyed traveling the globe with me, and that my journey inspires you to surround yourself with the finest pieces the world's artists and craftsmen have created, whether by starting your own collection or by visiting great museums. Collecting art has been a lifelong calling, one that has enabled me to travel the world and meet fascinating people. Had I not taken this journey, I might never have realized my childhood dream of living in a museum.

This book spotlights only a small portion of my collection, so perhaps we will meet again and travel further on the greatest voyage of my life, my collector's odyssey.

In addition to his international renown as a private art collector, Robert H. Blumenfield is a major real estate investor and developer in Southern California. He is the owner of The Roberts Companies, one of the leading real estate developers in Southern California. The Roberts Companies has developed a large number of condominiums and apartment complexes as well as industrial complexes.

Blumenfield's enterprising savvy and passion for collecting traces back to his childhood. He invented the Topps chewing gum baseball card at the age of 12, with the help of his uncle Abraham Shorin, who owned the company with his brother. His eye for exquisite pieces was also sharpened at a young age as he collected stamps. Unlike most children, Blumenfield—even at that young age—didn't care to sacrifice quality for quantity. He sought only German stamps from World War II, and as an adult, he sold that unique stamp collection at an auction in Hamburg—the first of many auctions to come.

A connoisseur and scholar of Asian art, as well as period European furniture, Blumenfield's first collections consisted of Chinese Export porcelain and bamboo carvings and scholars' objects in Chinese taste, which he began to hunt for in 1978. In 2002, he published his first book, the critically and academically acclaimed national best seller *Blanc de Chine: The Great Porcelain of Dehua* (Ten Speed Press).

Blumenfield has now dedicated over 40 years to amassing his distinguished private collection of rare objects, and has also acquired expert knowledge and a trained eye for exquisite English and French furniture and other objets d'art. He frequently loans out pieces from his collection to art museums and universities. He continues to add to the collection and has expanded into Southeast Asian and Himalayan art.

A businessman, scholar, collector and author, Blumenfield lives by the lesson his mother taught him as a young boy: "If you see it and you love it, buy it, because you may never see it again."